Compositing Visual Effects

Compositing Visual Effects
Essentials for the Aspiring Artist

Steve Wright

AMSTERDAM • BOSTON • HEIDELBERG • LONDON
NEW YORK • OXFORD • PARIS • SAN DIEGO
SAN FRANCISCO • SINGAPORE • SYDNEY • TOKYO

Focal Press is an imprint of Elsevier

Acquisitions Editor: Paul Temme
Publishing Services Manager: George Morrison
Project Manager: Paul Gottehrer
Associate Editor: Dennis McGonagle
Assistant Editor: Chris Simpson
Marketing Manager: Marcel Koppes
Cover Design: Joanne Blank

Focal Press is an imprint of Elsevier
30 Corporate Drive, Suite 400, Burlington, MA 01803, USA
Linacre House, Jordan Hill, Oxford OX2 8DP, UK

 Recognizing the importance of preserving what has been written, Elsevier prints its books on acid-free
paper whenever possible.

Library of Congress Cataloging-in-Publication Data
Application submitted

British Library Cataloguing-in-Publication Data
A catalogue record for this book is available from the British Library.

ISBN 13: 978-0-240-80963-2

For information on all Focal Press publications
visit our website at www.books.elsevier.com

07 08 09 10 11 5 4 3 2 1

Printed in China

Contents

Chapter 3
Compositing CGI . 41

Chapter 4
Bluescreen Compositing . 63

Chapter 9

Chapter 10

Chapter 11

Introduction

Digital compositing is a key component of today's visual effects, which create fantastic and exciting images for audiences everywhere. There are now many schools, universities, training institutes, and online training services attracting an ever-growing number of new students eager to join this exciting branch of the entertainment industry. Beyond formal training institutions, it is also one of those rare fields in which enterprising people can actually train themselves, then go out and get a seriously good paying job. You don't need a degree from any particular institute. You only need to demonstrate that you can do the work. The problem is it can be difficult to get started because so much of the training available out there makes assumptions about the background of the student. This book does not.

This is an introductory book on digital compositing for visual effects. It makes no assumptions about the readers' background and is written for those that do not yet have a deep exposure to digital compositing or visual effects, but would like to quickly and painlessly come up to speed. It is digital compositing *lite*, readable by all, lavished with hundreds of film shots, figures, illustrations, and diagrams to help tell the story for the visual reader. For those that already have a background in digital compositing, I would recommend my more advanced book on the subject, *Digital Compositing for Film and Video*, by Steve Wright. Those who would benefit most from this book include:

- Digital compositing or visual effects students new to the industry;
- Someone considering digital compositing as a career and would like to see what it is all about;
- Entertainment industry professionals that would like to understand digital compositing, such as producers, directors, editors, colorists, and postproduction supervisors;
- The curious, the interested, and the explorer.

While carefully written so as not to confuse or intimidate the newcomer, it is also packed full of information and techniques specifically designed to be useful to those new to compositing and visual effects. The reader will gain a valuable vocabulary

and a basic understanding of the full range of visual effects, in which digital compositing plays a key role, all the while avoiding the muck and mire of math. The first chapter takes you on an inspirational tour of the scope and magnitude of digital compositing for visual effects and provides a solid overview of the kinds of digital effects routinely done today. See how CGI (Computer Generated Image) is composited with live action, how set extensions are done, and what a match-move shot is. Following that, we reveal each of the key applications of purely digital compositing, which includes bluescreen compositing, bullet time shots, motion tracking, and rotoscoping, to name a few.

The second chapter offers a basic education on digital images in order to reveal the key concepts and terms used in the subsequent chapters. Each chapter focuses on one major application of digital compositing in the entertainment industry today, and also introduces the fundamental concepts and processes behind them. This includes the many ways to composite CGI, bluescreen compositing, animation, creating masks, working with digital keyers, and many more; but most importantly, the art of digital compositing—making your shots look not just photorealistic, but cool. We pay special attention to defining new terminology and telling a clear story from the ground up, with the only requirement being that you have read the previous chapters.

The entertainment industry professional who has no intention of becoming a digital compositor, but would like to better understand the process, will find it laid out in a way that is extremely accessible and informative. Learn what is easy and hard, possible and impossible, and what to expect when working on a job that entails digital compositing. There are tips on when not to use the new low-end DV video cameras and how they damage the quality of the visual effects shot. There are even tips for the client, such as guidelines on how to shoot a quality bluescreen or greenscreen to get the best results at compositing time.

It is often difficult for a senior person who has worked in any field for many years to tell his story at just the right level for a newcomer. However, I am very fortunate in that I also have many years of teaching, training, and instructing for all levels of proficiency in digital compositing, and this has given me insight into how to write an introductory book like this on a favored subject. I hope you have as much fun reading it as I did writing it.

Enjoy.

Steve Wright is a 20-year veteran of digital effects with 70 broadcast television commercials and over 60 feature film credits. He now teaches digital compositing at visual effects facilities around the world, as well as speaks, writes, lectures, publishes, and develops training material. To learn more about Steve Wright you can visit his web site at:

www.swdfx.com

Acknowledgements

A book like this is immensely visual and requires a great many pictures. While I do have a large library of 35 mm film scans and HDTV elements to tap into, it was not enough for a book of this scope. I am grateful to the following groups and individuals who contributed images that enliven the pages of this book.

A special heartfelt thank you goes to the amazing Sylvia Binsfeld of DreamWeaver Films and her fabulous 35 mm short film *Dorme*, which I had the privilege and pleasure of compositing for her. Her contribution of high-resolution 35 mm film scans, delightful CGI elements, and gorgeous digital matte paintings grace many pages of this book. *www.dormefilm.com*

Many thanks to Alex Lindsay and Christopher Marler of PixelCorps for contributing High Definition bluescreen and greenscreen footage shots with their fabulous Sony HDC-950 HD color video camera direct to hard drive. *www.pixelcorps.com*

I would also like to acknowledge the contributions of Jovica Panovski of Collaborative Media Group in Skopje, Macedonia, who contributed several 35 mm bluescreen shots as well as other film elements to help tell this story of digital compositing.

A special thank you to Tom Vincze, a terrific CGI artist, who created multipass GGI, sims, and particle system examples specifically for this book. *www. thomasvincze.com*

Many thanks to Greystone Films and the Mount Vernon Ladies' Association for providing high-resolution 35 mm film scans from their location-based film *We Fight to Be Free*, a docudrama about the early heroic life of George Washington.

My thanks to Pavel Dvorak, a photographer and friend, who contributed many high-quality digital still photos from his collection. *www.absolutpavel.com*

Thanks also to Kodak for their generous contribution of scanned 35 mm film elements from their corporate film *The Lightning Project*, courtesy © Eastman Kodak Company. *www.kodak.com*

I would also like to thank the very talented Ruairi Robinson for contributing key shots from his spectacular visual effects film *Silent City*. His examples of matchmove and set extension were valuable additions to this book. *www.ruairirobinson. com*

Thanks to the Foundry, a world leader in providing plug-ins for the visual effects community, for providing the crowd duplication example. *www.thefoundry.co.uk*

Finally, a very special thanks to my darling wife, Diane Wright, for she has been a great supporter and contributor to the entire effort of this book. She not only graciously tolerated the amount of time spent writing it, but also reviewed, critiqued, formatted, and contributed graphics. *info@swdfx.com*

1 Visual Effects Today

Digital compositing is an essential part of visual effects that are everywhere in the entertainment industry today: In feature films, television commercials, and many TV shows, and it's growing. Even a noneffects film will have visual effects. It might be a love story or a comedy, but there will always be something that needs to be added or removed from the picture to tell the story. That is the short description of what visual effects are all about—adding elements to a picture that are not there, or removing something that you don't want to be there. Digital compositing plays a key role in all visual effects.

The elements that are added to the picture can come from practically any source today. We might be adding an actor or a model from a piece of film or videotape; or, perhaps the mission is to add a spaceship or dinosaur that was created entirely in a computer, so it is referred to as a computer generated image (CGI). Maybe the element to be added is a matte painting done in Adobe Photoshop®. The compositor might even create some of their own elements.

It is the digital compositor who takes these disparate elements, no matter how they were created, and blends them together artistically into a seamless, photorealistic whole. The digital compositor's mission is to make them appear as if they were all shot together at the same time, under the same lights with the same camera, then give the shots a final artistic polish with superb color correction. This is a nontrivial accomplishment artistically, and there are a variety of technical challenges that have to be met along the way. Digital compositing is both a technical and an artistic challenge.

The compositor is first and foremost an artist, and works with other artists such as matte painters, colorists, CGI artists, and art directors as members of a visual

effects team. This team must coordinate their efforts to produce technically sophisticated and artistically pleasing effects shots. The great irony here is that if we all do our jobs right, nobody can tell what we did because the visual effects blend seamlessly with the rest of the movie. If we don't, the viewer is pulled out of the movie experience and begins thinking, "Hey, look at those cheesy effects!"

 So what is the difference between visual effects and special effects? Visual effects are the creation or modification of images, where special effects are things done on the set, which are then photographed such as pyrotechnics or miniatures. In other words, visual effects specifically manipulate images. Since manipulating images is best done with a computer, it is the tool of choice, and this is why the job is known as *digital compositing*.

I mentioned earlier that digital compositing is growing. There are two primary reasons for this. First is the steady increase in the use of CGI for visual effects, and every CGI element needs to be composited. The reason CGI is on the upswing is because of the steady improvement in technology, which means that CGI can solve more digital problems every year, thus increasing the demand by movie-makers for ever more spectacular effects for their movies (or TV shows or television commercials). Furthermore, as the hardware gets cheaper and faster and the software becomes more capable, it tends to lower the cost of creating CGI. However, any theoretical cost savings here are quickly overwhelmed by the insatiable appetite for more spectacular, complex, and expensive visual effects. In other words, the creative demands continuously expand to fill the technology.

 The second reason for the increase in digital compositing is that the compositing software and hardware technologies are also advancing on their own track, separate from CGI. This means that visual effects shots can be done faster, more cost-effectively, and with higher quality. There has also been a general rise in the awareness of the film-makers in what can be done with digital compositing, which makes them more sophisticated users. As a result, they demand ever more effects be done for their movies.

In this chapter, we take a wide-ranging tour of the incredible scope and scale of digital compositing in visual effects today. The first section describes digital compositing with CGI. A lot of our work is to composite CGI, so it warrants its own section.

 The second section reveals the many types of amazing visual effects that are done strictly with modern compositing software—no CGI required. The third section takes a brief look at the two types of compositing programs: Node-based and timeline-based. From this point on, I will refer to film in these examples, but I am also including video. It is just a bit too cumbersome to continuously refer to film (and videotape), or filming (and videotaping), or cinematographers (and videographers).

1.1 DIGITAL COMPOSITING WITH CGI

Whenever someone makes a CGI element, someone else has to composite it. In this section, we will look at three general areas where CGI elements are composited. First up is straightforward CGI compositing where a CGI object has been created and needs to be composited into the scene. Second, we will take a look at set extension, a rapidly expanding technique in filmmaking. Third, we will look at the match move, where separate programs are used to analyze the live action and provide terrain and camera move data for the CGI programs.

1.1.1 CGI Compositing

By far the most common application of digital compositing is to composite CGI. Whether it is for a $100,000 commercial or for a $100 million dollar movie, the CGI is created in a computer and composited over some kind of a background image. The background image is very often live action, meaning it was shot on film or video, but it too could be CGI that was also created in a computer, or it may be a digital matte painting. Regardless of where the background came from, the digital compositor puts it all together and gives it the final touch of photorealism. Figure 1-1 illustrates a basic CGI composite where the jet fighter was created in the computer, the background is live action footage, and the final composite puts the jet fighter into the background.

CGI object Live action background CGI composited over
 background

Figure 1-1 A CGI object composited over a live action background.

Today, CGI goes far beyond jet fighters and dinosaurs. Recent advances in the technology have made it possible to create a very wide range of incredibly realistic synthetic objects for compositing. Beyond the obvious things such as cars, airplanes, and rampaging beasts, CGI has mastered the ability to create photorealistic hair, skin, cloth, clouds, fog, fire, and even water. It has even become common practice to use a "digital double" when you want the movie star to execute a daring stunt that is beyond even the expert stunt double. It will not be long before the first "cyber thespian" (an all CGI character) stars in what would otherwise be a live action movie. However, after all the spaceships, beasts, water, and fire have been rendered, somebody has to composite them all together. That somebody is the dauntless digital compositor.

1.1.2 Set Extension

If you wanted your actors to be seen standing in front of the Imperial Palace on the planet Mungo, you may not want to spend the money to build the exterior of the entire Imperial Palace. Better to build a small piece of it on a movie set, place the talent in it, then extend the set later using CGI when you need a wide shot. For this little piece of digital magic, the film is digitized into the computer and the CGI folks build a 3D model of the Imperial Palace and line it up with the original film footage and its camera angle. There might even be a camera move in the live action that the CGI artists will carefully track and match; but eventually, the live action and the CGI set extension must be composited and color corrected to match perfectly.

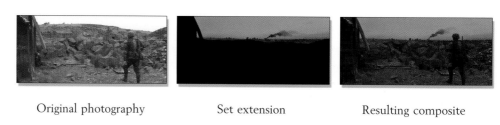

Original photography Set extension Resulting composite

Figure 1-2 Set extension.*

Figure 1-2 is a classic example of a set extension that demonstrates how they can even be applied to an exterior location shot. The original photography captures the future soldier walking along an otherwise small and uninteresting rubble pit. The middle picture shows the set extension element that was an all CGI city in the distance with smoke generated by a particle system and a matte painting for the sky. The resulting composite shows all of the elements composited together and color corrected to blend properly.

You can immediately see the enormous difficulty in trying to create this shot without using set extension and digital compositing. You would need to find a loca-

*Courtesy Ruairi Robinson's *Silent City*.

tion that had the rubble pit the correct distance from a real city that had the right look and was (unhappily) on fire at the time. You would then have to wait for the right time of day to get the sunset sky, and in location shooting, waiting is very expensive. If such a location could even be found, you would then have to fly the entire crew out there. This amounts to a very expensive if not nearly impossible production plan.

Instead, the producer wisely chose to do a set extension. The rubble pit was easy to find and close at hand. The crew drove to the location in only half an hour. Once the film was digitized, the CGI department took over and created the background city and smoke animation, while the digital matte painter made the sky painting. When all was ready, the digital compositor took all four elements: Original photography, CGI set extension, smoke animation, and matte painting, and then composited them together and then color-corrected them to blend naturally. Not only was this far less expensive, but (and this is the punch line) the director got exactly the shot he wanted. What CGI and digital compositing bring to the table is creative control—the ability to make exactly the shot you want—not just what is practical or affordable.

1.1.3 Match Move

Directors and cinematographers hate to lock off the camera. They love to swoop the camera through the scene, boom it up over a crowd, or swing it around the heroic character. This is fine if the shot is all live action, but it wreaks havoc if the shot requires CGI to be mixed with the live action. If the live-action camera is moving, then the CGI camera must also move so that the CGI will match the changing perspective of the live action. Not only must the CGI camera move, but it must move in perfect sync with the live action camera or the CGI element will drift and squirm in the frame and not appear to be locked with the rest of the shot. Special match-move programs are needed to pull off this bit of cinematic magic. An example of a match-move shot is shown in Figure 1-3 where the camera orbits around the live-action soldier. The soldier is in an all CGI environment.

Figure 1-3 Match-move sequence.

Match move is a two-step process. First, the live-action plate is analyzed by the match-move program. A *plate* is simply a shot that is intended to be composited with another shot. The match-move program correlates as many features as it can between frames and tracks them over the length of the shot. This produces a 3D model of the

terrain in the scene, as well as camera move data. The terrain model is low-detail and incomplete, but it does provide enough information for the next step.

The second step is to give the 3D terrain information and the camera move data to the 3D animators. They use the terrain information as a guide as to where to place their 3D objects. The camera move data is used by the computer camera to match the move of the live-action camera in order to render the 3D objects with a matching perspective that changes over the length of the shot. If the terrain information or camera move data is off in any important way, then the 3D objects will scoot and squirm rather than appear to be firmly planted on the ground.

After all the 3D elements are rendered, the live-action plate and the CGI arrive at the digital compositor for final color correction and compositing. Of course, the compositor is expected to fix any small (or large) lineup problems in the CGI or live action. The match move game can be played in two fundamental ways: Live action can be placed in a CGI environment (such as the example in Figure 1-3), or CGI can be placed in a live-action environment, like King Kong in New York City. Either way you work it, match move is truly one of the great wonders of visual effects.

1.2 COMPOSITING VISUAL EFFECTS

Now we will take a look at the many diverse applications of visual effects that are done with a modern compositing program. None of these requires any CGI. The steady advances in compositing software tools and algorithms have continuously added new capabilities for the digital compositor, which must be mastered both technically and artistically.

1.2.1 Bluescreen Compositing

There are many situations where placing an actor in a scene for real would be too expensive, too dangerous, or even physically impossible. In these situations, you would want to film the talent in an inexpensive and safe environment, then later composite them into the actual expensive, dangerous, or impossible background. This is what *bluescreen compositing* is all about. The talent is filmed in front of a solid blue background to make it easier for the computer to isolate and then composite them into the actual background as shown in Figure 1-4.

Bluescreen Background plate Composite

Figure 1-4 A basic bluescreen composite.

Bluescreen compositing offers a completely different set of challenges than CGI compositing, because the compositor must first isolate the talent from the backing color by creating a high-quality matte. This matte is then used to perform the composite, whereas with CGI, a perfect matte is automatically generated by the computer and comes with the CGI image.

The backing color can also be green, in which case it is called a *greenscreen*, but the principle is the same in either case. The computer detects where the backing color is in each frame and generates a matte that is used to composite the actor (or spaceship, animal, dazzling new consumer product, or whatever) into the background. This is where the artistic and technical challenges to the compositor skyrocket. Not only because of the difficulty of creating a good matte, but also because the various elements will not visually match the background very well so they must be heavily color corrected and processed by the digital compositor to blend them properly.

1.2.2 Motion Tracking

Motion tracking is the little brother to match move. With match move, the CGI artist is tracking hundreds, sometime thousands of points in a scene and using that data to build 3D models and a matching 3D camera move. Motion tracking usually only tracks a few points and its data is used to track a 2D image onto another 2D image.

Moving target

Graphic element

Graphic element tracked to moving target

Figure 1-5 Motion tracking.

Let's say that you have been given a graphic element such as a corporate logo and the mission is to attach it to the wing of a supersonic jet fighter like the one in Figure 1-5. The motion-tracking program locks onto key points on the wing of the fighter and tracks them over the length of the shot. That 2D tracking data is then applied to the graphic element so it will move in perfect sync with the fighter's wing when composited. Of course, even though the graphic element now moves with the fighter correctly that does not change its lighting as the fighter moves through

the shot, so that and other photorealism issues will have to be addressed by the compositor.

Motion tracking has many applications beyond tracking logos to jet fighters. One of the most common applications is monitor replacement in which a new image is tracked and composited over the face of a monitor or TV screen. When a digital matte painting is added to a shot that has a camera move, the matte painting will have to be motion-tracked to lock it to the shot. Another common use is to create a mask to isolate an object in the frame, then motion track the mask to stay on top of the object over the length of the shot. Any time one image needs to be locked onto another moving image, motion tracking is the technology that makes it possible.

1.2.3 Warping and Morphing

Warping is one of those magical things that only a computer can do. Imagine it as attaching an image to a sheet of rubber, then pulling and stretching only those parts of the rubber sheet that you want to deform. This especially allows you to push and pull on the interior parts of the image to deform it any way you want. When is this used? Any time you want to fit one image over another, but you can't make it fit just by pulling on just its corners. Figure 1-6 shows an example of warping a graphic element to fit over a curved surface. These warps can also be animated over time to maintain their warped shape over a moving surface.

Element to warp Warped element Warped element composited

Figure 1-6 Warping an element.

Morphs are the big brother to warps. It takes two warps and a dissolve to create a morph, but we will have to wait until Chapter 8 to see how this is actually done. For now, we can simply admire the fact that in the hands of a digital artist the computer can seamlessly transform one face into another, as if by magic—and it is magic—digital magic. But all magic requires a magician, and that's the digital compositor. Most compositing software today comes with warping and morphing capabilities. There are also separate dedicated programs available that do warping and morphing in case your compositing software does not.

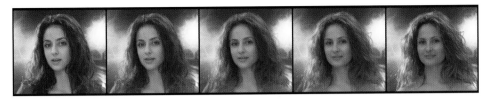

Image A Frame 2 Frame 3 Frame 4 Image B

Figure 1-7 Morph sequence.

Figure 1-7 illustrates a morph between image A and image B. What is not obvious from this example of a morph is that the two morphing images must be shot on bluescreen or isolated from their backgrounds in some other manner, such as a *roto*. The morph is performed on these isolated images, and then the results are composited over the background.

1.2.4 Bullet Time Shots

Ever since we were thrilled by the jaw-hanging spectacle of a camera flying around a suspended animation of Keanu Reeves in *The Matrix*, bullet time shots have become a permanent entry in the lexicon of visual effects. They present a never-before seen view of a frozen moment in time using methods that defy imagination. Unless you are a digital compositor, of course, as this is an all-compositing effect with no CGI required.

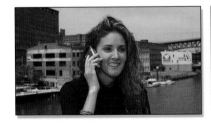
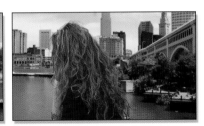

Frame 1 Frame 15 Frame 30

Figure 1-8 Bullet time shot.

Figure 1-8 illustrates just three frames out of a bullet time shot. The setup is that a number of still cameras are arrayed in an arc around the target character, like the top view diagram in Figure 1-9, and then they are all triggered electronically. If they are triggered at the same instant, the character is frozen in time; if they are triggered a fraction of a second apart the character moves in slow motion. Either way, the result of the photography shoot is a series of still frames, each taken from a slightly different point of view since each camera is in a different position around the character.

Now, enter the compositor. The first issue to be dealt with is that while the cameras were all pointing at the character, the alignment is not perfect so each camera is off center a bit. As a result, when the frames are played at speed there is some jitter that has to be removed using image stabilization techniques. Next, each camera will have taken a slightly different exposure due to the natural variation in the cameras, lenses, and film stock (or digital sensor), so each frame must be precisely color corrected so that they all match and there is no flicker in the shot when played at speed.

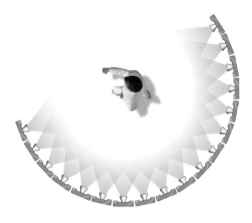

Figure 1-9 Bullet time rig of still cameras.

Last, the shot needs to get a digital speed change—what we call *retiming*. Here's why: let's say we want to end up with a 4-second shot. Since film plays at 24 frames per second, we will need 4 × 24, or 96 pictures. Setting up, aligning, and triggering 96 still cameras is an arduous task. Instead, we will just set up half that many (48 cameras), and then do a speed change to "stretch" the 48 frames to 96. The technology to do this is called *optical flow*, which is more digital compositing wizardry. We will learn all about optical flow in Chapter 7, but suffice it to say that it can create beautifully interpolated in-between frames to stretch a shot.

1.2.5 Crowd Duplication

If the director wants an attacking army of 50,000 Orks, he will open his checkbook and turn to the CGI artists. They will use what is called *flocking* software to avoid having to personally choreograph the behavior of 50,000 angry Orks. However, if the director wants to fill a baseball stadium with cheering fans he will either have to hire 50,000 excitable extras, or you, the dauntless digital compositor.

Original plate Duplicated crowd

Figure 1-10 Crowd duplication.*

*Crowd duplication images courtesy of The Foundry Visionmongers Ltd.

There are two basic crowd duplication technologies: Procedural and direct compositing. A procedural example is shown in Figure 1-10. The program samples nearby areas and creates similar looking pixel patterns on a frame-by-frame basis. Because the created areas are regenerated each frame they are animated and blend in naturally with the teaming crowd.

For the direct compositing approach, a few hundred extras are hired, then seated in the bleachers, then filmed while they cheer on command. They are then moved to the next section of bleachers to cheer again. This process is repeated several times until there are several shots of the stands with cheering fans sitting in different sections, all surrounded by empty seats. The compositor then lifts the crowds out of each of the different shots and combines them into one shot with all of the bleachers filled with fans.

It is amazing how often crowd duplication is done. The reason it is done is simple—cost. It is a heck of a lot cheaper to hire a few hundred extras (and a good compositor) than it is to fill a stadium with 50,000 fans. The tricky bit is that the lighting will have to be changed over the course of the day for outdoor shots, somebody will have bumped the camera causing the shots to be misaligned, and lens distortion will warp some of the shots as well. The digital compositor has to fix all this (and several other problems) to get a seamless crowd duplication shot. But, this is why they get the big bucks.

1.2.6 Atmospherics

Adding atmospherics to a shot is another digital compositing effect that is done all the time. What I mean by atmospherics are things such as fog, snow, rain, atmospheric haze, dust, smoke, light halos, lens flares, and just about anything else that can hang in the air and block, diffuse, reflect, absorb, or refract light, which covers a lot of things. In fact, the failure to put atmospherics in a shot when they are needed can contribute to a fake-looking visual effect shot.

There are several reasons to add atmospherics to a shot digitally. For example, take weather effects such as fog, rain, and snow. The film crew can either stand around waiting for it to happen, which it may never happen, or add the effect digitally. Another problem with the real thing is that rain and snow can be hard on cameras, crews, and sets. Sometimes the fog or smoke is required to follow a specific behavior to pull off the gag, such as twirl around the talent's head. However, it is not likely to happen with the real thing.

Original shot Atmospheric element Atmospherics added

Figure 1-11 Adding atmospherics to a visual-effect shot.

The example in Figure 1-11 shows a digital effect shot with a heavy atmospheric element added. In this example, the original shot is a matte painting that has been mixed with an atmospheric element from live-action footage. A bluescreen shot for example, may need to have an actor composited within a smoky or foggy background. In this case, the smoke or fog will somehow have to be added to the actor after the composite because smoking the bluescreen shot when it is filmed will ruin it. These atmospheric elements (fog, lens flare, and so forth) may come from a live-action plate, created by the digital compositor using the compositing program, a painting from Adobe Photoshop, a digital photograph, or created by the CGI department. You never really know.

1.2.7 Rotoscoping

Frequently, it comes to pass that a character or object that was not shot on bluescreen needs to be isolated for some reason, perhaps to composite something behind it or maybe give it a special color correction or other treatment. This situation requires the creation of a matte without the benefit of a bluescreen, so the matte must be *rotoscoped*, which means it is drawn by hand, frame by frame. This is a slow and labor-intensive solution, but is often the only solution. Even a bluescreen shot will sometimes require rotoscoping if it was not photographed well and a good matte cannot be extracted.

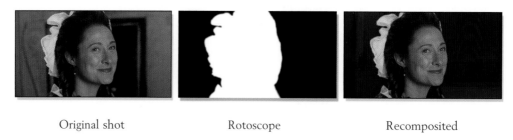

Original shot Rotoscope Recomposited

Figure 1-12 Rotoscoped shot recomposited over a new background.

Virtually all compositing programs have some kind of rotoscoping capability, but some are more capable than others. There are also programs available that specialize in just rotoscoping. Each frame of the picture is put up on the monitor and the roto artist traces an outline around the character's outer edge. These outlines are then filled in with white to create the familiar white matte on a black background, like the example in Figure 1-12. Large visual effects studios will have a dedicated roto department, and being a roto artist is often an entry-level position for budding new digital compositors.

There has even been a recent trend to use rotoscoping rather than bluescreen shots for isolating characters for compositing in big-effects films. I say big-effects

films because it is much more labor-intensive, and therefore, expensive to rotoscope a shot than to pull a bluescreen matte. The big creative advantage is that the director and cinematographer can shoot their scenes on the set and on location "naturally," rather than having to shoot a separate bluescreen shot with the talent isolated on a bluescreen insert stage. This allows the movie's creators to focus more on the story and cinematography rather than the special effects. But again, this is a very expensive approach.

1.2.8 Wire Removal

We have all seen kung-fu masters and super-heroes leaping and flying around the screen defying the laws of gravity. This is all done by suspending the stunt actors on wires with crews off-camera pulling on them at the right moment to give the hero a boost. This type of stunt is called a *wire gag* and is very common in action films of all kinds. However, after the film is shot someone has to remove the wires, and that someone is the digital compositor.

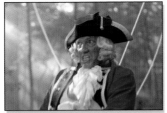 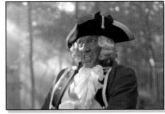

Character with wires Wires removed

Figure 1-13 Example of wire removal.

Figure 1-13 illustrates a classic wire gag where the rider is about to be yanked off his horse by a wire harness. Using the full library of techniques described above such as motion tracking, warping, morphing, rotoscoping, compositing, and even digital painting, the wires are removed frame by frame. The process can get very complex because the background region where the wires are removed must be replaced. If the wire removal is for a bluescreen shot, this is less of an issue. It gets even more complex when the wires drape over the front of the talent, which they often do. It gets yet even more complex when the wires drape over the front of the talent onto textured surfaces such as a herringbone jacket.

Sometimes the actors or props are supported by poles or mechanical arms called *rigs*, which must be removed as well. Wire and rig removal are also considered entry-level activities and could be your first job in digital compositing.

1.2.9 Scene Salvage

Sometimes things just go horribly wrong on the set, in the camera, or in the film lab. A light on the set flares into frame; the camera body was not closed properly and light leaked onto the raw negative; the developing lab put a huge scratch down 100 feet of camera negative; the film went through an X-ray machine and got fogged; or the negative got water spots on it in the developing lab. Fixing these production nightmares is referred to as *scene salvage*, and can be a rich source of income as well as a technical challenge.

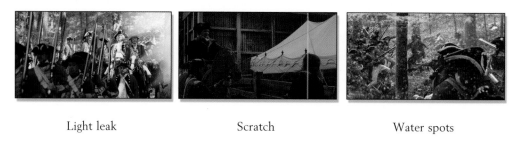

Light leak Scratch Water spots

Figure 1-14 Common production problems requiring scene salvage.

The reason a lot of money is paid to fix these problems is easy to understand if you simply consider the alternative, which could mean rebuilding the set and bringing Tom Cruise and the entire film crew back for an afternoon reshoot. I don't think so. Besides, most of these problems are paid for by the production insurance company anyway, so it's not like it's costing real people any real money.

1.3 COMPOSITING PROGRAMS

The visual effects described above are all done using digital compositing programs, so how is it that such a large array of different effects can be done with one program? Compositing programs do much more than just composite visual effects. They are designed like a toolbox that contains a myriad of individual tools that can be used in combination to do almost anything. They all contain the basic tools for compositing, of course, such as keying, color correction, animation, motion tracking, warping, and image blending operations. They all have ways to view the images as they are worked on, as well as ways to preview animations and render the final shot out to disk in a variety of file formats.

However, compositing programs differ greatly in the number of tools they come with, as well as the quality of those tools. Some have built-in morphing capability, and some don't. Some have very sophisticated mask-drawing tools that can be used to do high quality rotoscoping; others have only simple mask drawing tools. One thing they do have in common is the ability to add plug-ins. Plug-ins are additional programs that can be purchased and added to the main program, which either adds new tools or better tools than those that came with the original program. Some plug-ins actually cost more than the original compositing program!

Compositing systems come in two basic forms: large, dedicated hardware systems such as Flame and Inferno, and desktop software-based systems such as Shake and After Effects. The large dedicated systems are very fast so as to emphasize interactivity and production speed, but costs hundreds of thousands of dollars per workstation. In visual effects, speed costs. The desktop variety runs on small personal workstations costing only a few thousand dollars and the software may be $5000 or less. Compositing speed for the workstation can be improved by distributing the composite renders onto a "render farm" in a computer room.

While their functionality can be very similar, there are two distinctly different approaches to the design of their GUI, the Graphical User Interface. This is the "control panel" that the artist uses to operate the compositing program. There are two broad design philosophies: the node-based compositor and the layer-based compositor. We will take a look at each type because they represent very different approaches to the digital compositing workflow.

1.3.1 Node-Based Compositors

A node-based compositor represents each image processing operation with one "node," represented by an icon. These nodes are then connected together into a node tree, or *flowgraph*, which shows how each operation connects to the next. Figure 1-15 shows a node tree from Apple's Shake compositing program. The nodes labeled "greenscreen" and "background" fetch the images from the disk. The image from the background node goes into the ColorCorrect node to get color corrected, and from there to the Scale node to get sized down. The background is now prepped for the composite with the greenscreen.

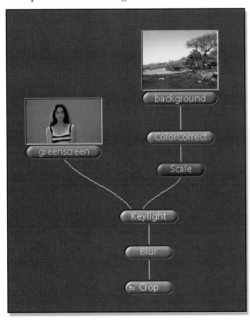

Figure 1-15 Node-based GUI.

The greenscreen and the prepped background image both feed into a Keylight node, which pulls the matte and performs the composite. The Keylight node passes its image down to the Blur node, which softens the picture, and then from there it goes to the Crop node to get cropped to the final size of the shot. Just by inspecting the node tree in Figure 1-15, you can determine not only what image processing operations are being done, but also the order in which they are being done. In digital compositing, order is everything.

The main virtue of a node-based compositor is that you can see what you are doing. It is obvious that the background is being scaled prior to the composite operation. The fact that

the blur operation is occurring after the composite is perfectly clear. Nothing is hidden. You can see the flow of the images as they move through the node tree from operation to operation. To be sure, each of these nodes can be opened up to reveal addition controls and settings within them, but the overall sequence of operations is abundantly clear.

The main advantage of node-based compositors is readily apparent when working on large, complex visual effects shots. An easy to read "road-map" of the compositing flow becomes extremely important when working on shots with hundreds of operations, because the complexity of the shot can become overwhelming without it. Trying to troubleshoot a large composite is much more manageable.

1.3.2 Layer-Based Compositors

The other GUI design paradigm used by some compositing programs is the layer-based compositor represented by an example from Adobe After Effects in Figure 1-16. This presentation of the compositing workflow places the emphasis on seeing the timeline—the timing relationship between the various clips, still images, and animations in the shot. Node-based compositors have the same type of control over the timing of clips and animation, but the timing information is deemed less important and is folded away out of view until the artist calls it up. With a layer-based compositor, it is always front and center and it is the image processing operations that are folded away and out of view until the artist calls them up. The example in Figure 1-16 shows one of the QuickTime movie layers that has been "unfolded" to reveal the animation controls and its audio tracks.

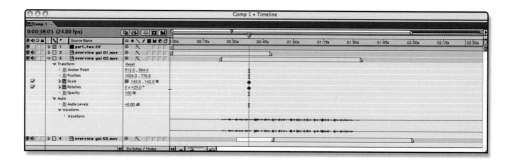

Figure 1-16 Layer-based GUI.

The reason for this different design emphasis is grounded in the original intended use of these programs. For programs such as Adobe After Effects, the original design intent was what is called *motion graphics*. In its simplest form, that means to create a graphic element in Adobe Photoshop such as a logo or title artwork, and then bring it into After Effects and fly it around. Over time, the visual-effects community starting using After Effects for much more than motion graphics; new features were

added, plug-ins were made available, and until today it has become a very powerful digital compositing program that has actually been used in many feature films. The node-based compositors, by contrast, were designed from the outset for compositing complex visual effects using CGI animation and live-action footage so their GUI designs reflect that workflow.

The main advantage of the layer-based GUI design is when working with motion graphics, but it is also possible to do fine visual-effects work with them. However, it is more difficult to see how the operations flow from one to another, so very large and complex shots become hard to work with. It is common practice to do "pre-comps" where a completed portion of the shot is composited and rendered to disk, then loaded back in as a new input file to add further effects to it. This simplifies the workflow and saves processing time, but carries with it a strong penalty when the precomp has to be revised.

Digital Images

Before we get into the really cool stuff about compositing visual effects shots, we first need to develop some key concepts and bulk up our vocabulary. While digital imaging is a very technical subject, we will explore it here with less tech and more illustrations. The key concepts can be understood without binary math or quadratic equations with the help of some carefully crafted explanations. A detailed account of digital imaging would actually be a whole other book. In fact, there are many such books available. Once you have a foundation in digital imaging basics on a conceptual level from this book, you can then comfortably move on to more advanced books on the subject. One that leaps to mind is *Digital Compositing for Film and Video*, by Steve Wright.

The first topic in this chapter is the structure of digital images. That is, how pictures on a monitor, digital projector, or film are represented inside the computer. This is essential information because this is what the digital compositor actually works with. We then take a look at key attributes of digital images that affect manipulating them with a computer such as resolution, aspect ratio, and bit depth. All of the images that we work with must come from and go to some kind of file format, from which there is a confusing array to choose. There is a special section on just the key file formats that you will likely need to work with, and a neat little summary of when to use which one. Very useful stuff if you ever plan to save an image to disk.

2.1 STRUCTURE OF DIGITAL IMAGES

Digital images have a "structure"—that is, they are built up from basic elements that are assembled in particular ways to make up a digital image. The basic unit of a digital image is the pixel, and these pixels are arranged into arrays and those arrays are arranged into one or more layers. In the following, we take a tour of those pixels, arrays, and layers to see how they make up a digital image.

2.1.1 The Pixel

Digital images are divided into little "tiles" of individual color called pixels.* This is necessary for the computer to be able to access each one individually in order to manipulate it. Each pixel is also filled with one solid color. When the pixels are small enough they blend together to form a smooth image to the eye, such as the example of Marcie, Kodak's famous film girl seen in Figure 2-1. However, if you move closer than the normal viewing distance, you may start to see her pixels, as in Figure 2-2. If you get really close, you can clearly see her pixels as shown in Figure 2-3.

Figure 2-1 Marcie. **Figure 2-2** Close up. **Figure 2-3** Marcie's pixels.

Pixels have two attributes essential to the computer. First, they are organized in neat little rows and columns like a checkerboard, and in computerland this is called an *array*. Having the pixels arranged into an array like this is essential for the computer to be able to locate them. The horizontal position of a pixel in an array is referred to as its position in "X" (the classic horizontal direction), and its vertical position is referred to as "Y" (the classic vertical direction). This gives each pixel a unique location, or "address," in X and Y. For example, if you had an image that was 100 pixels wide and 100 pixels tall, you could identify the exact location of a specific pixel by saying it was 50 columns over (50 in X) and 10 rows down (10 in Y). Shorthand for this is to say its XY location is 50, 10. This pixel would be distinct from its neighbor that was located one column to the right at 51, 10, or in the row below at 50, 11. In fact, each pixel would have a unique XY location in the image and could be addressed by the computer that way, which it is.

The other key attribute that a pixel has is its single color. By definition, a pixel is all one solid color. Color variations or textures are not allowed within a pixel. The

*Obligatory history lesson: "pix" is a slang abbreviation for "pictures," and "el" comes from "element," so **pix** + **el**ement = pixel, meaning "picture element."

color of each pixel is represented by a number. In fact, pixels are simply sets of numbers that represent colors that are arranged in neat rows and columns. They don't become a picture until those numbers are turned into colors by a display device such as a TV set or computer monitor.

2.1.2 Grayscale Images

Grayscale images are known by many names, such as: *Black and white images, one-channel images,* and *monochrome* (one color) images. The variety of names is due to the fact that several different technical disciplines have developed their own terms to describe the same thing. This happens a lot in computer graphics because it historically merges many disciplines. For purposes of clarity and brevity, I will refer to them here as grayscale images. Grayscale images are very common in computer graphics, and due to their simplicity, they are a nice way to gently approach the topic of digital images. They have only one channel, or layer, while color images have three channels or more, which we will see shortly.

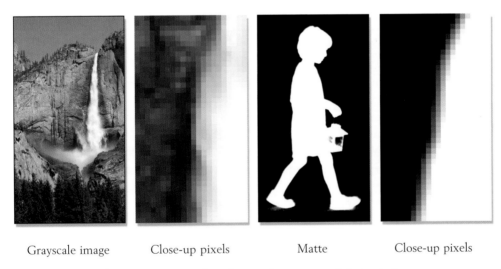

Grayscale image Close-up pixels Matte Close-up pixels

Figure 2-4 Examples of grayscale images and their pixels.

An example of a grayscale image is digitizing a black and white photograph, but another, perhaps more pervasive example are all of the *mattes* in the world. Mattes are used to composite one image over another. These two examples are illustrated in Figure 2-4. They are both grayscale images, so they have no color. While the two examples appear quite different, the one thing they have in common is that they are both one-channel images. This means they have one channel, or layer, that is made up of just one array of pixels with brightness values ranging from black to white and shades of gray.

29	29	50	109	163	184	191
33	30	46	120	269	188	204
32	40	66	134	180	196	213
34	38	78	148	185	203	217
35	29	72	153	187	205	229
35	22	77	163	184	205	230
33	29	88	167	181	203	223

Figure 2-5 An array of pixels.

To witness this one channel array of pixel values up close and personal, Figure 2-5 zooms in to a tiny little region of pixels in the grayscale image of Figure 2-4. The numbers in Figure 2-5 are the *code values* of each pixel. They are called code values because their numerical values encode, or quantify, the brightness of each pixel. The gray chip that each code value sits on represents how bright that pixel will appear when displayed on a monitor. These code values are organized into the array that the computer uses internally to represent the picture. The key points here are that there is only one array of code values, it is called a *channel*, and the code values represent only a brightness, not a color.

2.1.3 Color Images

The human eye appears to see a full spectrum of color in the real world, but is actually only sensitive to red, green, and blue wavelengths of light. We get all of the in-between colors because the brain "mixes" portions of red and green, for example, to get yellow. The same trick is used in all of our image display devices such as television, flat panel displays, digital projectors, and feature film. These display devices actually only project red, green, and blue colors, which our brains cheerfully integrate into all of the colors of the rainbow. To make a color display device for humans, all you need is red, green, and blue, which is abbreviated RGB.

 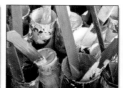

RGB image Red channel Green channel Blue channel

Figure 2-6 An RGB image is made of up three channels.

Digital images that need to convey color to human eyes obviously must have RGB data in them. In the previous section, we saw how a grayscale image has only one channel and it is made up of a single array of numbers to represent brightness values from black to white.

However, if we use three of these channels we can assign one channel to red, one to green, and the other to blue. This scheme will allow us to assign a unique RGB code value to each pixel in our color image by putting different code values in the red, green, and blue channels of each color pixel. We now have a color image composed of three channels, which is referred to as an RGB image, as illustrated in Figure 2-6. Note how the yellow paint cans in the RGB image appear bright in the red channel, medium in the green channel, and dark in the blue channel. Having these different values in each channel is what gives the image its colors.

The odd thing about the RGB image is that while the data in each channel represents the values of the red, green, and blue colors on a pixel-by-pixel basis, the data in each channel is various shades of gray. It is different shades of gray because the data actually represents the amount of brightness of that channel for each pixel. This is what Figure 2-7 illustrates.

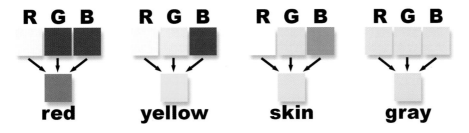

Figure 2-7 Gray RGB data becomes color.

Consider the red pixel on the left in Figure 2-7. The three gray RGB chips above it create the red pixel and you can see how the R (red) chip is very bright, while the G (green) and B (blue) chips are very dark. If you have lots of red and very little green and blue that means you have red. The yellow pixel next to the red has bright R and G values above it, but a low (dark) B value, which is the quintessential definition of yellow. The skin tone chip shows a more typical RGB combination to make a common skin tone color. The gray pixel on the end shows a special case. If all three of the RGB values are the same, it produces gray. In fact, that is the definition of gray—all three channels having equal values of brightness. When the RGB values of a pixel are different from each other, we get color.

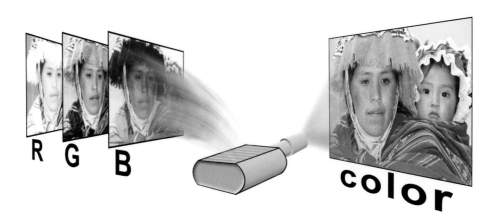

Figure 2-8 Gray RGB data gets its color from the display device.

So if the RGB data is actually gray, where does the color come from? The color comes from the display device (for example, television, digital projector, and so on) as illustrated in Figure 2-8. The gray data for the red channel, for example, is fed to the red lamp of the digital projector, which fills the entire screen with the appropriate amount of red light at each pixel. The green and blue data go to their respective lamps. The red, green, and blue images on the screen are superimposed over each other and the eye sees—color! The key point to take away from this is that a color image is a three-channel image that contains separate RGB data in each channel, and the data in these channels is, in fact, gray.

Adobe Photoshop can handily illustrate this point. Load any color photographic type image into Photoshop (as opposed to a simple graphic). Select the Channels palette (note that even Photoshop calls them channels), then turn off the visibility (the eyeball icon) for each channel except the Red channel. You should be staring at a gray image. Now click on the Green channel and see another, yet different, gray image. Try the Blue channel. It's different yet again. It is important to think of RGB images as three channels of gray data simply because that is how the computer thinks of them. To master digital compositing, you need to know how the computer thinks so you can out think it.

2.1.4 Four-Channel Images

A three-channel RGB image can have a matte included with it that is placed in a fourth channel, making it a four-channel image. This fourth channel is called the *alpha channel*, which is represented by the letter "A," so a four-channel image is referred to as an RGBA image. The most common example of an RGBA image is CGI, such as the example in Figure 2-9. It is also entirely possible to have images with more than four channels, but it will likely be later in your career before you encounter them.

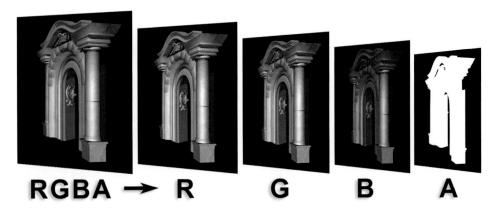

Figure 2-9 A four-channel RGBA image.

The RGB channels of a four-channel image contain the picture's color information, but the matte in the alpha channel is used for compositing. We will soon learn more about using this all-important matte in the next chapter, Compositing CGI.

2.2 ATTRIBUTES OF DIGITAL IMAGES

Now that the structure of digital images is behind us, we can take a look at the various attributes of digital images. They come in different sizes, shapes, and data precision; in addition, there are differences in how the image data is represented internally. In this section, we will begin by digitizing an image to see what that is about, then we'll have a ripping good discussion of the difference between image aspect ratio, pixel aspect ratio, and display aspect ratio—three very confusable concepts that we will attempt to de-confuse.

2.2.1 Digitizing Images

Simply put, computers are merely incredibly fast number crunchers. Even though they perform an enormous variety of functions, at the end of the day, all they can do is manipulate numbers (plus a little Boolean logic along the way). As a result, anything they work on must first be reduced to numbers. The letters of the alphabet are even assigned numbers in order to produce a text file such as an email, text message, word processor document, or a book. Sound is converted to numbers to make the MP3 files, which can be heard on iPods, DVDs, and other MP3-enabled devices. Moreover, pictures must be converted to numbers before the computer can work with them. If it is not first converted to numbers, the computer simply cannot deal with it.

Converting a picture (or a sound track) to numbers, or digits, is referred to as *digitizing* it. Once the computer has the digitized image, everything becomes possible. There are two things to understand about digitizing images: The first is how it is done, and the second is what problems it introduces. Following is an example that will illustrate both points by severely abusing a digitized image. It's not a pretty picture.

Figure 2-10 Original picture.

Figure 2-11 Sampling points.

Figure 2-12 Digitized picture.

Figure 2-10 starts with the original picture to be digitized. Whenever the image is digitized, its colors are measured or "sampled" at regular intervals, represented by the black dots as seen in Figure 2-11. The colors under these sampling points are converted to a number, and then the entire pixel gets that number and becomes a solid color as shown in Figure 2-12. For example, you can actually trace the sampling points becoming pixels by looking at the sample point on the white collar in the middle of Figure 2-11 and then finding the big white pixel in the middle of Figure 2-12. You can similarly map other sample points from various locations around the picture.

The hideous results in Figure 2-12 are caused by the fact that we have sampled the picture by far too few pixels to make a good digitized image, but it neatly illustrates our two key points. First, when an image is digitized it is converted into an array of discrete pixels; each is assigned a unique color that was sampled from the original image. Second, when an image is digitized, information is permanently lost. If we had sampled the original picture by, say, 1000 pixels across instead of the absurd 10 pixels in Figure 2-12, we would have a very nice looking digitized image, visually indistinguishable from the original. It would still have some lost information, but the loss would be below the threshold of visibility. The lesson is, the higher the sampling rate the less the loss. We will soon see what kind of problems this loss of information can cause.

2.2.2 Image Resolution

Image resolution refers to how many pixels wide and how many pixels tall a digital image is. For example, if an image were 400 pixels wide and 300 pixels tall, the

image resolution would be 400 by 300, or written as 400 × 300. An NTSC video image has a resolution of 720 × 486. A standard academy aperture feature film frame has an image resolution of 1828 × 1332. The images from a digital camera might have an image resolution of 3072 × 2048 or more.

Notice that nothing was mentioned about the "size" of the image. This is because the actual display size of an image varies depending on the display device it is viewed on. An obvious example would be a small 11-inch TV screen and a large 32-inch TV screen. The display size is very different, but the NTSC image resolution is identical—720 × 486. A feature film could be projected on a small screen in a little theatre, or on a huge screen in a large auditorium. Again, the display size is very different, but the 35 mm film image resolution is the same.

We do have to be careful here because the term *resolution* has a very different meaning in other disciplines. The usual meaning for the word outside of digital compositing is not how many pixels are in the entire image, but how many pixels there are per unit of display—that is, how many pixels per inch or dots per centimeter. Where life gets real confusing is when a compositor with his definition of image resolution gets into a conversation with an Adobe Photoshop artist that has the other definition of resolution. To deal with this all too common conundrum, there is a special reluctant section at the end of this chapter titled *DPI* that is designed specifically to sort this out.

2.2.3 Image Aspect Ratio

The aspect ratio of an image is actually a description not of its size or its resolution, but of its *shape*. It describes whether the image is tall and thin, or low and wide. Every job you work on will have an established aspect ratio, as well as an image resolution, and all of your work must conform to it. The aspect ratio of an image is also frequently needed when trying to fit one image over another. The aspect ratio is simply the ratio of the image's width to its height, so it is calculated by dividing the image's width by its height. For example, if the image resolution is 400 × 300, divide 400 by 300 to get an aspect ratio of 1.33, the classic video resolution. Keep in mind that the image aspect ratio applies to the image file, and not necessarily how it will look on the final display. As we will see shortly, sometimes the image aspect ratio and its display aspect ratio differ.

An aspect ratio of 1.0 would mean that the width and height are identical, making it a square image. An aspect ratio of less than 1.0 would be a tall and thin image, and if an aspect ratio is greater than 1.0, the image gets wider as the number goes up. Figure 2-13 illustrates several common aspect ratios starting with a square example of 1.0, followed by the typical NTSC aspect ratio of 1.33, then a couple of common feature film aspect ratios. The key observation to note is that as the aspect ratio number gets larger, the image gets wider.

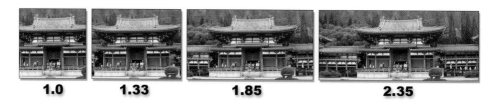

Figure 2-13 The image gets wider as the aspect ratio gets larger.

There is one last thing to discuss before we leave the exciting subject of aspect ratios. As we have seen, different disciplines have different ways of describing the same thing. Film folks like to do the math and describe their movie aspect ratios as a decimal number such as 1.85 and 2.35. Video people don't.

Video folks prefer to leave their aspect ratios in the form of ratios such as 4 × 3 (4 by 3) and 16 × 9 (16 by 9). They may also write these as 4:3 and 16:9 just to mix things up a bit. If you do the math, a 4 × 3 aspect ratio calculates out to 1.33 (4 ÷ 3), and the 16 × 9 is the same as 1.78 (16 ÷ 9). Again, these are simply two different ways of describing the same shaped image. Having two different ways of doing it, depending on whom you are talking to, just adds to the fun of digital compositing.

2.2.4 Pixel Aspect Ratio

As we saw earlier, digital images are made up of pixels. Yes, like images, pixels also have a shape, and that shape is also defined by its aspect ratio. However, not all pixels are equal—this is to say, square. A square pixel, like a square image, would have a pixel aspect ratio of 1.0, but many display systems do not have square pixels. Figure 2-14 illustrates the most common non-square pixel aspect ratios you will encounter in production.

NTSC = 0.9 PAL = 1.1 Cscope = 2.0

Figure 2-14 Common pixel aspect ratios.

The left example illustrates an NTSC (American television) video pixel that has a pixel aspect ratio of 0.9, making it tall and thin. The middle illustration depicts a

PAL (European television) video pixel that has a pixel aspect ratio of 1.1, making it short and wide. While most feature film formats have square pixels, the Cinema-Scope (Cscope) format is a special widescreen format that has a pixel aspect ratio of 2.0, making its pixels very, very wide. Fortunately, all HDTV (High Definition Television) video formats have square pixels.

These non-square pixels have no impact when they are in their native display environments—NTSC pixels on NTSC television sets, and so forth. Where they do affect digital compositing is when they are taken out of their native environments, like to a workstation for digital compositing or Adobe Photoshop painting. Suddenly the pixel aspect ratio becomes a major issue that must be dealt with correctly, or there will be trouble. Coping strategies on how to deal with these non-square pixels are addressed in their respective chapters, "Working with Video" and "Working with Film." At this point, we are just trying to get familiar with the troubling concept of non-square pixels in order to set things up for the next section—the display aspect ratio.

2.2.5 Display Aspect Ratio

We have seen how the image aspect ratio describes the shape of the image and the pixel aspect ratio describes the shape of the pixel. These two factors combine to define the display aspect ratio—the shape of the image after it is projected with its display device. This is altogether important, because the aspect ratio of the image may be different from the aspect ratio of the display that it is displayed on, and that difference is caused by the pixel aspect ratio. Not to worry, any compositing program worth its pixels has image viewer options to compensate for non-square pixels so that you can view the image with its proper display aspect ratio. The good news is that if the pixels are square (an aspect ratio of 1.0), then the image aspect ratio and the display aspect ratio are identical. We will see why in a moment.

Figure 2-15 Squeezed C-scope image.

The display aspect ratio is simply the image aspect ratio multiplied by its pixel aspect ratio. A few examples will serve to make this clearer. We will start with the most severe case, and that is the C-scope film format with a pixel aspect ratio of 2.0 (see Figure 2-14). If a C-scope frame were displayed on your workstation uncorrected, it would look squeezed like the example in Figure 2-15. The image resolution of a C-scope image is 1828 × 1556, so its image aspect ratio would be 1.175 (1828 ÷ 1556). It would appear like this on your workstation monitor because the monitor has square pixels; however, the film projector doubles the image in width giving the projected film a pixel aspect ratio of 2.0. If we multiply the pixel aspect ratio (2.0) by the image aspect ratio (1.175) we will get the display aspect ratio of 2.35 (1.174 × 2.0).

We know that NTSC and PAL television has an aspect ratio of 1.33, but consider the NTSC image in Figure 2-16. Its resolution is 720 × 486, making its image aspect

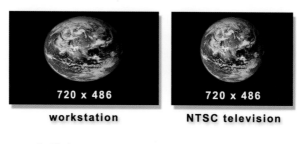

Figure 2-16 NTSC image display.

ratio 1.48 (720 ÷ 486). What is wrong here? We have not factored in the NTSC pixel aspect ratio of 0.9. If we multiply the image aspect ratio of 1.48 by the pixel aspect ratio of 0.9, we will get a display aspect ratio of 1.33 (1.48 × 0.9). If this NTSC image is displayed uncorrected on a workstation, it will stretch about 10% in width compared to how it will look on TV because the workstation has square pixels.

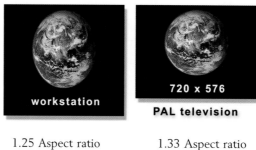

Figure 2-17 PAL image display aspect ratios.

For PAL, the image resolution is 720 × 576 so its image aspect ratio is 1.25 (720 ÷ 576) as shown in Figure 2-17. Here again we don't get the expected 1.33 aspect ratio for television. When we factor in PAL's pixel aspect ratio of 1.1 by multiplying it by the image aspect ratio we do get the expected 1.33 (1.25 × 1.1). By the way, if you were to dig out a calculator and check the math, you would find slight discrepancies in the calculated image aspect ratio. This is due to small round-off errors in the numbers used in these examples in order to simplify our story and the math, so it is harmless. If a PAL image is displayed uncorrected on a workstation monitor it will stretch about 10% vertically compared to a television monitor due to the workstation's square pixels.

This brings us to HDTV, which mercifully has square pixels. I like to think this is due in no small part to the vitriolic cries of outraged digital compositors complain-

ing about working with the non-square pixels of NTSC and PAL. Because square pixels have an aspect ratio of 1.0, when the display aspect ratio is calculated by multiplying the image aspect ratio by 1.0 there is no change. The conclusion is that the display aspect ratio and image aspect ratio are the same for images with square pixels.

2.2.6 Bit Depth

You have undoubtedly heard that computers only work with ones and zeros. This is literally true. Each one and zero is called a *bit* (binary digit—get it?), and these bits are organized into 8-bit blocks called *bytes*. Here is a byte—00000001. Here is another one—11001010. If you group 8 bits into a byte, the number of possible combinations of ones and zeros is only and exactly 256, and their values range from 0 to 255. In other words, an 8-bit byte can hold any integer number between 0 and 255. The number of bits being used is what is meant by the term, *bit depth*. If the number of bits were increased to 10, we could make 1024 different numbers. If they were reduced to 4, we could only make 16 numbers. The greater the bit depth, the more numbers we can make.

To relate this back to digital images, if a pixel's brightness is described by an 8-bit byte, then there can only be 256 brightness values ranging from black (0) to white (255). This seems sensible enough. For an 8-bit three-channel RGB image, then, each channel can have only 256 brightness values ranging from 0 to 255. The maximum possible number of different color combinations becomes $256 \times 256 \times 256$ (for all three channels), or about 16.7 million colors. That may sound like a lot of colors, but read on.

Modern compositing packages also support 16-bit images. When the bit depth is increased from 8 to 16 bits per pixel, we now have a whopping 65,536 possible brightness steps from black to white (0 to 65,535)—but, note this—the black isn't any blacker nor the white any whiter. There are simply a lot more tiny little brightness steps in the 16-bit image compared to the 8-bit image. In fact, the 16-bit image has 256 brightness steps for each one in the 8-bit image. The maximum number of different colors for a 16-bit RGB image becomes 65,536 to the third power, or a tad over 281 trillion. That will usually do it.

Figure 2-18 Smooth sky gradient.

Figure 2-19 Banding sky.

Now for the part about why you care about all this. The 8-bit image with its 256 brightness steps is barely adequate to fool the human visual system into seeing smooth continuous colors like the sky gradient in Figure 2-18. If such marginal images are heavily processed during compositing (which often happens), the number of brightness steps becomes depleted. Instead of 256 steps there might remain only, say, 100 or less. A smooth gradient cannot be made with only 100 steps of brightness, so the resulting image erupts with banding like the sky in Figure 2-19. Increasing the bit depth of images protects them from banding. If you start with far more steps of brightness than you need then you can lose some of them without seeing any problems. Therefore, it is common practice in digital compositing to "promote" 8-bit images to 16-bits to avoid banding. Better yet, use 16 bits to create the original image in the first place.

2.2.7 Floating-Point

The previous discussion about bit depth pertained to integer data. That is to say, the 8-bit data, for example, ranged from 0 to 255, using only whole numbers. There were no decimals such as 10.3 or 254.993. However, decimals, called *floating-point*, are a very important alternative way to represent pixel values so compositing programs also support it. The computer can easily convert integer data to floating-point and Figure 2-20 illustrates how this is done using 8-bit data as an example.

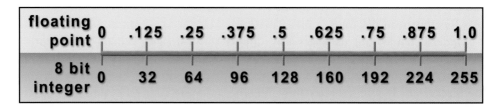

Figure 2-20 Floating-point representation of 8-bit data.*

The floating-point value of zero is set to the 8-bit integer value of zero, and the floating-point value of 1.0 is set to 255, the largest number that 8 bits can make. For 16-bit data, 1.0 is set at 65,535. Two important benefits and one problem result from working in float ("float" is salty computer talk for *floating-point*).

The first important benefit is that, unlike integer numbers, you can multiply and divide float numbers, which is constantly done in digital compositing. Case in point: Suppose you want to multiply two pixels that are 50% gray. Logic tells you that if

*To the alert mathematician, the floating-point numbers displayed in Figure 2-20 will be slightly off. For example, the correct calculation of the floating-point value for 128 is $128 \div 255 = 0.50196078431$. However, the story is easier to follow if things are simply rounded off to the intuitive values used above.

you multiply 50% times 50% the answer has to be 25%. However, if you are working in 8-bit integer, a 50% gray pixel is 128. If you multiply 128 times 128, you get 16,384, which is a far cry from 25%. However, if the same problem is done in float, it becomes 0.5 times 0.5, which is 0.25, exactly 25%. The float value of 0.25 can then be converted back to an integer value of 64. Much better.

The second benefit of float is to avoid clipping the pixel values. Suppose you want to add two 8-bit pixels together, each with a value of 160. The answer will obviously be 320. However, since 255 is the largest number we can make with 8-bit integer data, the 320 gets whacked (or, more technically, clipped) to 255 by the computer. Data lost, picture ruined. However, if we are working in float, the vale of 160 becomes 0.625. If we add 0.625 to 0.625, we get 1.25, which is a value greater than one. While 1.0 is the brightest pixel value that can be displayed on the monitor, the computer does not clip the 1.25 to 1.0. Instead, it preserves the entire floating-point number. No clipping, picture saved.

The problem that float introduces is that it is slower to compute than integer. In fact, that is why integer was used in the first place—because it was faster. However, modern computers have become so fast that the speed penalty for working in float is getting less and less over time.

2.2.8 Multiplying Images

In the previous floating-point discussion, it was pointed out that by using floating-point data, the computer could multiply two pixels together. It follows, then, that two images can be multiplied together. Multiplying two images together may sound a bit daft—sort of like multiplying a bird times a rat to get a bat—but in actuality, it is a hugely important and common operation when working with digital images. It is at the very core of the compositing process as well as matte and masking operations, so pausing to take a closer look would be a good idea.

Figure 2-21 Color image. **Figure 2-22** Mask. **Figure 2-23** Multiplied.

Consider the color image in Figure 2-21 and the elliptical mask in Figure 2-22. These two images have been multiplied together and the results are shown in Figure 2-23. Now let's follow the action. The white pixels in the center of the mask have a floating-point value of 1.0. When those pixels are multiplied by their partner pixels in the color image, the color pixels are unchanged and go to the multiplied image in Figure 2-23 totally intact. The black pixels around the outside of the gradient have

a floating-point value of zero, so when they are multiplied by their partners in the color image the results are zero, resulting in the black region of the multiplied image. The gray pixels around the gradient have a range of values between zero and 1.0, so in that region the multiplied image has pixels that range between black and the original color image, giving it the soft edge fade off. Multiplying a color image by a mask like this is done all the time in digital compositing.

2.3 IMAGE FILE FORMATS

Every image you receive from or deliver to a client or colleague is contained in a file, and files come in a wild variety of different formats. It's a real zoo out there, and you need to pick your file formats wisely. There are several reasons why you care about this issue: First, if you deliver a file, or one is delivered to you in a format that the target program cannot read, you are dead in the water before you even start. Second, some file formats compress the image file in ways that degrade the image. There are times when this is OK and times when this is not. Third, picking the wrong file format can make the file size much larger than it needs to be. Most folks do not appreciate having their disk space, download time, network bandwidth, and production time wasted.

However, before actually looking at the file formats, there are a few key concepts to know about certain image types and compression schemes. In this section, we take a look at the differences between photographic images and graphics because the type of image you have mightily affects the choice of the compression scheme. The EXR file format gets its own special mention because of its emerging importance in the visual effects industry.

2.3.1 Photographic Images vs. Graphics

There are really two major types of images: Photographic images and graphic images. Photographic images are real scenes captured by some kind of camera, either digital or film. Their key feature is that their pixel values vary considerably all over the image, thus making them "complex." Graphics, on the other hand, are simple images created with a graphics program or drawn with a paint system such as Adobe Photoshop. Their key feature is that their pixel values don't vary much at all over the image.

photograph photograph closeup graphic graphic closeup

Figure 2-24 Pictures and graphics have very different pixel variations.

Figure 2-24 illustrates this profound difference between the two types of images at the pixel level. In the photograph close-up, no two pixels are the same color. In the graphic close-up there are large areas of identical pixel values. These differences are used when selecting a compression scheme. A lossless type of compression would be used on the graphic because the file size could be compressed by taking advantage of all the pixels of the same value. Such a scheme would be useless on the photograph and result in virtually no file size reduction. A lossy compression scheme would noticeably damage the graphic, but could go unnoticed in the photograph if not pressed too far.

2.3.2 Indexed Color Images (CLUT)

The file size of any RGB image can be considerably reduced by converting it to an indexed color image. The computer first does a statistical analysis of all the RGB colors in the image and then produces a Look-Up Table (LUT) of only 256 colors, which represent the closest 256 averages of all the colors in the RGB image. It then creates a one-channel 8-bit "index" image where each pixel is really a pointer or index to one of the colors in the color table. To display the image in color the computer looks at each pixel in the index image, follows that index to its color chip in the LUT, gets that RGB value, and displays it on the monitor as the red arrows show in Figure 2-25.

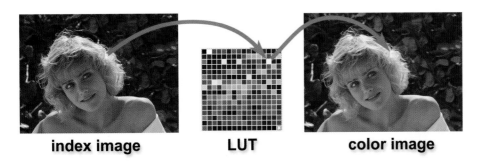

index image **LUT** **color image**

Figure 2-25 An indexed color image.

Even though the range of colors is seriously reduced (256 colors instead of 16 million), the resulting color image looks surprisingly good (if you don't look too closely). The Marcie color image in Figure 2-25 is an actual index color image. The reason it looks so good is that the 256 colors in the LUT are full 24-bit RGB values. Since there are only 256 of them, they do not increase the file size by much. A common abbreviation for index color images is CLUT, which stands for Color Look-Up Table.

CLUT images work very well for graphics, especially if the graphic has less than 256 colors in it. The CLUT version would then be a lossless compression.

Photographic images can be converted to a CLUT, of course, but they get badly hammered in the process. They may look OK for a web site, but not for printing an 8 × 10 portrait.

2.3.3 Compression

Almost all file formats offer some kind of data compression feature. Some types of data compression are *lossless*, meaning that after the compressed file is opened, the image is an exact replica of the original. However, some compression schemes are *lossy*, meaning that the compressed image has suffered some losses, or degradation.

Two predominant lossless compression schemes are RLE and LZW. Run Length Encoding (RLE), which is almost always used for rendering CGI images; and, Lempel-Ziv-Welch (LZW), which is important because it is available in a great many image file formats. Since these are lossless compression schemes, they reduce file size without any degradation of the image; in addition, they can also be used together. Use them freely on CGI and graphics knowing that they will not harm your pictures. Photographic images can use LZW, but there will be minimal compression.

Two predominant lossy compression schemes are JPEG and MPEG-2. The JPEG compression is intended for still photographic images and basically removes fine detail in the image to reduce its file size. It degrades the image quality, and if set too high can degrade it seriously. The MPEG-2 compression is specifically designed for moving pictures such as video. It starts by performing a JPEG-type compression on selected key frames, and then shrinks the in-between frames by constructing a list of what the differences are between the key frames.

2.3.4 EXR

OpenEXR, or EXR, is a floating-point image file format developed by Industrial Light & Magic (ILM) that is fast becoming an industry standard. It is very likely that you will encounter it early in your digital compositing career and more likely over time, so it behooves us to take a moment to look at it closely. The next section talks about the various important image file formats, but EXR is both unique and important enough to get its own spot in the sun, especially because it was specifically developed with us compositors in mind. Here is a summary of its main features:

- High dynamic range—Designed specifically to accommodate high dynamic range image data such as film scans and photorealistic CGI elements. The dynamic range (darkest to brightest) of an average monitor might be around 150 to one and projected film perhaps 2000 to one, while EXR's dynamic range is over a billion to one!
- Many channels—While the typical CGI render is a four-channel image, EXR is expandable to any number of channels. The purpose is to avoid having to

render the multiple passes of a CGI object into multiple separate files. They can all be in their own channels within one EXR file.

- Lossless compression—Designed for feature film work, film frames are large photographic images that take up a lot of disk space and network transfer time. A unique lossless compression scheme is supported that cuts file sizes in half without any degradation to the image and it is very fast to compress and uncompress.
- Short float—A floating-point format, but instead of the usual 32-bit float, implements a unique 16-bit "short float." This solves the speed penalty usually associated with floating-point, while maintaining more than enough precision even for feature film work. In other words, the speed of integer with the precision of float.

OpenEXR was released by ILM to the world as an open standard for free in 2003 in order to rapidly propagate it into the visual effects industry. It has worked. Most 3D animation and compositing programs now support EXR. It has even penetrated to the ubiquitous Adobe After Effects® and Adobe Photoshop®.

2.3.5 File Formats

We cannot discuss every file format in the known universe since that would be an entire book on its own. What we have here instead is a mercifully brief description of several of the most common file formats that you are likely to encounter in your budding digital compositing career. No effort is made to tell you everything about each file format, as that would be tedious and boring. What is described here is just what is important to our type of work.

It is standard practice to add an extension to the filename of an image to identify what file format it is. If the file is in TIFF format, for example, it would be named "filename.tif," a JPEG image would be named "filename.jpg," and so on. Based on this, the file formats are listed below in alphabetical order based on their filename extensions.

- .bmp—A flexible Microsoft® Windows® image file format that supports both photographs and graphics. Images can be saved as 8 or 16 bits, BW, RGB, RGBA, and CLUT. No compression.
- .cin—Cineon, an older, very specialized file format specifically for 10-bit log film scans. No compression, no options, no nothing. Supports BW, RGB, and RGBA images.
- .dpx—Digital Picture Exchange, a modern file format for 10-bit log film scans that is replacing the Cineon format. Supports multiple channels, multiple bit depths, and linear and log data. HDTV video frames are sometimes saved in the .dpx format.
- .exr—Short for OpenEXR, Industrial Light and Magic's (ILM) extended dynamic range file format for working with feature film images. It features

floating-point data and the enormous dynamic range of brightness and color required for top-quality feature film work.

- .gif—Most commonly seen as an 8-bit CLUT file format for graphics that is extensively used for the web. Includes support for animations in one file and assigns one CLUT color for hard-edged transparency. It also supports 8- and 16-bit images, BW, RGB with lossless compression, but nobody seems to care.
- .jpg—JPEG, or Joint Photographic Experts Group, is an older lossy compression file format specifically designed for photographic images. The main feature is the ability to dial in the amount of compression to make the file size smaller, which also affects how much picture information is lost. Excessive compression causes serious loss of picture quality and introduces artifacts.
- .jp2—JPEG 2000, a newer lossy compression file format, which is also specifically designed for photographic images. Based on a completely different technology than JPEG, it compresses image files to a smaller size while introducing fewer artifacts.
- .mov—Apple's® ubiquitous QuickTime® movie file format is used to store moving pictures. The QuickTime file format is actually a "wrapper" that supports a long list of possible compression schemes called *codecs* (Coder/Decoder). While many programs can read QuickTime movies, trouble comes when the movie is compressed with a codec that the program trying to read the file doesn't have.
- .png—The Microsoft Windows version of a .gif file that supports true transparency.
- .psd—Adobe Photoshop file format that supports separate layers for the various elements of an image. Intended for Photoshop picture editing, so not supported by very many other programs.
- .tga—Targa, a Microsoft Windows-based file format that supports CLUT, BW, RGB, RGBA, 8 bits per channel, and lossless compression.
- .tif—TIFF, the most important image file format because it is supported by virtually every digital imaging program in the known universe. An extremely flexible and fully featured file format that supports multiple channels, 8- and 16-bit images, and lossless compression. Ideal for CLUT, BW, RGB, RGBA, graphics, photographs, CGI, and virtually every other image type except a compressed photograph (use JPEG or JPEG 2000).
- .yuv—A file format specifically for video frames. Many programs can read .yuv files and convert them to RGB for display on the monitor, then write out the results as a .yuv file.

2.4 DOTS PER INCH (DPI)

Even though we shouldn't have to be explaining this in a book on digital compositing, it is unfortunately necessary to digress for a moment to discuss dpi, or "dots per inch," simply because it is a constant source of confusion and disarray in visual effects.

The concept of dpi is used in print media for books and magazines and the like. It also shows up in Adobe Photoshop in the Image Size dialogue box as "Resolution." In the context of printing, resolution means how many pixels are printed per inch of paper. In the context of digital compositing, resolution means the width and height of an image in pixels. Already we are conflicted.

If you have an image that is 100 pixels wide and printed it in a magazine as a 1-inch wide picture, you would obviously have 100 pixels spread across one inch of paper. Therefore, the picture would have a print resolution of 100 pixels per inch. For the sake of honoring print tradition, it would actually be referred to as 100 dpi (dots per inch). Now suppose you have a 500-pixel image and printed it as a five-inch picture. The resolution would still be 100 dpi because in one inch of picture you still have 100 pixels. Never mind the fact that the picture is five inches wide. But, suppose your 500-pixel image was printed as a one inch picture. You would now have a 500 dpi image because 500 pixels are spread over one inch. For a given image width in pixels, the smaller it is printed, the more pixels per inch, the greater the dpi. For a fixed picture size, the higher the dpi the sharper the image will be (Figure 2-26).

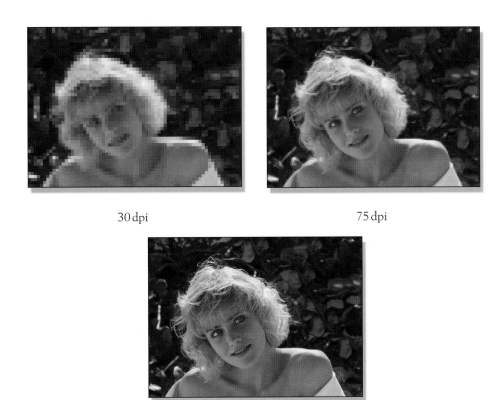

30 dpi 75 dpi

300 dpi

Figure 2-26 Increasing the dpi makes the picture sharper.

You can actually watch this in action in Photoshop. Load in any image, then go to the "Image Size" dialogue box. First, uncheck "Resample Image" near the bottom. This tells Photoshop not to change the image "Pixel Dimensions: Width or Height" (what we digital compositors call *image resolution*). Now go to the "Resolution" window and change the number and watch the "Document Size: Width and Height" values change. Now change the "Width or Height" values and watch the "Resolution" value change. What is happening is that we have locked the image width and height so that the actual pixel counts are not changed while altering the dpi to see how the resulting picture will be printed larger or smaller on paper.

There are two points to this story. The first point is that if an image is created in Photoshop for a visual effects shot, the question of what the dpi should be may come up. The answer is that the dpi is irrelevant. It is only the image Width and Height in pixels that are important to us. This will confound some Photoshop artists who are print-oriented. The second point is that when images are taken from a visual effects shot to Photoshop or to print (such as PR photos), this may also raise the question of the dpi. A frame of film or video from a visual effects shot has no intrinsic dpi. It has only Width and Height in pixels. When it goes to print it will need to be assigned a dpi in order to set how large the image is printed. The higher the dpi is set the smaller the image will print. For example, if a 600×300 image was assigned a dpi of 300 it would print 2 inches wide. However, if it is set at 600 dpi it would only cover one inch of paper.

3 Compositing CGI

The trend in visual effects today is an ever-closer integration of digital compositing within the CGI production pipeline. Compositing software is continuously evolving in the direction of more support for CGI issues, so the modern digital compositor needs to not only understand how to composite CGI, but also have a good understanding of CGI. In this chapter, we will begin by taking a look at the composite of a CGI element with its background to introduce the concepts of the foreground layer, the matte (or alpha), the background, and how they go together to create a basic CGI composite. In subsequent sections, we build on this to introduce the complexities of a more typical production shot. We will also be taking a close look at the interface between CGI and digital compositing—the boundary where they meet and how the workflow in the CGI pipeline affects the digital compositor.

In the not too distant past, a CGI object was rendered whole and given to the compositor to composite into the scene. Today, the standard practice is to render each CGI element in a series of separate passes, or layers, with each layer containing different color and lighting information that the compositor then combines, merges, and massages to create the final look. In addition to this multipass compositing, there is also multiplane and depth compositing. One must not just understand the distinction, but also know how to work with them.

CGI is also a rapidly evolving technology so it is essential for the modern digital compositor to stay abreast of developments, or they may risk not being hired for lack of background. For this, we will take a look at both sims (simulations) and particle systems. Sims are a critical and continuously expanding development that actually creates the animation for many CGI objects. Particle systems are responsible for generating what used to be some of the more difficult classes of CGI objects—amorphous elements such as clouds, water, smoke, and fire. Particle systems are now extremely prevalent and even starting to show up in advanced 2D systems.

3.1 THE CGI COMPOSITE

A composite requires three elements: A foreground image, a background image, and a matte. Only some of the pixels in the foreground and background images are used

in the final composite, so the computer needs a way to know which pixels to use where. It is the matte that tells the computer which pixels to use from the foreground image and which pixels to use from the background image.

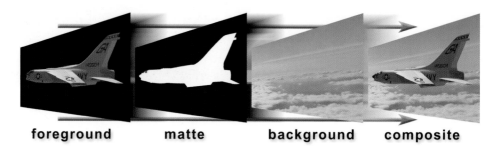

foreground **matte** **background** **composite**

Figure 3-1 The matte controls the foreground and background mix.

Figure 3-1 illustrates how the foreground and background images are layered using the matte to tell the computer which pixels to use from the two layers. Where the computer finds a white pixel in the matte, it will use a pixel from the foreground layer; where it finds a black pixel, it will use a pixel from the background layer. Very importantly, where it finds a gray matte pixel somewhere between black and white, it will mix the foreground and background pixels in the same proportion. For example, a 75% white matte pixel will result in 75% of the foreground being mixed with 25% of the background in the composite. More on this exciting concept to come later.

The folks that make CGI prefer to call their mattes the *alpha channel* or just the *alpha*. The alpha channel of a CG image is simply the matte that the computer has calculated for a CG object, but they needed to have their own special term. In the next chapter, we will take a look at bluescreen compositing and see how we get to make our own mattes for the bluescreen layer. Great fun.

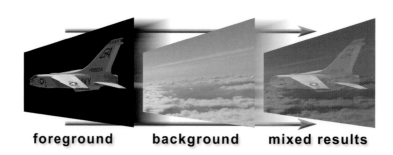

foreground **background** **mixed results**

Figure 3-2 Without a matte, the results are mixed.

So what would happen if you tried to do a composite without a matte? Figure 3-2 shows the sorry results. The computer has no guidance as to when to use the foreground or background pixels so the results become a bland mix of the two. It seems you just can't do a nice composite without a matte.

3.1.1 Scaling the Background

We now know that the matte is the grand arbiter of the composite, but how is it actually used? It clears the background pixels to black in order to make a "hole" for the foreground object to fit into, as shown in the example in Figure 3-3. This is done by multiplying the matte and the background plate together, which scales some of the background pixels to black. Note how the scaled background of Figure 3-3 looks like a perfect match to the foreground in Figure 3-2. When the foreground and scaled background layers are brought together for the actual composite, they will fit perfectly because they share the same matte.

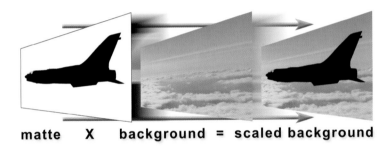

matte X background = scaled background

Figure 3-3 The scaled background.

Now, let's consider how the matte actually scales the background plate. Note how the matte in Figure 3-3 has been inverted (black and white swapped) compared to how it looks in Figure 3-1. The jet is now zero black and the surrounding area is now white. Recall from Chapter 2 what happens when a mask and an image are multiplied together; the white parts of the mask preserve the pixels in the image, while the black parts scale them to zero. When the inverted matte in Figure 3-3 is multiplied by the background plate, the RGB code values where the jet will go become zero black. This is necessary to set things up for the final step in the composite.

3.1.2 Semi-Transparent Pixels

So far, we have been talking about the matte only in terms of black and white pixels. However, not every pixel in the composite is either 100% foreground or 100%

background. There are a lot of pixels that are a mix of both layers and these tend to be the most important pixels for a convincing composite. They can generally be found in three places. First, they are found in any semi-transparent objects in the foreground, such as smoke or a jet canopy for obvious reasons; second, any motion-blurred part of the picture where something has moved so fast that it has smeared edges will produce semi-transparent pixels; and third, they are found where the edge pixels of the foreground object meet the background. These pixels are always a mix of the two layers, not 100% of either.

To address these types of situations, the matte must have gray pixels to represent the degree of transparency. The "density" of a matte pixel refers to how transparent it is. If it has high density, it is not very transparent and as it approaches white, it becomes opaque. Low-density matte pixels are highly transparent and as they approach black, they become totally transparent.

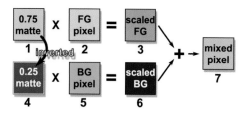

Figure 3-4 Semi-transparent pixel calculations.

Utilizing our newfound knowledge of multiplying images from Chapter 2, let us trace how a mixed pixel is calculated from a semi-transparent matte pixel. Following along in Figure 3-4, (1) is a light gray matte pixel with a density value of 0.75. It is multiplied by the foreground pixel (2), a typical skin tone, to produce the scaled FG pixel (3). It now has 75% of the brightness of the original. The 0.75 matte pixel (1) is then inverted to make the 0.25 density matte pixel (4) at the lower left. This inverted matte pixel is multiplied by the background pixel (5), a typical sky value, to produce the scaled BG pixel (6), which is now only 25% of its original brightness. The scaled FG (3) and the scaled BG (6) are then summed (added) to create the final mixed pixel (7) which contains 75% of the skin and 25% of the sky.

3.1.3 Summing the Layers

It turns out that, unlike the background layer, a CG image has already been scaled by its matte (I mean alpha) when it comes to you, so it is ready to composite; whereas, as we saw in Figure 3-3, the background layer must first be scaled by the inverted alpha to prepare it for the actual composite. Once this is done, all that is needed is to simply sum (add) the two layers together. The pixels of the CGI layer and scaled background are lined up together and then the computer simply sums them together on a pixel-by-pixel basis to produce the pixels of the final image, the composite. A black pixel has a value of zero and any number plus zero is the original number, so a black pixel summed with a colored pixel will always result in the colored pixel.

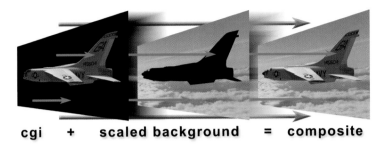

cgi + scaled background = composite

Figure 3-5 Sum the scaled layers to make the composite.

You can see this in action in Figure 3-5 if you follow the top green arrow starting at the CGI layer on the jet's tail and follow it through to the scaled background pixel, which is black. After they are summed in the composite image, that pixel is the color of the jet tail. Following the lower green arrow, it starts on the CGI layer at a black pixel and goes to a cloud pixel in the scaled background. When these two pixels are summed together in the composite, the result will be the cloud pixel. After scaling the background layer by the alpha channel, it can be merged with the CGI layer using this simple addition operation to make the finished composite.

3.2 MULTIPASS COMPOSITING

It turns out that the real world is annoyingly complex. When we first started making CGI objects for movies, they did not look very realistic. The movie *The Last Starfighter* leaps to mind. Delightful movie, but no attempt was made to make it photorealistic as that was far out of reach in those days, way back in 1983. As the founding fathers of CGI studied the problem, they discovered what I meant by the real world is annoyingly complex. You need to account for a multiplicity of complex lighting, materials surface attributes, and atmospherics to get a photorealistic CGI object. As the computer models got more complex, the rendering times skyrocketed. Rendering times of 24 hours per frame are legendary. Something had to be done.

The solution to this problem (besides faster computers and more efficient software) was to render each of these multitudes of surface and lighting attributes as separate images, or passes. These multiple passes are then combined by the compositor, and in doing so, the compositor, being the consummate artist, also makes the final adjustments and color corrections that give the shot its final look. This is a much faster workflow because the compositor can turn out a new version in a few hours when the look has to be adjusted—and it always has to be adjusted. If all the passes were initially rendered together, changing the look would require re-rendering all of the CGI, which can take days, or even weeks. One nice thing about this arrangement is that it is now the digital compositor that applies the finished look to the shot, raising the importance of our artistic contribution to the job.

We will now look at an example of a simple multipass CGI render to see how the layers go together to create the final look. Keep in mind that this is but one example showing a CGI object rendered in five passes: diffusion, specular, occlusion, shadow, and reflection. Other situations will require not only a different number of passes but also different types of passes. Big budget feature films with 20 passes per object are not unusual.

3.2.1 Diffuse and Specular Passes

We begin with the diffuse pass as shown in Figure 3-8. The diffuse layer of a CGI object represents the "flat" light that is reflected from the surface as if it were made of felt. No shiny bits. Note that it has shading, which means that those parts that face toward the light are brighter than the parts that face away from the light. We have one strong light to the upper right of the camera, and a softer light to the left of camera. Often the matte is also rendered as a separate pass as shown in the example in Figure 3-6.

The next pass is the specular pass, shown in Figure 3-7. This represents just the shiny bits of the rendered surface. Note that it is a different color than the diffuse layer. Specular highlights can either take on the color of the light source, the color of the surface material, or change color based on the viewing angle, all depending on what kind of material you are modeling—plastic, metal, wood, and so forth. In addition, different metals have different specular behaviors. Like I said, annoyingly complex.

The specular highlights have been added to the diffuse layer in Figure 3-9. In this particular case the specular layer was first darkened, then actually added to the diffuse pass with an addition operation, but one could choose any number of image blending operations to combine the passes. Each blending method would have resulted in a different look. Choosing the blending method for each layer is one of the creative decisions that the compositor must make.

Figure 3-6 Matte.

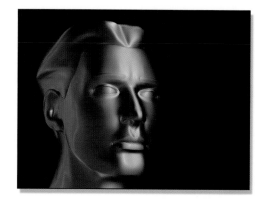

Figure 3-7 Specular pass.

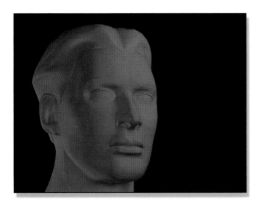

Figure 3-8 Diffuse pass.

Figure 3-9 Specular highlights added.

3.2.2 Occlusion and Shadow Passes

Next, we will consider the occlusion pass, or more formally, the ambient occlusion pass, shown in Figure 3-10. Ambient light is the light bouncing between objects in a scene, as opposed to the light coming directly from light sources. Ambient occlusion considers how this ambient light is blocked, or occluded, between and within the CGI objects, which casts subtle shadows and darker regions in the scene. Note where the dark areas are in Figure 3-10, where the eyelids meet the eyes, above the ear, and in the nostrils. This occlusion pass would look the same even if you moved the lights around in the scene. The occlusion pass has been added to the head from Figure 3-9 using a multiply operation to create the new version in Figure 3-11.

Figure 3-10 Occlusion pass.

Figure 3-11 Occlusion added.

Figure 3-12 Shadow pass.

Figure 3-13 Shadow added.

Now we'll add actual shadows to the head using the shadow pass from Figure 3-12. This too is multiplied by the previous version in Figure 3-11 to produce the next version of the head in Figure 3-13. Note the deep shadow in Figure 3-13 in the ear and to a lesser degree on the neck. Now compare those same two regions between Figure 3-11 and Figure 3-13 to see the effect of the shadow pass.

3.2.3 Reflection Pass

The last pass of our "simplified" example of multipass CGI compositing is the reflection pass. For this pass, the CGI surface attribute was set for 100% reflectivity as if it were a mirrored surface, then the intended background image was reflected off the surface. The results are shown in Figure 3-14, and the background plate is shown in Figure 3-15. Again, there are many choices for how to combine the reflections, but in this example, a screen operation was used to create the final version in Figure 3-16. This version of the head was used for the final composite in Figure 3-17 using the separate matte from Figure 3-6.

Figure 3-14 Reflection pass.

Figure 3-15 Background.

Figure 3-16 Reflection added.

Figure 3-17 Final comp.*

The startling truth about this multilayer compositing example is that it is a simplified case. To create a truly photorealistic gold statue would require many more passes than we have here, including a "grunge" pass. A *grunge pass* is a subtle layer of dirt and debris that roughs and dirties up the otherwise perfectly smooth and mathematically pristine surface of a typical CGI object. Made famous by George Lucas during the first *Star Wars*, he wanted all of his space hardware to look used to give it more texture and realism. Up to that time, model makers would never dream of dirtying up their meticulously crafted models, so visual effects shots had a "too clean" look. Now that CGI is the dominant visual effects technology, the grunge layer is used to add that touch of life.

3.2.4 Creative Control

With the CGI object rendered in multiple separate passes, it now becomes possible to dramatically alter the final look of the composite by adjusting the layers. These variations can come from two completely different directions—how the layers are combined and how they are color corrected.

In the previous examples, we saw various layers combined using add, multiply, and screen operations. These image-blending operations and many others are discussed in Chapter 7, Image Blending. Changing the image-blending operation between layers completely changes the results, and this is one method of creative control the compositor has in the final look of a CGI composite. The other creative control is color correction; not just color correction of the finished composite, but of each render pass that makes up the finished composite, plus the finished composite.

*Solid gold man courtesy of Tom Vincze.

Figure 3-18 Soft.

Figure 3-19 Copper.

Figure 3-20 Brush.

Some examples of these variations are seen beginning with Figure 3-18. Compare this head to the one in Figure 3-16. It looks softly lit and is much less shiny. Both the specular highlights and the reflections were turned down to get this look. Figure 3-19 takes on a copper look by applying a color correction to the original diffusion pass. The reflections were also turned down a bit and given a gentle blur to reduce the shininess of the surface. A brush finish, meaning not very shiny and reflective, was achieved in Figure 3-20 by turning the reflection pass way down and giving it a big blur. When you factor the possible variations created by altering the image blending operation for each layer, along with varying the color correction for each layer, you begin to see the enormous range of creative control available to the compositor when working with multipass CGI.

All of these possibilities introduce a major problem. Suppose our gold statue man is to appear in 35 shots, which will be composited by six different compositors. If

each compositor dreams up their own recipe of layer combination and color correction, it will be impossible to maintain continuity from shot to shot. Each shot will look different. It will not even work to provide one "hero" color corrected image for everyone to look at because there are a thousand ways to achieve that one look. What needs to be done is to have a senior compositor set up the layer combining strategy as well as the color correction operations in a compositing script. This script, along with the hero image, forms the "recipe" for the composite and is made available to all of the compositors on the team to use as a reference. Variations will be required to refine the final look to allow for different lighting conditions in the various shots, but at least they will all start from the same reference point.

3.3 DEPTH COMPOSITING

Depth compositing is one of the many examples of the trend in the visual effects industry to have the 2D compositing more closely integrated into the 3D production pipeline. The idea behind depth compositing is to add a 5th channel to the RGBA image we met in Chapter 2, and this 5th channel carries depth information about the objects in the frame. Since the Z-axis is the depth into the scene, this information has been named the *Z channel*, so now we have an RGBAZ image. Most digital compositing programs can read the Z channel and use the depth information to automatically set the layering order to place the various objects in front of and behind each other. The depth of an object in the scene is indicated by how bright or dark its Z channel data is. Objects close to the camera are typically whiter, and objects further away are darker. Your system may vary.

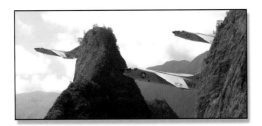

Figure 3-21 Depth composite.

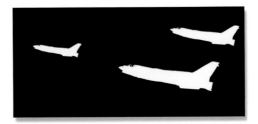

Figure 3-22 Jet alpha channel.

Our case study of the depth composite starts with the finished composite in Figure 3-21, which shows a formation of CGI jets doing some risky nap of the earth flying. Note how the nearest jet appears both behind the rock on the right and in front of the rock on the left. This is the depth composite in action. Figure 3-22 shows the typical alpha channel for the jets that represents the transparency of the CGI objects. They are not clipped or cut off in any way to fit to the rocks.

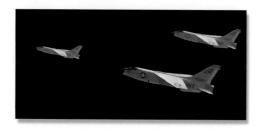

Figure 3-23 CGI jets.

Figure 3-24 Background.

The original CGI jets are shown in Figure 3-23 and the background for the composite is in Figure 3-24. For the depth composite to work, the compositing program will need the Z-channel depth information for all three jets plus the rocks from the background. The Z channel for the jets is easy because virtually all CGI programs now support Z-channel data. Since the computer is rendering the jets, it knows darn well how far in Z they are from the camera. The rendering program is simply told to include the jet's Z channel in the render, which is shown in Figure 3-25. Compare the Z-channel data to the CGI jets in Figure 3-23 and you can actually see a correlation between the apparent distances of the jets to the brightness of their Z channel. The farther from the camera, the darker the Z data.

Figure 3-25 Jet's Z channel.

Figure 3-26 Background Z channel.

The background is live action, not a CGI, so the computer does not have any depth information about it. This will take a human touch. Figure 3-26 shows the Z channel for the background with closer objects whiter and farther objects darker. This Z map was painted by hand with Adobe Photoshop, and then given to the compositing program. It now knows the depth of all the objects in the scene and will layer them correctly. One additional trick with the Z channel is to use its depth data to add a depth haze to the composite. Nice. Now that you appreciate how this all works, you can go back and admire the finished depth composite in Figure 3-21 one more time.

This is all marvelous and wonderful, but why would you want to do it? Because if you don't do it, then each jet will have to be composited individually and the

layering order with the rocks will have to be set by hand. This is not too serious a prospect for three jets, but what if you had 30 CGI objects? Or 300? Now imagine a whole squadron of jets circling one of the rocks; first in front of it and then behind it, changing the layering order every few seconds. Yikes! You would quickly begin to wish for an automatic method of keeping the layering order correct. You would wish for depth compositing with Z-channel data. If the background is also CGI, the computer can render a Z channel for it too, making our lives even ee-Z-er. Sorry about that.

3.4 MULTIPLANE COMPOSITING

Multiplane compositing bridges between the 2D and 3D departments. It composites 2D images, but does it in a 3D environment within the compositing program. Referring to Figure 3-27, the 2D images are spread out in 3D space from front to rear, and a computer camera is positioned at the far left to frame them all. This is a true 3D environment where the image planes can be moved from front to rear and they will shrink and grow with perspective. The camera can also be moved, and the image planes will behave as though the images are on invisible sheets of glass that don't shatter as the camera moves through the scene.

The difference between depth compositing and multiplane compositing is that depth compositing is strictly a 2D event with the Z channel simply controlling the compositing layer order. Multiplane compositing has no Z channel and is a true 3D environment with a moving 3D camera, even though the images are just 2D elements. The image layers can be CGI, live action footage, digital matte paintings, pictures of your mom, or any other image source you have. This technique is commonly used to combine CGI with live action scenes because it can utilize 3D match move data, which we will learn all about in Chapter 8.

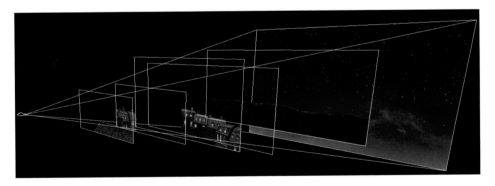

Figure 3-27 Multiplane composite setup.

When the camera moves through the scene, the image planes grow and fly past the camera just like they should. The night village multiplane sequence in Figure

3-28 shows three frames of a camera fly-over using the setup in Figure 3-27. You can see each layer of the multiplane composite change size and position, while the far background plate of the sky remains locked at infinity just like a real sky.

Frame 1 Frame 2 Frame 3

Figure 3-28 Multiplane composite sequence with moving camera.

The limitation of all this is that the images are in fact just 2D elements so the effect cannot be pushed too far or the viewer will see your 2D-ness. Where this method really shines is with match move data where the live action scene has been motion tracked to extract the 3D motion of the camera filming the scene. This information can then be used to add elements to the shot and lock them to the background layer even while the camera is moving. There is more information about the match move process in Chapter 8 just in case you can't wait.

3.5 SIMS

"Sims" is short for "simulations," a very important and rapidly expanding aspect of CGI for creating animation. A *sim* is a computer simulation of some natural phenomena, such as weight and gravity. A simple example would be to build a 3D ball, assign it a mass, and then declare the strength of gravity. Release the ball on frame one of an animation and the computer can model it gaining speed and falling faster in each frame over the length of the shot. Add to the 3D rendering program a motion blur calculation and you would end up with an image like the gravity example in Figure 3-29. The sim can be made even more accurate by including the shape of the ball and wind resistance factors.

There are three compelling reasons for using sims. The first is that it can be extremely difficult and complicated for an animator to correctly animate physical objects that are any more complicated than a bouncing ball. Even with a simple bouncing ball, what if you needed a thousand of them? The second reason is that a sim is invariably much more realistic than what a simple human could conjure up. Third, you can "dial in" the sim behavior to achieve the creative intent of the director, even if that means cheating the physics a bit—as long as it doesn't cross the line and start looking wrong. Remember, in visual effects, if it looks right, it is right.

gravity cloth turbulence

Figure 3-29 Typical sim examples.

Consider the example of the flapping cloth in Figure 3-29. Can you imagine pushing and pulling on dozens of control points scattered all over the cloth to simulate Superman's cape flapping in a supersonic slipstream? Not only would this be immensely time consuming, but it would also look awful. No human actually knows how cloth behaves under the laminar flow of a supersonic wind—but the computer does. The animator simply adjusts the parameters of the simulation and the material's attributes until the desired action is achieved instead of adjusting animation control points.

In addition to building a synthetic world of weight, gravity, wind, fabric stiffness, and almost any other property you can imagine, turbulence can also be added. These are mathematical whirls and vortices of wind or water, which then shoves 3D objects around with a realistic random motion like the turbulence example of the blowing leaves in Figure 3-29. The 3D animator has control over how strong it is and can "dial it in" to get any desired amount of turbulence.

Sims go far beyond the few simple examples here. It can simulate the collapse of an entire building or the bending of a steel bar under a massive load. In the last few years it even became possible to simulate the behavior of liquids, especially water, although this is still extremely difficult and computer intensive. It can also simulate the collision of solid bodies, such as dumping a truckload of bricks on the ground, or even elastic bodies, such as bouncing rubber balls. The bouncing, flowing hair on a CGI character is often animated with a hair sim.

Complex sims such as these not only require very sophisticated software, but also very powerful computers because of the sheer number of calculations required to compute all of the possible interactions of all the objects in the scene. No wonder they are a recent development. Sims are guaranteed to become progressively more pervasive in visual effects because they solve a critical need and are becoming ever more capable and easier to create.

3.6 PARTICLE SYSTEMS

An entire other class of 3D animation is what we call *particle systems*. Particle systems are used to create images that are made up of thousands or even millions of

tiny particles, such as the fog, rain, and smoke illustrated in Figure 3-30. The concept here is that the 3D animator first defines the attributes of their particles—size, color, transparency, softness, and so on, and then gives them a "life." This means that each particle is born, lives, and then dies. These attributes are not individually assigned to each particle of course, but are instead done by declaring rules and setting parameters with statistical distributions over all the particles so that each is unique, but still conforms to the overall behavior of the "particle cloud." By simply changing the rules and parameters, a particle system can generate a wide variety of amorphous photorealistic phenomena such as fog, rain, smoke, dust, snow, fire, tornadoes, clouds, as well as Tinker Bell's trailing pixie dust.

Fog Rain Smoke

Figure 3-30 Classic particle system examples.

The particle system creates the item of interest by generating a huge number of particles, which are typically given some built-in motion such as the smoke example in Figure 3-30. In addition to this inherent motion, sims can be added to stir things up. For example, a wind force could be applied to the smoke particles and cause the smoke to drift off to the right. Turbulence could then be added to the wind to swirl the smoke particles. When you add sims to particle systems, and then throw in advanced lighting and rendering capabilities, you begin to see how these separate systems combine together to build a progressively more sophisticated and photorealistic image.

There is one surprising aspect shared by both particle systems and sims, and that is you cannot start rendering them on frame one. Consider, for example, the smoke in Figure 3-30. On frame one the particles are just starting out and have not begun rising yet, so they are just sitting on the floor. The smoke may not achieve the full form you see here until, say, frame 100. Only then can the image render begin. In actual practice, the process of outputting the rendered images does begin on frame one, but the particle system and the sim has started on frame −100 (minus 100). This way, the particles have 100 frames to populate the screen and take on their full form before the first image is output.

The compositing process is not really affected when working with sims because they are just another way to animate 3D objects. The compositing program does not

know or care which agent—man or machine—moved those objects; however, particle systems represent a different case. They are typically amorphous and often semi-transparent or even glowing and the particle system software must generate an appropriate alpha channel. The compositor must also make creative decisions as to how to composite the particle element—a typical composite, an add-mix, a screen operation, or some other image combining strategy.

3.7 WORKING WITH PREMULTIPLIED CGI

There is a bit of a technical issue about compositing CGI that needs to be addressed, and that is the issue of premultiplied and unpremultiplied CGI. To understand this issue, we will need to dive inside the CGI rendering process for a moment. So why do we care about the grizzly innards of a CGI render? There are three reasons. The first is that you need to get this issue correct in order to properly composite, color correct, and transform CGI elements. Second, getting this wrong adds dark edges to your CGI composites, which in turn, spawns a cascade of compensating errors in a frantic attempt to make them go away. Third, you may get work in a visual effects facility that surprises you by handing you unpremultiplied CGI to composite, so this information will help you to avoid that "deer caught in headlights" look.

Some of the difficulty of this subject comes from the unfortunate use of the awkward CGI terms *premultiply* and *unpremultiply*. It might help to realize that "premultiply" merely means that the RGB image has been multiplied by the alpha channel, like we saw in Section 3.1.1, Scaling the Background, while "unpremultiply" means that it hasn't. To see how scaling the RGB code values of the CGI element by multiplying it with its alpha channel affects our compositing, we'll now dive inside the rendering of a CGI object.

Figure 3-31 Actual geometry.

Figure 3-32 Unpremultiplied.

Our story starts deep inside the 3D program where the actual geometry of the CGI object resides, visualized in Figure 3-31 as a close-up of a curved surface. At this point, it has not been rendered so it doesn't know or care about pixels, but when

it comes time to be rendered the resulting image must be divided up into discrete pixels, which are represented by the feint lines in Figure 3-31. The problem that the rendering program has is that at the edges of the geometry it cuts across pixel boundaries only partially covering them. The edge may cover one pixel by 30%, but another by 90%.

This problem is universally solved by breaking the render into three steps. The first step is to render the edge of the geometry as if it covered all of its pixels by 100%. This produces an image like the unpremultiplied image in Figure 3-32 where the edges are jaggy. It is called *unpremultiplied* because it has not been scaled by its alpha—but don't worry, we are not done yet. The second step is to render the alpha channel shown in Figure 3-33. This channel represents the percentage of each pixel that is covered by the geometry. If the geometry covers a pixel by 100%, its alpha pixel will be 100% white. If the edge of the geometry covers a pixel by 30%, its alpha pixel will be 30% white, and so on.

Figure 3-33 Alpha channel. **Figure 3-34** Premultiplied.

The last step is to multiply the alpha channel (Figure 3-33) by the unpremultiplied version (Figure 3-32) of the render to produce the premultiplied version shown in Figure 3-34. We normally get CGI delivered in this familiar form; however, it is not the best form for color correcting it. The unpremultiplied version is.

3.7.1 Color Correcting

That's right, you want to perform color correction operations on the hideously jaggy unpremultiplied version of the CGI shown in Figure 3-32. The reason is that if you perform color correction operations on the premultiplied version (Figure 3-34), it can introduce color artifacts around the edges of the composited CGI. Why this happens is too messy to go into in a nice introductory book like this, but you will find all the gory details in my more advanced book *Digital Compositing for Film and Video* if you would really like to know.

So, if you are only given the premultiplied CGI, how do you get back to the unpremultiplied version? Remember how multiplying the unpremultiplied version by the alpha channel created the premultiplied version? This is a reversible process, so we can simply divide the premultiplied version by the alpha channel to revert back to the unpremultiplied version. This is referred to as *unpremultiplying* the CGI. The whole procedure, then, is to first divide the CGI by its alpha channel, perform the color correction, and then re-multiply the results by the alpha channel. All compositing programs offer such capabilities, but you may have to rummage through the manual to discover what your software calls it. One more point: all this multiplying and dividing of RGB values is hard on 8-bit images, so they should be promoted to 16 bits prior to the unpremultiply operation, and then they can be restored to 8 bits after the re-multiply operation if needed.

Having said all this about how to properly color correct CGI, let me now say it is OK to skip all of it if you are only making minor color corrections. Perhaps you only need to increase the brightness a bit or tap down the gamma. If the color corrections are small, then the introduced errors are small and will not be noticeable. My advice is to try the color correction first on the premultiplied CGI, then inspect the results carefully. You will often get away with it. To be safe, you could apply an exaggerated version of the color correction (twice the intended brightness, for example), and then check for problems. If none are found, dial it back to the real setting and move on.

3.7.2 Transformations and Filters

While color correction operations should always (technically) be done on unpremultiplied versions of the CGI, all transformations (move, scale, rotate, etc.) and filters (blurs, median filters, etc.) should be done on the premultiplied version. If transformations or filters are applied to the unpremultiplied version, edge artifacts can show up in the composite. Why this happens is another arduous story, so we can't get into it in this book. It's just the rule, but we can see what will happen.

Figure 3-35 Unpremultiplied.

Figure 3-36 Premultiplied.

The unpremultiplied jet in Figure 3-35 is an example of the edge artifacts that are introduced by simply rotating it 10 degrees and then re-multiplying it for the final composite. Some of the pixels around the outer edge of the jet have become badly brightened, especially on the top and bottom edges. Compare that to the pre-multiplied version in Figure 3-36, which has very nice edge pixels. In some compositing programs, the edge artifacts may be dark instead of light depending on how they perform the unpremultiply operation. Tragically, the dark version of this artifact can look very similar to the artifact introduced by a very common mistake, which we will examine next.

3.7.3 The Common Mistake

Most compositing programs assume that the CGI you are compositing is premultiplied. However, virtually all of them allow you to switch the compositing operation for either premultiplied or unpremultiplied CGI. If you tell the composite operation that the CGI is unpremultiplied, then it will apply a premultiply operation during the composite. However, if you have performed an unpremultiply operation for color correction, you may or may not have reapplied the premultiply operation prior to the composite operation, so it will have to be set for . . . something or other.

This can get confusing. The common mistake is to inadvertently have the compositing operation apply a premultiply operation to CGI that is already premultiplied. If that happens, the edges of the CGI will turn dark like the double premultiplied edges example in Figure 3-37. The example in Figure 3-38 is set up correctly, while Figure 3-37 sports the dark edges of a double premultiply operation. The reason this happens is because the premultiply operation naturally darkens the edges. If the CGI is unpremultiplied (like Figure 3-32), then this is a good thing. If the edges are already premultiplied (like Figure 3-34), then this is a bad thing and you wind up with the double darkened edges of Figure 3-37.

Figure 3-37 Double premultiplied edges.

Figure 3-38 Normal edges.

If you see dark edges like this around your CGI composite, you can usually assume that the premultiply operation has been applied twice and you can start troubleshooting your composite accordingly. The most likely fix is to go into the composite

operation and find the button to press so it does NOT perform a premultiply operation. However, sometimes the edges of the CGI are naturally dark and you are not sure if things are set up correctly. Fear not, there is a simple test that you can perform to confirm that you have set up the composite correctly (or not).

Simply switch out the background image with a plate of zero black so that the CGI is composited over the zero black plate. If the composite is set up correctly, the black composite can be compared to the original CGI element (which is already over zero black), and toggling between the two in the image viewer will show that they are identical. If the black composited version appears to shrink around the edges compared to the original, then there is a double premultiply. To be sure, there are other compositing problems that can also produce similar looking dark edges, but this is one of the most common causes so it is the first place to look.

4 Bluescreen Compositing

As we saw in Chapter 1, when a character or object is filmed for later compositing, it is photographed over a bluescreen. By filming an object in front of a uniform solid blue backing the computer can more easily detect it from the background and create, or "pull" a matte for compositing. Pulling the matte for a composite is a very high art and is the cornerstone of digital compositing. The starting point of a good composite is a good matte, and in the real production world, you are constantly trying to pull good mattes from bad bluescreens. While we may call the process bluescreen, the color of the backing screen can also be green or red, the other two primary colors. For the sake of simplicity we will refer to all of them as bluescreens regardless of their actual color.

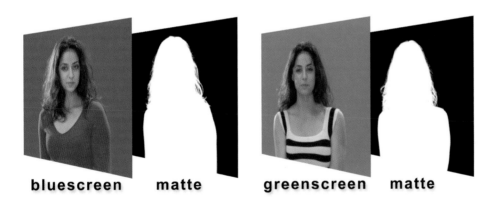

bluescreen **matte** **greenscreen** **matte**

Figure 4-1 A matte can be made from a bluescreen or a greenscreen.

Bluescreen compositing is much more challenging than CGI compositing. The reason for this is that the element you are working with, the bluescreen, is a piece of live action film photographed by someone, instead of a mathematically perfect CGI element. As a result, it can come to you infected with a host of photographic problems. These problems can range from over or under exposure, out of focus,

excessive grain, bad lighting, wrong bluescreen color, and even bad composition. Of course, the digital compositor is expected to pull a good matte anyway, fix all of these problems, and make a beautiful composite regardless of how pitiful the elements are. By comparison, I have never seen an over-exposed, grainy, or badly focused CGI render.

The main tool for pulling a matte is the *keyer*, a sophisticated program that isolates the foreground object from the bluescreen and composites it over the background. In the process, the keyer must perform many complex internal operations such as despill and color correction, in addition to pulling the matte. These keyers have many adjustments and settings that the compositor must understand and master to get the best results. The keyer often fails to do a good job and it must be helped, so a variety of techniques are shown that you can use to assist the keyer in its job. Sometimes the keyer just cannot do the job and the only solution is to composite the shot outside of the keyer using heroic rescue efforts to salvage the situation. In the off chance that you are actually asked how to shoot the bluescreen plates, the last section in this chapter contains a list of tips.

4.1 THE BLUESCREEN COMPOSITE

Like CGI compositing, bluescreen compositing requires three elements: A foreground image (the bluescreen), a background image, and a matte. The difference here is that a mathematically perfect matte automatically comes with the CGI, but for bluescreen compositing, the digital compositor must create one. Creating a matte from a bluescreen is a precarious operation due to the wild variations from shot to shot. Some bluescreens are shot well and create lovely mattes, while others are poorly shot and must be wrestled to the ground and coerced into giving up their mattes. In this first section, we will get an overview of the bluescreen compositing process to introduce some key concepts, which will then be elaborated in the subsequent sections. While all the examples and discussions here are for bluescreens, these same principles apply to greenscreens as well.

4.1.1 Pulling the Matte

Creating a matte from a bluescreen is often called *pulling the matte*, and it is done with a marvelous program called a *keyer*. Figure 4-2 shows a whimsical illustration of this keying process. The keyer gets its name from the fact that it is going to create the key, or matte, for the bluescreen composite. All compositing programs come with keyers, and they often have more than one. In addition, third-party keyers can be purchased and added to the compositing program. The reason for so many different keyer designs is that pulling a matte from a bluescreen is a difficult task, and some keyers work better than others on different bluescreens. In other words, if you used three different keyers to pull a matte on the same bluescreen, you would get three different results.

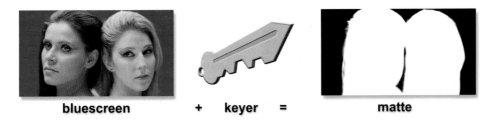

bluescreen + keyer = matte

Figure 4-2 The bluescreen plus a keyer makes a matte.

The keyer processes the bluescreen images and generates a matte, while the digital artist adjusts sliders and tunes parameters trying to coax the best possible matte out of the keyer. The keyer may also need assistance by giving it garbage mattes to help it identify the blue parts of the bluescreen as well as holdout mattes to help it identify the objects to be isolated. Like I said, pulling a matte from a bluescreen is a difficult task and even the best keyers need some help. But keyers do so much more than just pull the matte.

4.1.2 The Basic Composite

On the face of it, the bluescreen composite process illustrated in Figure 4-3 is remarkably similar to the CGI composite illustrated in Figure 3-1 of Chapter 3. One obvious difference is that the target objects in the bluescreen composite (the pensive maidens, in this example) are surrounded by blue, while the foreground object in the CGI composite is surrounded by black. This difference is solved by another operation done by the keyer, and that is to scale the foreground RGB by the matte. This results in the target object being surrounded by black and ready for composite, just like CGI. Almost.

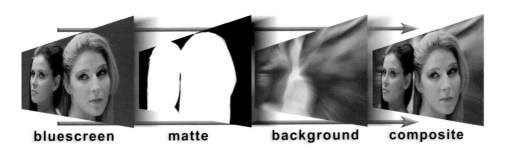

bluescreen matte background composite

Figure 4-3 The keyer pulls the matte and performs the composite.

Figure 4-4 Blue spill contamination.

One problem with filming (or video-taping) the target object in front of bluescreens is the spill light. Blue light bounces (spills) off the bluescreen and contaminates the target object. The blue backing color also mixes with the edge of the target object giving its outer edge an unpleasant blue fringe like the example in Figure 4-4. Further, any semi-transparent regions such as hair, thin cloth, or motion blur allows the blue to show through so these regions also pick up a blue tint. To cope with these spill problems, digital keyers perform the additional service of *despill*, which removes the blue tints and fringes introduced by the bluescreen photography.

Of course, the bluescreen layer must be color corrected before it is composited over the background if it is to look right. Unfortunately, you cannot color correct the bluescreen layer before giving it to the keyer because that would alter the blue backing color, which would in turn, confound the keyer trying to pull the matte. You cannot color correct it after the composite because it is now mixed with the background layer. What is a compositor to do? The answer is that the bluescreen layer must be color corrected *inside* the keyer, after it pulls the matte but before it lays it down over the background. Therefore all digital keyers also have internal color correcting capabilities. The background layer can be color corrected before it is given to the keyer, so no problem there.

The two remaining operations, scaling the background and summing the layers together, are also performed by the keyer. As you can see, the digital keyer actually performs a long list of operations to do a bluescreen composite, while the compositing node that composites CGI only does a couple of operations. Further, there are a great many adjustments that must be mastered by the compositor in order to get a good composite out of the keyer. Just to drive the point home, Table 4-1 lists all of the operations performed by a typical digital keyer compared to a simple compositing operation used to composite CGI.

Table 4-1 Comparison of operations performed by a keyer vs. a composite operation

Digital Keyer	CGI Compositing Operation
Pull the matte	Scale the background RGB
Despill the bluescreen layer	Sum the layers
Color correct the foreground	
Scale the bluescreen RGB	
Scale the background RGB	
Sum the layers	

4.2 ABOUT KEYERS

The keyers that come with a sophisticated compositing program are themselves a sophisticated program. Some compositing programs come with more than one, and there are even more keyers that can be purchased from third-party developers and added to a compositing program. The reason for so many different keyers made by so many different companies is that it is in fact very difficult to pull a good matte from a bluescreen, so each manufacturer has its own special design that is better than all the others are.

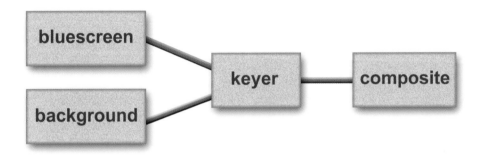

Figure 4-5 Flowgraph of a keyer performing a composite.

Figure 4-5 is a flowgraph that illustrates connecting the bluescreen and the background layers to the keyer and its output, the finished composite. Would that it were that simple. To pull this off, the keyer must perform the long list of operations we saw in Table 4-1. There are a great many ways to pull the matte, despill the bluescreen layer, and color correct the foreground, and there are even special ways to combine the bluescreen layer and the background for better edge detail. So there is a lot going on inside of a keyer, and each of them have their own unique way of performing these various operations. Next we will peer inside of a keyer to see the operations that go on in there.

4.2.1 How Keyers Work

Regardless of their differences, most keyers work on the same basic principle, which is that the red, green, and blue channels will have important differences between the target object (the item we are trying to composite) and the colored backing region. The pixels in the blue backing region will have blue values much greater than their red and green values, while the pixels in the target object will have blue values that are less than the red and green values. The key is not that the blue values are large and the other two are small, it is the relationship between the three values—that is, the blue values are greater than the red and green. The bluescreen could be dark, as in a shadowed area, with low blue values. But if its blue values are greater than its

red and green values, then it will be considered part of the backing region in the matte.

This relationship between the values of the three channels can be used to "sort" the pixels of the bluescreen layer into three groups—those that are 100% the backing color (the bluescreen), those that are 100% the target object, and those that are somewhat in-between. The pixels that are 100% the target object become the white part of the matte, the 100% backing pixels become black, and the somewhat in-between pixels become gray, or the semi-transparent parts of the matte.

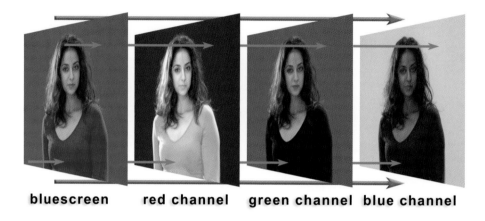

bluescreen red channel green channel blue channel

Figure 4-6 The color channels of a bluescreen.

The green arrows in Figure 4-6 point out the critical differences in the three channels between the target object and the backing region. The top green arrow starts at a pixel in the blue backing region of the bluescreen image. Following it through to each color channel, at the red channel it hits a dark region with low pixel values, then to the green channel which is also dark, but the blue channel has higher pixel values so it is brighter. The blue value at this point is greater than the red or green, so the keyer considers it part of the backing region. This part of the matte will become black.

Conversely, the bottom green arrow points to a bright red pixel in the target object of the bluescreen image. Following it through each channel reveals the red channel to be bright, while the green and blue channels are dark. Here, the blue value will be less than the red or green, so this area will be considered part of the target object. This part of the matte will become white.

In fact, in a properly photographed bluescreen, every pixel in the target object will have a blue value that is less than its red and green values. Even in the skin tones, the blue channel is darker than the red or green channels. The fact that the blue channel is greater than the red and green channels only in the backing region is the principle upon which keyers create the matte. This underscores the importance

of a uniform and saturated bluescreen. The more saturated it is, the greater the difference between the blue channel and the other two, the better the matte. Therefore, these types of keyers are known as color difference keyers.

4.2.2 Despill

As we saw in Figure 4-4, the problem of blue spill contamination requires the keyer to perform another operation called *despill*. Blue light from the bluescreen backing bounces onto the target object contaminating it with blue, such as on the skin tones. Blue contamination also occurs around the edges of the target, any semi-transparent regions, any motion-blurred elements, plus any shiny surfaces that might partially reflect the bluescreen. All of this excess blue light must be removed as part of the keyer's overall bluescreen compositing operation.

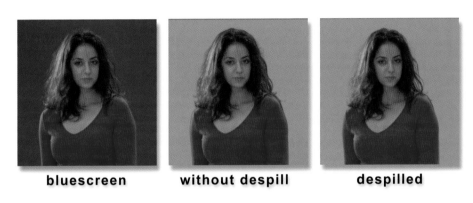

bluescreen **without despill** **despilled**

Figure 4-7 The need for despill.

Figure 4-7 illustrates the importance of the despill operation for the composite. The center image shows the bluescreen composited over a neutral gray background without a despill operation. There is a blue outline around the edge of the girl and a lot of blue spill mixed with her semi-transparent hair. The last image shows the fine results of performing a despill operation to remove the excess blue spill.

While the despilled composite looks very nice, there is a dark side to the despill operation. If you look closely at the color of the red sweater in the despilled image of Figure 4-7, you will see that it is not exactly the same red as the image without despill. The sweater naturally had a little excess blue, which was inadvertently removed along with the blue spill. This shifted the color of the sweater a bit. Whenever an undesirable side effect of an operation like this occurs, it is called an *artifact*. So be advised, the despill operation, while essential, can introduce color artifacts.

4.2.3 Color Correction

As we saw earlier, color correcting the bluescreen layer has to be done at exactly the right place in the processing flow within the keyer. It cannot be done prior to the keyer because any change in the RGB values of the bluescreen layer introduced by a color correction operation will disturb the relationship between the red, green, and blue channels, which the keyer counts on to pull the matte. This would result in a degraded matte and a poor composite; in addition to that, the despill operation must also be performed before any color correction as it is trying to remove the excess blue from just those pixels that have been contaminated by the backing color. If the RGB relationships have been disturbed by a previous color correction operation, then it is no longer clear which pixels are contaminated from the blue spill.

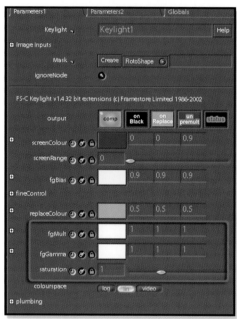

Figure 4-8 Keylight color corrector.

Figure 4-8 shows the user interface for Keylight, a world-class keyer. Of the entire interface, only the area outlined in red is for color correcting the foreground and represents a typical case for the color correctors built into bluescreen keyers. It offers a foreground RGB scaling operation labeled "fgMult," a gamma correction labeled "fgGamma," and a saturation adjustment. The RGB scaling and gamma operations can be set for each color channel individually, which allows shifts in the color of the foreground in addition to its brightness.

This nicely illustrates how the color correction operation is "embedded" within the keyer because it must be an integral part of the keying process since it cannot be done before or after the keyer does its work. One of the problems with this arrangement is that you are obviously limited to only doing the color correction operations that the keyer's designers built into their keyer. If you need something different or need to add a blur operation, for example, you are out of luck. In those situations, the answer is to use the keyer only to pull a nice matte, but then to perform all of the other operations normally done within the keyer externally using individual operations. Compositing outside the keyer like this will be demonstrated in a later section.

4.2.4 Scaling the Foreground and Background

We have already seen how a CGI element is already scaled by its alpha channel and is normally delivered to compositing premultiplied. However, with bluescreen com-

positing, the foreground layer is not scaled by the matte so this step must be added to the keyer's internal operations. Figure 4-9 shows a greenscreen being scaled by its matte to produce the scaled foreground, which prepares it for the final composite. It now looks just like a premultiplied CGI element. Within the internal logic of the keyer, the greenscreen is despilled prior to being scaled by the matte.

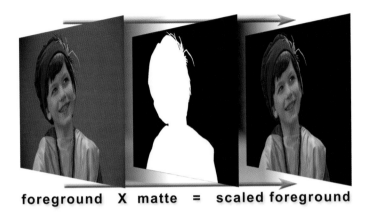

foreground X matte = scaled foreground

Figure 4-9 The foreground layer is scaled by the matte.
(*Film elements courtesy of Sylvia Binsfeld of DreamWeaver Films and "Dorme."*)

The keyer must also scale the background, of course. As with compositing CGI, the matte is inverted (black and white are swapped) before multiplying it with the background. The inverted matte is shown in Figure 4-10 to produce the scaled background. Again, inverting the matte before multiplying the background is necessary because we want that black "hole" where the target object will go.

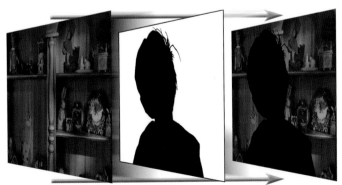

background X inverted matte = scaled background

Figure 4-10 The background layer is actually scaled by the inverted matte.

4.2.5 Sum the Layers

Now that we have both the scaled foreground and scaled background, the keyer can simply sum the two layers together to create the final composite as shown in Figure 4-11. This step now looks very much like Figure 3-5 in Chapter 3 where we added the CGI jet and scaled the background to create the final composite. We just had to do a lot more work with a bluescreen to get a matte and create the scaled foreground first.

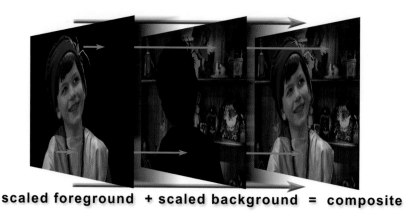

scaled foreground + scaled background = composite

Figure 4-11 Sum the scaled layers to make the composite.

Again, if you follow the top green arrow in Figure 4-11 starting with the scaled foreground layer, you will see its black pixel will be added to a colored pixel in the background resulting in a background pixel in the composite. Following the lower arrow shows that a foreground colored pixel will be added to a black pixel in the background resulting in a foreground pixel in the composite.

4.2.6 The Final Composite

The flowgraph in Figure 4-12 maps out the sequence of operations that the keyer must perform. Starting with the bluescreen layer, it pulls the matte and performs the despill and color correction. It then performs the actual compositing operation by scaling the foreground and background layers and then sums them together. This is a lot of work for a keyer to do, so all keyers have a variety of buttons, dials, and sliders to adjust the settings of its internal workings so that the operator (that's you) can "tweak" the finished composite for best results.

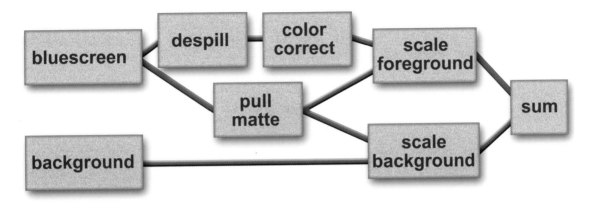

Figure 4-12 Flowgraph of the internal operations of a keyer.

This is a lot to ask even if a keyer has a dozen or more adjustments. Sometimes the keyer doesn't do such a good job—hence the many available brands of keyers, each better than the next. If the compositing program has more than one keyer, you might try a different one and hope for better results. Regardless of which keyer you use, there are many operations you can do to assist the keyer to pull better mattes and make a better composite. You can help the keyer.

4.3 HELPING THE KEYER

As we have seen, pulling a good matte from a bluescreen is often difficult. It is rare to plug in the bluescreen and background layers, adjust a few settings, and voila—a great composite! The problems may be in the backing region (the blue- or green-screen) or the target object, or both. The backing region may be unevenly lit, off color, or may be made up of several mismatched panels of color. The target object may have very transparent areas or contain colors that baffle the keyer. On top of all this, the grain of the film (or the noise of the video) can add its own problems to the shot. Next, we will take a look at how we may assist a struggling keyer to output a better composite.

4.3.1 Garbage Mattes

The garbage matte helps the keyer to clear out the blue or green backing region. The backing material may not extend all the way to the edges of the frame, there might be props or other obstructions, it could be unevenly lit, or it might be made up of a patchwork quilt of off-color panels that the keyer cannot cope with. Figure 4-13 illustrates how a very simple, loose-fitting matte is drawn around the greenscreen target object (yellow outline) and is used to composite it over a clean plate of solid

color that matches the backing color. The light colored outline that is still around the boy in the composite comes from the fact that the lower part of the backing is lighter than the upper part. However, a good keyer will be able to cope with this minor variation in the backing region.

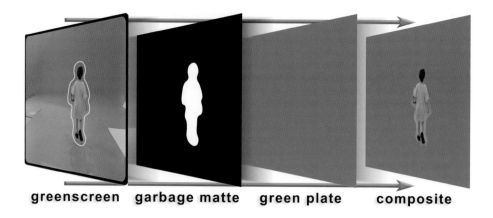

greenscreen garbage matte green plate composite

Figure 4-13 Garbage matting the greenscreen.

The key words here for the garbage matte were "*very simple*"—a simple matte that does not come too close to the edges of the target object. There are two reasons for this: First, the keyer must be the one to extract the matte at the target's edges. If the garbage matte touches the target's edge then it overrides the keyer and extracts the matte at the edge instead, introducing a hard edge in that area. Second, by keeping the garbage matte a "loose fit" around the target it may not need to be redrawn for several frames. If the action is minimal, this might be only every 10 or 20 frames, making the garbage matte very quick and easy to draw. The tighter the garbage matte is drawn around the target, the more key frames will be needed.

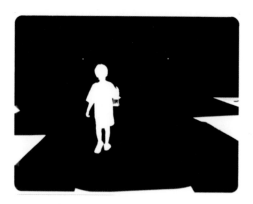

Figure 4-14 Original matte.

Figure 4-15 Garbage matted.

The example in Figure 4-13 illustrates how to clean up the greenscreen prior to giving it to the keyer. Another alternative is that some keyers will accept a garbage matte as a separate input image and then use it internally to clean up the matte. If your keyer supports this option, it is usually the best approach.

A third way to apply the garbage matte is to use it to clean up the matte after the keyer has created it. This approach is only used when you are using the keyer just to pull the matte and plan to do your own composite external of the keyer. Figure 4-14 shows the original matte created from the greenscreen in Figure 4-13 without any garbage matting. The props and floor panels have shown up in the matte along with the boy and need to be cleared out. The original matte in Figure 4-14 is simply multiplied by the garbage matte from Figure 4-13 to produce the cleaned-up matte in Figure 4-15.

4.3.2 Procedural Garbage Mattes

There is another way to create a garbage matte that does not require drawing it by hand, and that is a *procedural garbage matte*. A procedural garbage matte is created by the computer based on a "procedure," or rule. The most common procedural garbage matte for bluescreens is a chroma-key, where the "procedure" is for the computer to find all the bright blue pixels in each frame and make a matte out of them. We will learn more about chroma-keys in Chapter 5.

While the chroma-key garbage matte may sound like a slick way to create a bluescreen matte for compositing, it is not. Compared to a color-difference matte, the chroma-key has ragged edges, lack of fine detail around hair, and miserable transparency characteristics. It is far too crude to be used in any serious composite.

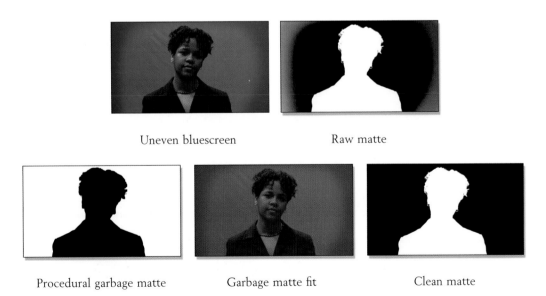

Uneven bluescreen Raw matte

Procedural garbage matte Garbage matte fit Clean matte

Figure 4-16 Procedural garbage matte used to clean up the backing region.

However, it is just the thing for crudely blocking out the nasty parts of the backing region.

Figure 4-16 shows a sequence of frames that illustrates how the procedural garbage matte works to clean up the uneven backing region of a bluescreen. The uneven bluescreen gets dark near the edges of the frame, a very common problem. The raw matte next to it shows the problem the keyer has without a garbage matte. The bottom left picture in Figure 4-16 shows the procedural garbage matte that was created using a chroma-key. It was adjusted so it would not come too close to the edges of the target (the lady). A test of the garbage matte fit is shown next to it using a desaturation operation to turn the backing region gray so you can see how far away the garbage matte is from the edges. Finally, the clean matte at the bottom right shows the results of using the garbage matte to clean up the backing region compared to the raw matte above it.

4.3.3 Holdout Mattes

We saw how a garbage matte helps the keyer to produce a clean matte in the backing region. A holdout matte does the same job, but for the target object. The target object may have some colors that confuse the keyer, which then thinks that those colors are part of the backing region so it creates a semi-transparent region right in the middle. Not good. Another problem can come from reflective objects such as belt buckles, rings, or any shiny surface. They will reflect the backing color toward the camera, which punches a hole in the target object. A lot can go wrong when pulling a bluescreen matte so the keyer needs all the help it can get.

Figure 4-17 Greenscreen.

Figure 4-18 Raw matte.

Figure 4-19 Holdout mattes.

Figure 4-20 Fixed matte.

Figure 4-17 illustrates multiple things going wrong with one greenscreen shot. These toy cars have color contamination problems in three different areas. Looking at the raw matte in Figure 4-18, it has holes in the wheels where the chrome rims have reflected the greenscreen, the pink car's hatchback is semi-transparent because it too reflects the greenscreen, and the entire yellow car body is semi-transparent because the keyer is confused by its color. A holdout matte is needed for each problem area.

Figure 4-19 shows the holdout matte created to address each problem area. When it is applied to the raw matte in Figure 4-18, it results in the fixed matte in Figure 4-20. A remaining problem area is the shadows under the cars. They are so dark that the keyer did not see them as part of the backing so it filled in the matte. A garbage matte will be needed to fix that problem.

Like a garbage matte, a holdout matte can be hand drawn as was done in Figure 4-19 or generated procedurally, whatever works best. Also, just like the garbage matte, it can be used three ways: to clean up the greenscreen before the keyer gets it, to clean up the matte that the keyer produces, or it can be input to the keyer directly if it has an input option for a holdout matte.

4.3.4 Degrain

One of the banes of bluescreen compositing is "sizzling" edges. The edge of the composite where the target object merges with the background layer has a noisy "chatter" to it as if the grain (or video noise) were cranked up to "high." Actually, that is literally what is going on. This is most noticeable with bluescreens because, in a cruel twist of physics, the blue channels of both film and video have the most grain (or noise). This noise becomes incorporated in the matte and is exaggerated at the matte edges. Greenscreens can have sizzling edges too, but to a much lesser degree because of the normally finer grain of the green channel.

bluescreen red green blue matte

Figure 4-21 The heavy blue grain makes for sizzling matte edges.

Figure 4-21 is a close-up of an actual feature film bluescreen that reveals how the blue grain turns up in the matte edges. You can see that the red and green channels have a much smaller, finer grain structure compared to the blue channel. Since this

is a bluescreen, the keyer will use a lot of the blue channel in its calculations of the matte so the blue grain ends up in the matte. Part of the internal calculations of the keyer is to scale the matte up in brightness, which then literally scales up the blue grain embedded in the matte edges. The white flecks of grain visible in the matte on the right will change from frame-to-frame and cause the edge to sizzle.

The fix for this is to degrain the bluescreen before pulling the matte. One could even conceivably degrain just the blue channel. This degrained version would then be used to pull the matte, but is not used in the composite because its grain structure would not match the background layer. Some keyers even have an internal degrain feature to save you the trouble. If not, you may have to manage your own grain and composite outside the keyer.

4.4 COMPOSITING OUTSIDE THE KEYER

It often happens that no matter how sincerely you adjust the settings of a keyer, it just will not make a good composite. The problem might be in the matte quality, the despill operation, or perhaps the color correction is just not working. A few of the problems that you may not be able to adjust out from within the keyer are: discolored edges, dark edges, hard edges, chewy edges, sizzling edges, loss of fine edge detail (typically in hair), hue shifts in critical areas, semi-transparent regions, holes in the target object, grain added to the background, and so on. Keyers are wonderful and keyers are brilliant, but they are designed to work with elements that are "in spec." Your elements may be less than ideal or you may have special issues that the keyer was not designed to cope with. It is time to composite outside the keyer.

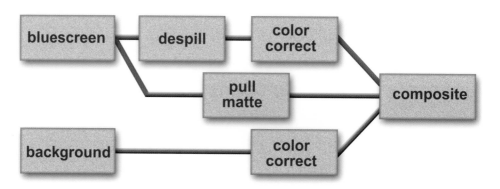

Figure 4-22 Sequence of operations for compositing outside the keyer.

The basic strategy here is to use the keyer just to pull the matte, then do your own despill, color correction, and compositing outside the keyer. The sequence of operations is shown in the flowgraph of Figure 4-22. Starting with the bluescreen (or greenscreen), it is first despilled using the despill operation that comes with the compositing program, then it is color corrected. The original bluescreen is also pre-

sented to a keyer to pull its best matte (more on this in the next section). Starting at the background plate, it is first color corrected, then all three elements—the despilled and color corrected bluescreen, the matte, and the color corrected background—are composited together. The keyer is used to pull the matte, but does not perform the actual composite.

4.4.1 Merging Multiple Mattes

One of the main causes of having to composite outside the keyer is the inability to get a good matte. The adjustments and settings of the keyer are global, which means they affect the entire matte everywhere at the same time. Sometimes (very often, actually), what is really needed are different keyer settings for different parts of the matte. One setting is good for the hair, but the torso has problems. Another setting gets a good solid matte for the torso, but the hair turns ugly. One solution is to let the keyer pull a matte and "export" it. This exported matte can then be combined with other mattes that were pulled with other keyers using different settings, or mattes drawn by hand in an attempt to create a good looking final matte. Divide and conquer.

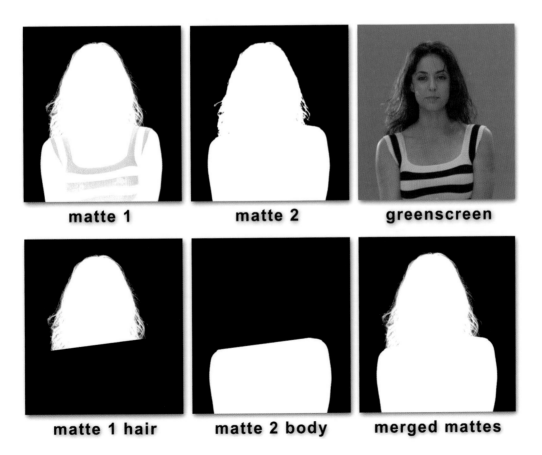

Figure 4-23 Combine mattes from more than one keyer.

This approach is shown in Figure 4-23 where two different mattes were pulled and then combined. Matte 1 in Figure 4-23 has very nice hair, but the yellow sweater stripes have flummoxed the keyer, which has responded by making the stripes semi-transparent. A second keyer was set up with completely different settings to make matte 2. This fixed the holes in the sweater, but the hair is just too ugly for words. The good hair from matte 1 and the good body from matte 2 were split at the hairline, then merged to make the final merged mattes in Figure 4-23. Of course, the line where the two mattes meet must be carefully managed so as not to reveal the seam.

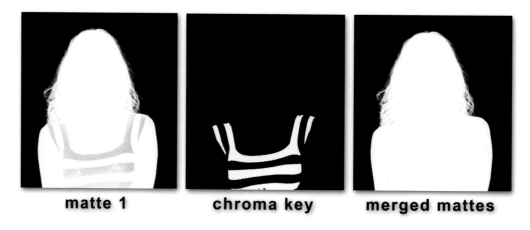

matte 1 **chroma key** **merged mattes**

Figure 4-24 Pull different keys and combine them.

Figure 4-24 illustrates yet another approach for combining multiple mattes. In this approach, two different keyers were used to fix the yellow stripe problem in matte 1. A chroma-key was used to create a matte of just the yellow stripes and then it was merged with matte 1 to create the final merged matte. One virtue of this approach is that there is no seam that has to be carefully managed.

Edge mattes are yet another strategy favored by some. With this approach, the edges are isolated with a separate edge matte so they can be finessed directly. The core (center) matte and the backing region mattes can then be simple and solid.

Once you have the multiple mattes required to cover the situation, the next question then becomes which method to use to merge them together. Figure 4-25 demonstrates the merging of matte 1 and matte 2 on the top row using three different matte merging methods. The visual differences between the three methods are shown in the bottom row where clear differences can be seen at the intersections of the two mattes—their "crotches," if you will. The "Add" operation on the left tends to fill in the crotch. The "Maximum" operation next to it looks much better and is the operation of choice if you want a clean and sharp intersection. The "Screen"

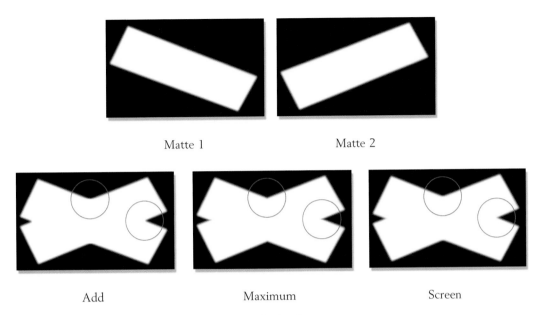

Matte 1 Matte 2

Add Maximum Screen

Figure 4-25 Methods of merging mattes.

operation offers a more blended union of the two mattes and has a more organic look. More about these three image blending operations can be found in Chapter 7, "Image Blending."

4.4.2 Performing the Despill

Once a good matte has been extracted, we can turn our attention to the despill operation. Any compositing program worth its pixels has a separate despill operation that can be applied to the bluescreen. There is a selection for either the blue or green screen, plus some settings that can be adjusted for the best effect. Figure 4-26 illustrates how greenscreens and bluescreens appear after they have been despilled. Your results may vary.

Greenscreen Despilled greenscreen Bluescreen Despilled bluescreen

Figure 4-26 Despilled greenscreen and bluescreen.

The despill adjustments should be made while looking at the final composite because the despill must be judged in context of the composite, not simply the appearance of the despilled bluescreen. Compare the finished composite with the original bluescreen to check for hue shifts, the main artifact of the despill. You will likely see some. Do not despair, for these shifts may not be problematic. You don't have to fix a hue shift just because it is there; you only have to fix it if it is a problem. Be sure to point it out to the client. You don't want the client suddenly noticing a problem just as the job is finished.

Should you be cursed with a compositing program that does not have a dedicated despill operation, there are two fallback positions: One is to create your own despill operation from discrete operations, a description that is outside the scope of an introductory book such as this one; and the other fallback position is to use hue curves. Hue curves are a color correction operation that uses a curve to adjust the hues of an image within a selected range and are a common feature of virtually all compositing programs. By lowering the curve over the hue that represents the backing region (blue or green), the despill can be minimized. Note that this is not an ideal solution. The hue curve is altering every pixel that the curve affects, whether it is a despill pixel or not. A dedicated despill operation is much more selective and only goes after pixels that are contaminated with spill. Mostly.

4.4.3 Color Correcting

Again, following the sequence of operations from the flowgraph of Figure 4-22, the despilled version of the bluescreen can now be color corrected. The main objective is to color correct the despilled foreground so that it blends naturally with the background. This is a high art, so there is an entire chapter devoted to it—Chapter 9, The Art of Compositing.

However, we do need to talk about the background for a minute. What should be done depends on the situation. If the shot stands alone and is not one of several similar shots, then the background should most likely not be color corrected. The reason is because there will be an overall color correction of the finished project (such as a movie, television show, commercial, and so forth) by a colorist down the road, and you do not want to second-guess that work. The composited elements should blend as naturally as possible with the background and then the colorist can give it a final look. An exception would be if the background plate were obviously out of whack. In this case, a conservative color correction to make it appear "normal" may be appropriate. Be sure to check with the client lest you inadvertently turn a night shot into a day shot.

However, if the background is part of a sequence of similar shots, a different approach is usually used. All of the background plates will normally be "color graded" first so that they match each other, then the compositing is done over the color-graded versions. If this color-grading step is not done, then each of the background plates can have very different exposures—one too dark, one too bright, one too warm, and so on. These variations in the background plates will require

variations in color correcting the foreground element to match, which is not good. When the finished shots go to the colorist, small mismatches between the foreground and background can become exaggerated and suddenly a crisis erupts. Again, the color grading operation of the background plates is simply intended to "even them up" to give them a more uniform look. It is not intended to give them the final color correction. That is the colorist's job.

4.4.4 The Composite

We now have all the pieces we need for a composite outside of the keyer: A fine matte, a color corrected foreground, and a color corrected (or not) background. The last step is to give all three elements to the compositing operation and let it do its thing. Note that this compositing operation will be different than the one used for compositing CGI. That one expected two inputs, a four-channel image that has already been premultiplied by its alpha, plus a background. You need the compositing operation that expects three inputs: A foreground (our prepped bluescreen), a matte, and a background. This type of compositing operation uses the matte to scale the foreground (perform the premultiply operation in CGI-speak), invert it and scale the background, then sum the layers together.

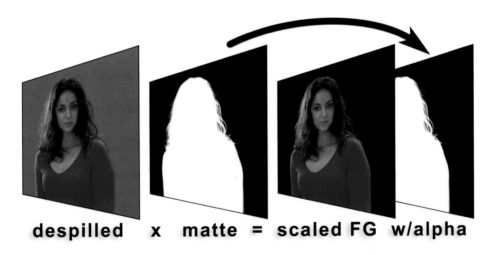

despilled x matte = scaled FG w/alpha

Figure 4-27 Creating a four-channel premultiplied bluescreen layer.

Should you be unable to find a compositing operation that takes the three inputs, not all is lost. You can turn the bluescreen layer into a four-channel premultiplied image just like CGI, then use the same compositing operation that is used for CGI. Figure 4-27 illustrates the way to do this. The first step is to multiply the despilled and color corrected foreground by the matte, creating the scaled, or "premultiplied"

foreground. Then simply copy the matte into the alpha channel of the scaled foreground as indicated by the arrow. You now have a four-channel premultiplied image that the compositing operation thinks is CGI and it will cheerfully composite it for you.

4.5 SHOOTING BLUESCREENS (AND GREENSCREENS)

The starting point of a good bluescreen composite is a good bluescreen plate. While it is true that modern digital compositors can perform cinematic miracles and create beautiful visual effects shots from tawdry elements, it is also true that the better the bluescreen, the better the composite. So let's take a look at what is needed on the set to shoot quality bluescreens for today's visual effects pipeline. While the discussion cites bluescreens, the issues apply equally as well to greenscreens. Where there are differences they are noted.

The entire point in shooting a good bluescreen is to get a good composite in post. Fussing over the lighting of the flesh tones at the expense of good lighting of the bluescreen is a very poor trade. With modern digital compositing tools and heroic rescue efforts, even a poorly shot greenscreen can be made into a good composite, but it will take more time (schedule) and more money (budget), and the results will still not be as good as with a well-shot bluescreen. The flesh tones can always be restored during compositing with color correction. The photographic objective for the backing region (whether red, green or blue) is purity of color (saturation), sufficient brightness, and uniformity so that the digital keyer can pull a good key.

4.5.1 Lighting the Backing

- The number one issue is uniformity of lighting—within 1/2 stop of uniformity all over.
- The number two issue is purity of the backing color. The photographed backing must be as close to 100% of its primary color with 0% of the other two colors as is technically possible. Of course, this is not technically possible, but as close as possible.
- The brightness level should be 1 to 1.5 stops under the key light. Two bad things happen with too much light on the backing. The backing loses purity (saturation) and it throws more spill onto the talent.
- The careful, uniform lighting is only needed in the area where the talent appears, but if they don't go near an edge then don't worry about the lighting there. It can easily be garbage matted in post.
- Tungsten lights on a properly colored backing can produce very good results. Expensive colored lights are not a requirement.
- Blue or green colored gels on the lights improve the purity of the backing color, but can be dangerous. They lower the light levels of the light source and if they shine on the talent, they add to the spill problems. Use with caution.

- Similarly, blue or green colored lights improve the purity of the backing color, but can be dangerous. If they shine on the talent, then they also add to the spill problems.
- Don't use dimmers as they shift the color temperature of the lights toward red, which reduces the purity of the backing color.

4.5.2 Lighting the Talent

- Light the talent for the intended background they are to be composited into—a dark interior, sunny outdoors, high contrast, and so forth. The talent lighting is independent of the backing lighting.
- To set up the lighting for the talent, turn off the backing lighting. After the lighting is set up for the talent, turn the backing lights back on and re-meter.
- Keep the talent 8 to 10 feet from the backing; the closer they get to the backing the more spill light will land on them.
- Ensure the talent lighting does not hit the backing.
- Watch out for reflective objects on the talent such as rings, belt buckles, and so on. They will reflect the backing color and make that part of the key transparent, which will punch a hole in the talent.
- Never counter-light the edges of the talent with a complementary color of the backing (yellow for bluescreen and magenta for greenscreen) as an on-set spill suppression technique. This was useful in the old days when video chroma-key was the only keying technology. Today's digital keyers routinely cope very well with spill; however, they become flummoxed if you try to help them with edge lighting.
- If a cove (cyclorama) is used, then the talent will have to be lit with the same lights as the backing. Since the backing must be lit evenly, this means that the talent will also be lit bright and flat.

4.5.3 The Backing Material

- The backing may be made by painting a wall with special paint or by the use of a specially colored fabric.
- If paint is used, it needs to be a specialty paint made for keying, not just some blue or green paint from the hardware store. More than one coat will probably be necessary to get uniform coverage. It needs to be a "flat" paint (not shiny), and watch out for glare spots.
- You can use paint from the hardware store if you do it right. Pick up some paint chips and photograph them with the same camera and lights to be used for the shoot. Give the digitized frames to the compositor to pull test keys on the various chips to find the best paint color to use.
- If fabric is used, it needs to be a specialty fabric made for keying, not just any blue or green fabric. It should not have any wrinkles, seams, or folds and if several panels must be used, then they must be the same color and joined with matching colored tape.

- The backing need not fill the frame; just cover the talent from the camera as it can be easily fixed in post with a garbage matte. Ensure that the talent does not go off the backing, of course, or you will endure some extra costs for rotoscoping.

4.5.4 Bluescreen vs. Greenscreen

- The choice of backing color may be dictated by the colors in the objects being filmed. If the foreground objects have a lot of green, then you should use bluescreen, and if the foreground objects have a lot of blue, then you should use greenscreen.
- It is not true that a digital keyer "prefers" blue or green as they work equally well on equally well-shot plates.
- Skin tones work equally well with green or blue backings when using modern digital keyers.
- Green is easier to light brightly than blue, which requires less lighting on the set.
- Bluescreens lit by natural sunlight work well too. Throw up a large diffusion silk to kill shadows if needed, or schedule an overcast sky for the day of the shoot.
- Blue spill is less of a problem than green spill because of its less offensive hue and its lower intensity. However, digital keyers have excellent despill tools that normally render this point moot.
- The blue channels of both film and video by far have the most noise, so a bluescreen produces mattes with the noisiest matte edges.
- The green channels of both film and video have low noise content, so it produces the smoothest matte edges. This is one very compelling reason to shoot greenscreen, with all else being equal.

4.5.5 Bluescreen Floors

- Bluescreen floors are often necessary to key the talent all the way to their feet, but it introduces two problems:

 1) A great deal of blue light will bounce from the floor up onto the talent causing keying problems for the digital keyer.
 2) Walking on the paint will scuff and discolor the floor making the key more difficult to pull in post. Care must be taken on the set to ensure the floor is as clean as possible.

- A reflective mirror (such as Mylar) on the floor that reflects the backing will create a blue floor without any "up-spill" onto the talent. However, the price is that the talent's reflection will have to be removed by roto in post.

4.5.6 Film Issues

- The finest grain film stock possible should be used. Grain becomes exaggerated in the keying process and can introduce noise problems in the matte edges or in the despilled regions.
- Kodak's SFX 200 film stock is made specifically for bluescreen and greenscreen photography and produces superior results; however, it's expensive.
- 16 mm film is not pin-registered and has gate weave that is bad for compositing, as the layer will drift around when composited. However, this can be solved in post using an image-stabilizing

program. In addition, 16 mm film has a much larger grain structure than 35 mm film, which can create mattes with noisy edges.

4.5.7 Video Issues

- Film is a highly consistent medium, but there are many types, flavors, and formats of video encompassing an astounding range of quality from excellent to "don't bother." It is essential to know the characteristics of the camera before shooting bluescreens with video as there are many video cameras that cannot shoot a good bluescreen.
- Video cameras all have an "edge enhancement" feature to artificially sharpen the picture. This introduces edge artifacts that flummox the keyer. Turn off all edge-enhancement features in the camera.
- Do not shoot bluescreens with a DVcam. They both have low sampling in chrominance (the very basis of a good key), plus they compress the video data unmercifully, which introduces compression artifacts that further enrage the keyer. Chapter 11 explains these issues in detail.
- Shoot greenscreens with 4:2:2 or 4:4:4 video cameras with as little compression as possible, preferably none. Again, see Chapter 11.

4.5.8 Photography Tips

- Shooting a clean plate of the backing screen considerably boosts the keyer's ability to pull a good matte. If the camera is moving this is not practical; however, if the camera is locked off or it is a motion control shot, then it should be done.
- For motion tracking shots, make sure that there are at least three tracking markers in frame at all times, preferably more. Watch out for the talent covering up the markers.
- Tracking Markers:

 1) Make tracking markers shaped like a "+" (plus sign). This provides a strong vertical and horizontal edge for the motion tracker to lock onto.
 2) Don't let them get too small in frame. You should still be able to discern their shape in the final photography, rather than just a tiny blob. There is not much you can do if they become out of focus due to depth of field.
 3) Their color is not important, as the markers will most likely be painted out anyway. If they are to be keyed out, then make them either green or blue, whichever is not the backing color.

Creating Masks

Creating a mask is a core competency for any compositor. There is a constant need to isolate an object out of the frame for some kind of special treatment such as color correction, blurring, regraining, and many others. The challenge is that the object of interest has not been neatly shot on a bluescreen for easy isolation. It is an arbitrary object within an arbitrary background. This process is distinctly different from creating a matte for a bluescreen composite where a keyer creates the matte and the purpose is to composite two layers. A mask is created in any number of ways, by hook or by crook, without using a keyer. Because the target object and its background are arbitrary, this is an especially challenging part of digital compositing. To meet this challenge, the digital compositor must have a wide array of techniques at their disposal to take advantage of any unique aspect of the background or target object to isolate it.

5.1 KEY, MATTE, ALPHA, AND MASK

Before we get too deep into the magic of creating a mask, let us first take a moment to deconflict our nomenclature. As the title for this section implies, there are many terms used in the industry such as key, matte, mask, and alpha. So which is which? The truth is, they are basically all the same. They are all a one-channel black and white image that tells the computer to do one thing in the white parts and something else in the black parts. The reason for the different names is that many different industries developed this same solution, but each gave it their own name.

Having said all that, custom has generally assigned the different names based on either how they were created or what they are used for, a tradition we will try to honor. Following is a definition of each term as used in this book and its etymology (historical source).

- Key—Used interchangeably with "matte." It is used in a composite to demark which pixels are to be used from the foreground layer, and which pixels are to be used from the background layer. The historical source is the video industry

that developed luma-keys and chroma-keys for compositing, but also to isolate color correction operations.

- Matte—Used interchangeably with "key." It is used in a composite to demark which pixels are to be used from the foreground layer, and which pixels are to be used from the background layer. The historical source is the film industry that used mattes with optical printers and in-camera composite shots.
- Alpha—Used in a composite to demark which pixels are to be used from the foreground layer, and which pixels are to be used from the background layer. The historical source is the 3D world of CGI, where the computer automatically renders a matte for the CGI object and places it in the fourth channel of the image, which was named the "alpha" channel by CGI folk.
- Mask—Used to limit or "mask off" an image processing operation such as color correction, a blur, or a regrain to a specific region of the picture. The historical source is probably Adobe Photoshop, which popularized the term for masking off regions of the picture to isolate them for special treatment.

What key, matte, and alpha all have in common is that they are the "matte" for a composite. Their difference is that keys and mattes are created by the compositor, while the alpha is automatically rendered by the CGI computer. Their method of creation may differ, but their use is the same.

The mask is the one odd man out. It is used to limit an image processing operation and can be created by the compositor in any number of ways. It might be a hand-drawn shape, a luma-key, or an imported image. However, one could always use the alpha channel to mask off an area of the screen, or a mask may be drawn by hand, and then used as the matte in a composite. Just when you thought it was getting clear! Anyway, let us take a look at a variety of methods of creating masks for isolating objects of interest.

5.2 CREATING A LUMA-KEY

A luma-key is a key that is created from the luminance or brightness part of a picture. Once the key has been created, it can be used for a variety of purposes, but a very common use is to mask off a region of a picture for color correction. A main virtue of a luma-key is that it can work on moving footage. Meaning, once you get a good luma-key set up, it will usually generate a key for every frame of the shot—unless the target object changes its luminance over the length of the shot, or another object of equal luminance enters the frame, or the lighting changes. A good luma-keyer will allow its settings to animate over the length of a shot, which will help with this problem of continuously pulling a key on a target with changing luminance.

Figure 5-1 Original picture. **Figure 5-2** Luma-key. **Figure 5-3** Yellow lamps.

Figure 5-1 shows a pair of lamps that we want to change the color from white to yellow. The lamps will have to be isolated so that the color correction operation does not affect the entire picture. The first step is to "pull" (create) a luma-key from the original picture. The luma-keyer has settings for the upper and lower limits of the luminance, or brightness values in the original image that are to be isolated. A good luma-keyer will also have additional settings for the softness of the edges of the key. The luma-keyer settings are adjusted until the lamps turn white and the rest of the key turns black, like the example in Figure 5-2. The color correction operation then uses the luma-key as a mask to isolate the yellow color correction only to affect the lamps. Figure 5-3 shows the resulting color corrected plate with yellow lamps.

The key point about the luma-key is that it is created from the luminance, or brightness part of the picture. Therefore, if the target object is the brightest part of the picture, as in this example, it can work very nicely. If it is the darkest part of the picture, it can also work very well. However, if it is a middle gray, then there will be other parts of the picture that share the same brightness values and the luma-key may not work so well at all. If other objects show up in the luma-key, the target object can often be isolated further by using a simple garbage matte.

Figure 5-4 Luma-key. **Figure 5-5** Garbage matte. **Figure 5-6** Multiplied.

The use of a garbage matte to isolate the target object of a luma-key is shown starting with Figure 5-4. The raw manta ray luma-key has some unwanted contamination from the water's surface surrounding the manta ray. The garbage matte in Figure 5-5 was quickly drawn using a simple shape, and then multiplied by the manta ray luma-key. The results of the multiply operation are shown in Figure 5-6. The zero black parts of the garbage matte cleared out the contamination, while retaining the original manta ray luma-key. This type of operation is done all the time when creating keys and mattes. When two mattes are multiplied like this only the pixels that are white in both survive the multiply operation.

5.3 CREATING A CHROMA-KEY

A chroma-key is a key that has been created from the color, or (in video-speak) the chrominance part of a picture. In truth, the chroma-key is made by selecting all three aspects of the image simultaneously; that is the hue (color), saturation, and brightness, where the luma-key only works with the brightness. Because the chroma-key considers three aspects of the image instead of just one, it is more selective than the luma-key at isolating parts of the picture.

Once the key is made, it can be used for a variety of purposes with the most common being to isolate a region of the picture for color correction. Like the luma-key, the chroma-key is often good over the length of a shot, unless the target's color changes, or a similar colored object enters frame, or the lighting changes. By animating its settings, the chroma-keyer can often be coaxed into delivering a good key despite a changing target, and a garbage matte can be added to exclude undesirable objects caught in the same key.

Figure 5-7 Original picture. **Figure 5-8** Chroma-key. **Figure 5-9** Blue puppet theatre.

Figure 5-7 shows a very red children's puppet theatre that an impulsive art director suddenly wanted changed to blue. Since the target red is a unique color in the picture, a chroma-key is a good choice for isolating it. The original picture

is processed through a chroma-keyer to produce the chroma-key as seen in Figure 5-8. The chroma-key operator has settings for selecting the narrow range of color, saturation, and brightness that make up the red parts of the theatre and exclude the other parts of the picture. Then, the chroma-key is used as a mask by the color correcting operation so it only turns the selected parts of the picture blue.

While all of this sounds fine, things are not completely copasetic. Note the little puppet laying face down on the center of the stage. The chroma-keyer saw its red costume as the same range of red as the theatre and promptly included it in the key so it is now colored blue too. Also, the edges of a chroma-key are often not very nice, and if there is a shadow over part of the target the chroma-keyer can get confused. Multiple chroma-keys must sometimes be combined to cover the target object. However, regardless of its shortcomings, the chroma-key is a staple of the digital compositing business and an essential tool for pulling a key to mask off operations.

5.4 CREATING A MASK

In the previous sections, we saw how a luma-key or a chroma-key is often generated to be used as a mask for isolating an operation such as color correction. However, many times the target object will not succumb gracefully to a luma-key or chroma-key, and then other more radical techniques have to be used. The challenge is to isolate a random object out of a random picture. The solution is to create a mask. The question is, which method to use?

The methods for creating a mask are divided into two basic types: Procedural and manual. A procedural method is one that gives the computer a rule or procedure to follow to create the mask and the luma-key is a good example. The manual method is to literally draw the mask by hand. Drawing a mask by hand may be done in two different ways; one uses splines and control points to define the outer edges of the mask, and the other is to literally paint the mask. Following are several alternative methods for creating a mask with their strengths and weaknesses.

5.4.1 The Difference Mask

The difference mask is one of the truly magical things that only a computer can do. It is also one of those things that sounds a lot better than it really is. Here's the concept: There is a target object you would like to isolate with a mask, such as the boy in Figure 5-10. You start with a clean plate, which is the same picture without the target object (Figure 5-11) and task the computer with finding the difference between the two pictures, which is obviously the boy, and voila! You have a difference mask.

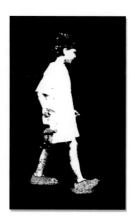

Figure 5-10 Target object.

Figure 5-11 Clean plate.

Figure 5-12 Raw difference mask.

Figure 5-13 Final difference mask.

Back in the real world, there are many problems with this idea that are nicely illustrated by the raw difference mask in Figure 5-12. This is the raw image produced by the computer when asked to take the difference between the two images. Ideally, we would have a clean white mask where the boy is with a clean black surround, but this is clearly not the case.

There are two basic problems. The first is that the boy's mask is not a solid white everywhere. This is because the difference between the boy's pixels and the clean plate's pixels is very small, resulting in dark pixels in the mask. This is especially noticeable in the hair, which is dark, and the same region of the clean plate, which is also dark. Therefore, the computer found very little difference between the target and clean plates in that area. The second problem is that the black surrounding the mask is not very black. This is because of small differences between the target and the clean plates in the areas outside the boy that you would expect were identical. These differences are introduced by anything that changes between the two plates—the wind blew the plants, the boy's shadow on the ground, the bounce light from the boy's shirt onto the rocks, the camera moved a bit, a light source shifted, the grain, space quarks—you get the picture.

The final difference mask in Figure 5-13 simply increases the contrast of the raw difference mask to firm up the white areas and clear out the black areas. Unfortunately, it also exaggerates the flaws in the raw difference mask and we end up with virtually no mask for the hair and lantern, semi-transparent feet, and chewed edges on the legs and under the chin. This is rather typical for a difference mask.

Sometimes you may get lucky and the target object will be very different than the clean plate and the surround regions will match perfectly (except for grain). Under those idyllic circumstances, you will get a decent difference mask. However, even under those idyllic conditions, the matte edges will be harsh and some blurring and smoothing will be required in order to be useful. Another difficulty is that over

the length of the shot, the target can move over different areas of the background so different parts of the mask disintegrate from frame to frame. Like I said, it sounds better than it is.

5.4.2 The Color Difference Mask

The color difference mask is a simple but powerful method for creating a mask for an object in a picture and is one of my personal favorites. In fact, very sophisticated and nuanced variations on this basic method are the basis for most of the keyers that are used to pull mattes for bluescreens and greenscreens such as those we saw in Chapter 4. The main virtues of this technique are that it is very simple and easy to try and it is useful in a great variety of situations. The basic idea is very simple. Simply subtract one color channel of an image from another and something pops out of the picture as a mask. What pops out depends on the colors in the picture and which channel is subtracted from which.

Figure 5-14 Source image. **Figure 5-15** Red minus green. **Figure 5-16** Green minus blue. **Figure 5-17** Blue minus green.

Consider the source image in Figure 5-14, cleverly chosen for its colorful and varied content. By simply subtracting the green channel from the red channel (red minus green), the mask in Figure 5-15 was created. Subtracting the blue channel from the green channel (green minus blue) produced the mask in Figure 5-16, which isolated the yellow star. By subtracting the green channel from the blue channel (blue minus green), a mask for the blue curtains was created and is shown in Figure 5-17.

One of the great virtues of the color difference mask is that it usually has good edge quality—not too hard or jaggy. Another virtue of the color difference mask is its ability to survive variations in the lighting over the length of the shot. As we saw with the luma-key and chroma-key, if the appearance of the target changes at all, the key can quickly break down. However, the color difference key is remarkably tolerant to changes in appearance. If a shadow moves over a red object, its luminance is seriously altered, but the red minus green color difference will only be slightly affected. The color difference mask; try it—you'll like it.

5.4.3 Geometric Primitives

A geometric primitive is simply a basic geometric shape such as a circle or a square. However, if we just use the words circle or square, we will not keep the client impressed with our esoteric terminology, which would be bad. Maintaining the priesthood is every compositor's responsibility. All compositing systems can make a geometric primitive, and circles can be squeezed into ovals and squares can be squeezed into rectangles. Unfortunately, very few objects in the universe are perfect circles or squares, so the geometric primitive has limited uses. Add the likelihood of the target object moving during the shot and its prospects grow dimmer.

Figure 5-18 Original image.

Figure 5-19 Geometric primitive.

Figure 5-20 Enhanced hero.

Beyond masking geometrically perfect objects like the moon or a building shot with a perfect lens, geometric primitives can also be used to good effect for color correcting. In fact, geometric primitives with big soft edges are the "power windows" used all over the digital intermediate color timing process of a feature film. Note the client-dazzling terminology—POWER WINDOWS! Much more impressive than "big fuzzy circle." Good marketing here.

Returning to our story, consider the dark interior shot in Figure 5-18. Although our hero is appropriately centered in the frame, he is somewhat lost in the dim lighting. With the aid of the geometric primitive mask—excuse me, POWER WINDOW!—in Figure 5-19, the center of the frame in Figure 5-20 has been brightened up dramatically, which has enhanced the presence of our hero. For moving targets or a moving camera, the geometric primitive has to be keyframed over the length of the shot to stay on target. The good news is that this is normally easy to do because the big fuzzy shape is very forgiving of minor misalignment, so only a few keyframes over the length of the shot are usually required.

5.4.4 Drawing Shapes

When all else fails, the time-honored tradition is to just draw the darn mask yourself using what is often called a *shape*. All modern compositing programs have tools for doing this in one form or another. The upside is that it unambiguously isolates the item of interest regardless of how similar it is to other parts of the picture. The downside is that if the target has a complex outline (a tree, for example), the task

can take the better part of a lifetime. Another downside is that if the target moves from frame to frame, which things tend to do in movies and commercials, you have to draw a new shape every few frames. You have now entered the realm of rotoscoping, which is a large subject in its own right covered in exquisite detail in Chapter 6, so it is not covered here. However, we can explore the key points of drawing a shape to be used as a mask.

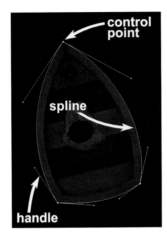

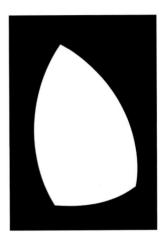

Figure 5-21 Target object. **Figure 5-22** Spline-based shape. **Figure 5-23** Resulting mask.

Drawing a shape is done with splines, which are mathematical lines that can be straight or bent into graceful curves, like a stiff piano wire. Let's say we want to draw a shape around the boat in Figure 5-21. Three control points are clicked over the picture, dropping one at each corner of the boat (see Figure 5-22), and then the control point "handles" are pulled out and adjusted for angle and tension (stiffness). As the artist adjusts the control points, the spline lines can be bent around the boat edges exactly matching their curvature. The resulting mask is then rendered by the computer, as shown in Figure 5-23.

While the shape for a simple object such as this boat will only take half a minute to draw, you can see how a complex object would take a great deal longer. Shapes with their splines are appropriate for objects of limited complexity, such as the human form or man-made objects like boats and buildings. If the object has smooth mechanical edges like a car or the boat, then the spline is an ideal method of creating a matching smooth curve.

If the object is static and unmoving, then we are done. But what if it moves? If the object does not change shape over the length of the shot and only moves slowly, it might be possible to track the original shape to move with the object over the length of the shot. Otherwise, it's over to Chapter 6 and rotoscoping.

5.4.5 Painting a Mask

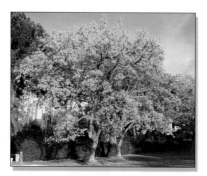

Figure 5-24 Hopelessly complex target.

Sometimes you will encounter a situation such as Figure 5-24, where drawing a shape is hopelessly complex. The mission here is to create a mask for the pink tree, but there are so many fiddly little details around all the leaves and small branches that pulling the control points of thousands of splines would be a hopeless task. Perhaps the parts of the tree that overlap the sky could be used to create a luma-key, but that would only take care of a portion of the problem. The picture will have to be loaded into a paint program and the mask painted by hand.

If the wind is blowing and the tree is moving over the length of the shot, then the paint solution encounters two serious new problems. The first is the enormous number of man-hours required to hand paint such a complex mask frame by frame. The other is the difficulty in maintaining "temporal coherency," where the mask moves smoothly from frame-to-frame like the blowing tree without chattering or twitching. While there are digital paint artists out there with the skill and patience to pull it off, there are darn few clients out there with the budget to pay for it.

There are paint systems that support keyframe animation, which are called *procedural paint systems*. Following along with Figure 5-25, the top row shows five frames of a thick red paint line. Only the first and last frames are actually painted, keyframe 1 and keyframe 2. The three frames in between were interpolated by the computer. The bottom row in Figure 5-25 shows how it was done. The operator's paint stroke actually "painted" a spline with control points that are hidden from view, and then the spline is "stroked" with the thick red line by the computer. When the splines are visible like this, the operator can go in and touch up the control points to keep the paint line right on target. With some systems, motion trackers can be

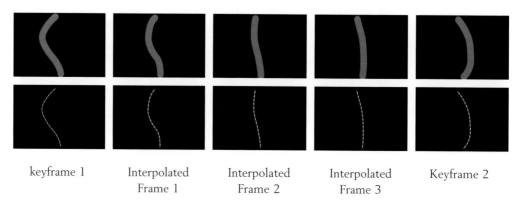

| keyframe 1 | Interpolated Frame 1 | Interpolated Frame 2 | Interpolated Frame 3 | Keyframe 2 |

Figure 5-25 Procedural paint strokes.

connected to the spline control points so that the brush stroke actually tracks a moving object across the frame.

5.4.6 Combo Masks

Very often, the effort to create a mask with one method will be met with only partial success. The solution is to create several masks and combine them as we saw for compositing mattes in Chapter 4. Divide and conquer. For example, a luma-key might create a good mask for most of the target, but still leave a hole. Perhaps a color difference mask could also be created and combined with the luma-key to fill in part of the hole. The last bit may be filled in by drawing a shape. Perhaps you are drawing a shape over an object but there are portions of it that are too complex for the splines. Spline what you can, and then paint the rest.

These combination techniques are also important for Adobe Photoshop artists. Many artists will just start painting a mask without first trying to pull a luma-key or chroma-key. Often the computer can be made to do most of the work by first pulling a key, then the artist just paints the parts the computer can't do. Key what you can, and then paint the rest.

6 Rotoscoping

Rotoscoping is the process of drawing a matte frame-by-frame over live action footage. Starting around the year 50 B.C. (Before Computers), the technique back then was to rear project a frame of film onto a sheet of frosted glass, then trace around the target object. The process got its name from the machine that was used to do the work, called a *rotoscope*. Things have improved somewhat since then, and today we use computers to draw shapes using the splines we saw in Chapter 5. The difference between drawing a single shape and rotoscoping is the addition of animation. Rotoscoping entails drawing a series of shapes that follow the target object through a sequence of frames.

Rotoscoping is extremely pervasive in the world of digital compositing and is used in many visual effects shots. It is also labor intensive because it can take a great deal of time to carefully draw moving shapes around a moving target frame by frame. It is often an entry-level position in the trade and many a digital compositor has started out as a roto artist. There are some artists who find rotoscoping rewarding and elect to become roto kings (or queens) in their own right. A talented roto artist is always a valued member of the visual effects team.

In this chapter, we will see how rotoscoping works and develop an understanding of the entire process. We will see how the spline-based shapes are controlled frame-by-frame to create outlines that exactly match the edges of the target object, as well as how shapes can be grouped into hierarchies to improve productivity and the quality of the animation. The sections on interpolation and keyframing describe how to get the computer to do more of the work for you, and then finally the solutions to the classic problems of motion blur and semi-transparency are revealed.

6.1 ABOUT ROTOSCOPING

Today, rotoscoping means drawing an animated spline-based shape over a series of digitized film (or video) frames. The computer then renders the shape frame-by-frame as a black and white matte, which is used for compositing or to isolate the target object for some special treatment such as color correction.

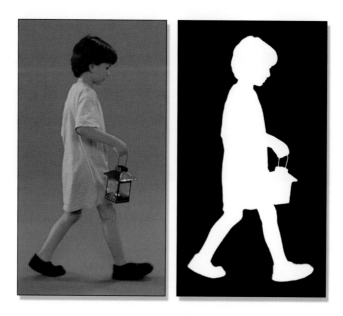

Figure 6-1 Frame 1 with roto.

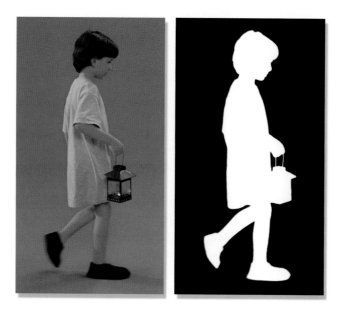

Figure 6-2 Frame 2 with roto.

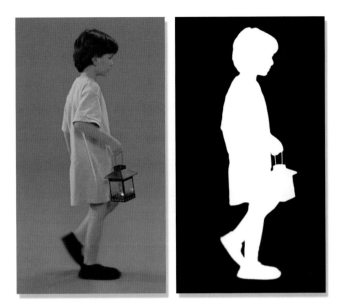

Figure 6-3 Frame 3 with roto.

Figure 6-1 through Figure 6-3 illustrates three frames out of a moving sequence for a greenscreen shot that was rotoscoped. Not only does the target object (the boy) move, but he also changes shape as his feet move, his hand and lantern swing, and his head bobs while he walks. What makes it a "roto" (rotoscope) is that the outline of the shape needs to change every frame, so it must be animated.

Figure 6-4 Original background. **Figure 6-5** Roto matte. **Figure 6-6** New background. **Figure 6-7** Composited.

The virtue of roto is that it can be used to create a matte for any arbitrary object on any arbitrary background. It does not need to be shot on a bluescreen. In fact, roto is the last line of defense for poorly shot bluescreens in which a good matte cannot be created with a keyer. Compositing a character that was shot on an "uncontrolled" background is illustrated beginning with Figure 6-4. The bonny lass was shot

on location with the original background. A roto was drawn (Figure 6-5) and used to composite the woman over a completely new background (Figure 6-7). No blue-screen was required.

There are three main downsides to roto. First, it is labor intensive. It can take hours to roto a simple shot such as the one illustrated in Figure 6-4, even assuming it is a short shot. More complex rotos and longer shots can take days, even weeks. This is hard on both schedules and budgets. The second downside to roto is that it can be difficult to get a high quality, convincing matte with a stable outline. If the roto artist is not careful, the edges of the roto can wobble in and out in a most unnatural, eye-catching way. The third issue is that rotos do not capture the subtle edge and transparency nuances that a well-done bluescreen shot does using a fine digital keyer. If the target object has a lot of very fine edge detail like a frizzy head of hair, the task can be downright hopeless.

6.2 SPLINES

In Chapter 5, we first met the spline during the discussion of shapes. We saw how a spline was a series of curved lines connected by control points that could be used to adjust the curvature of those lines. We also used the metaphor of a piano wire to describe the stiffness and smooth curvature of the spline. Here we will take a closer look at those splines and how they are used to create outlines that can fit any curved surface. We will also push the piano wire metaphor to the breaking point.

A spline is a mathematically generated line in which the shape is controlled by adjustable control points. While there are a variety of mathematical equations that have been devised that will draw slightly different kinds of splines, they all work in the same general way. Figure 6-8 reviews the key components of a spline that we saw in Chapter 5, which consisted of the control point, the resulting spline line, and the handles that are used to adjust its shape. In Figure 6-8, the slope of the spline at the control point is being adjusted by changing the slope of the handles from position 1 to position 2 to position 3. For clarity, each of the three spline slopes is shown in a different color.

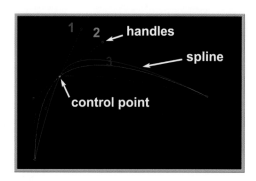

Figure 6-8 Adjusting slope.

Figure 6-9 Adjusting tension.

The handles can also adjust a second attribute of the spline called *tension*, which is shown in Figure 6-9. As the handles are shortened from position 1 to 2 to 3, the "piano wire" loses stiffness and bends more sharply around the control point. A third attribute of a spline is the angle where the two line segments meet at the control point. The angle can be an exact 180 degrees, or flat, as shown in Figure 6-8 and Figure 6-9, which makes it a continuous line. However, a "break" in the line can be introduced like that in Figure 6-10, putting a kink in our piano wire.

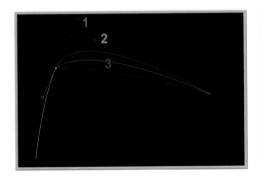

Figure 6-10 Adjusting angle.

Figure 6-11 Translation.

In addition to adjusting the slope, tension, and angle at each control point, the entire shape can be picked up and moved as a unit. It can be translated (moved, scaled, and rotated), taking all the control points with it. This is very useful if the target has moved in the frame, such as with a camera pan, but has not actually changed shape. Of course, in the real world it will have both moved and changed shape, so after the spline is translated to the new position, it will also have to be adjusted to the new shape.

Figure 6-12 Mr. Tibbs.

Figure 6-13 Roto spline.

Figure 6-14 Finished roto.

Now let's pull together all that we have learned about splines and how to adjust them to see how the process works over an actual picture. Our target will be the insufferable Mr. Tibbs, as shown in Figure 6-12, which provides a moving target that also changes shape frame-by-frame. Figure 6-13 shows the completed shape composed of splines with the many control points adjusted for slope, tension, and angle. The finished roto is shown in Figure 6-14.

Figure 6-15 Too many control points. **Figure 6-16** Fewest possible control points.

One very important guideline when drawing a shape around a target object is to use as few control points as possible that will maintain the curvatures you need. This is illustrated by the shape used to roto the dapper hat in Figure 6-15, which uses an excessive number of control points. The additional points increase the amount of time it takes to create each keyframe because there are more points to adjust each frame. They also increase the chances of introducing chatter or wobble to the edges. Figure 6-16 shows the same shape for the hat using about half as many points. Always use the minimum number of control points possible.

6.3 ARTICULATED ROTOS

Things can get messy when rotoscoping a complex moving object such as a person walking. Trying to encompass an entire character with crossing legs and swinging arms into a single shape like the one used for the cat in Figure 6-13 quickly becomes unmanageable. A better strategy is to break the roto into several separate shapes, which can then be moved and reshaped independently. Many compositing programs also allow these separate shapes to be linked into hierarchical groups where one shape is the "child" of another. When the parent shape is moved, the child shape moves with it. This creates a "skeleton" with moveable joints and segments rather like the target object. This is more efficient than dragging every single control point individually to redefine the outline of the target. When the roto is a collection of jointed shapes like this, it is referred to as an *articulated roto*.

 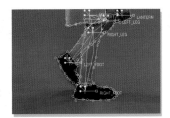

Figure 6-17 Frame 1. **Figure 6-18** Frame 2. **Figure 6-19** Frame 3.

Figure 6-17 through Figure 6-19 illustrates a classic hierarchical setup. The shirt and lantern are separate shapes. The left and right leg shapes are "children" of the shirt, so they move when the shirt is moved. The left and right feet are children of their respective legs. The light blue lines inside the shapes show the "skeleton" of the hierarchy.

To create frame 2 (Figure 6-18), the shirt was shifted a bit, which took both of the legs and feet with it. The leg shapes were then rotated at the knee to reposition them back over the legs, and then the individual control points were touched up to complete the fit. Similarly, each foot was rotated to its new position and the control points touched up. As a result, frame 2 was made in a fraction of the time it took to create frame 1. Frame 3 was similarly created from frame 2 by shifting and rotating the parent shape, followed by repositioning the child shapes, then touching up control points only where needed. This workflow essentially allows much of the work invested in the previous frame to be recycled into the next with just minor modifications.

There is a second, less obvious advantage to the hierarchical animation of shapes, and that is it results in a smoother and more realistic motion in the finished roto. If each and every control point is manually adjusted, small variations become unavoidable from frame to frame. After all, we are only human. When the animation is played at speed, the spline edges will invariably "wobulate" (wobble and fluctuate). By translating (moving) the entire shape as a unit, the spline edges have a much smoother and more uniform motion from frame to frame.

6.4 INTERPOLATION

Time to talk temporal. Temporal, of course, refers to time. Since rotos are a frame-by-frame animation, time and timing are very important. One of the breakthroughs that computers brought to rotoscoping, as we have seen, is the use of splines to define a shape. How infinitely finer to adjust a few control points to create a smooth line that contours perfectly around a curved edge, rather than to draw it by hand with a pencil or ink pen. The second, even bigger breakthrough is the ability of the computer to interpolate the shapes, where the shape is only defined on selected keyframes, and then the computer calculates the in-between (interpolated) shapes for you.

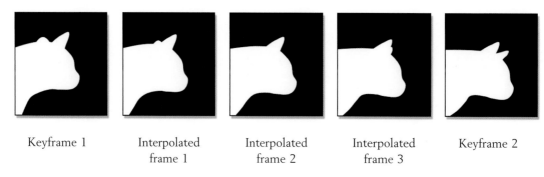

| Keyframe 1 | Interpolated frame 1 | Interpolated frame 2 | Interpolated frame 3 | Keyframe 2 |

Figure 6-20 Keyframes with interpolated frames.

A neat example of keyframe interpolation is illustrated in Figure 6-20. For these five frames, only the first and last are keyframes, while the three in-between frames are interpolated by the computer. The computer compares the location of each control point in the two keyframes, then calculates a new position for them at each in-between frame so they will move smoothly from keyframe 1 to keyframe 2.

There are two very big advantages to this interpolation process. First, the number of keyframes that the artist must create is often less than half the total number of frames in the shot. This dramatically cuts down on the labor that is required for what is a very labor-intensive job. Second, and perhaps even more important, is that when the computer interpolates between two shapes, it does so smoothly. It has none of the jitters and wobbles that a clumsy humanoid would have introduced when repositioning control points on every frame. Bottom line, computer interpolation saves time and looks better. In fact, when rotoscoping a typical character it is normal to keyframe every other frame. The interpolated frames are then checked, and only an occasional control point touch-up is applied to the in-between frames as needed.

6.5 KEYFRAMES

In the previous discussion about shape interpolation, the concept of the keyframe was introduced. There are many keyframing strategies one may use, and choosing the right one can save time and improve the quality of the finished roto. What follows is a description of various keyframe strategies with tips on how you might choose the right one for a given shot.

6.5.1 On 2's

A classic and oft used keyframe strategy is to keyframe on 2's, which means to make a keyframe at every other frame—that is, frame 1, 3, 5, 7, and so forth. The labor is cut in half and the computer smoothes the roto animation by interpolating nicely in between each keyframe. Of course, each interpolated frame has to be inspected

and any off-target control points must be nudged into position. The type of target where keyframing on 2's works best would be something like a walking character shown in the example in Figure 6-21. The action is fairly regular, and there are constant shape changes, so frequent keyframes are required.

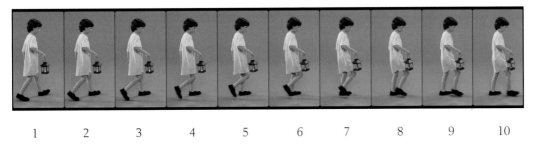

| 1 | 2 | 3 | 4 | 5 | 6 | 7 | 8 | 9 | 10 |

Figure 6-21 Keyframe on 2's.

On shots where the action is regular but slower, it is often fruitful to try keyframing on 4's (1, 5, 9, 13, etc.), or even 8's (1, 9, 17, 25, etc.). The idea is to keep the keyframes on a binary number (on 2's, on 4's, on 8's, etc.) for the simple reason that it ensures you will always have room for a new keyframe exactly halfway between any two existing keyframes. If you keyframe on 3's (1, 4, 7, etc.) for example, and need to put a new keyframe between 1 and 4, the only choice is frame 2 or 3, neither of which is exactly halfway between them. If animating on 4's (1, 5, 9, etc.) and you need to put a new keyframe between 5 and 9, frame 7 is exactly halfway between them.

	1	2	3	4	5	6	7	8	9	10
Pass 1 – on 4's	•				•				•	
Pass 2 – in-between			•				•			

Figure 6-22 Keyframe passes on 2's.

Figure 6-22 shows the sequence of operations for keyframing a shot on 2's in two passes by first setting keyframes on 4's, then in-betweening those on 2's. Pass 1 sets a keyframe at frames 1, 5, and 9, then on a second pass the keyframes are set for frames 3 and 7. The work invested in creating keyframes 1 and 5 is partially recovered when creating the keyframe at frame 3, plus frame 3 will be smoother and more natural because the control points will be very close to where they should be and only need to be moved a small amount.

6.5.2 Bifurcation

Another keyframing strategy is bifurcation, which simply means to fork or divide into two. The idea is to create a keyframe at the first and last frames of a shot, then

go to the middle of the shot and create a keyframe halfway between them. You then go mid-way between the first keyframe and the middle keyframe and create a new keyframe there, then repeat that for the last frame and middle frame, and keep subdividing the shot by placing keyframes midway between the others until there are enough keyframes to keep the roto on target.

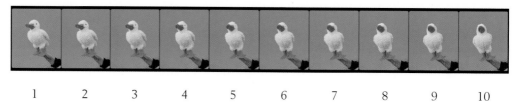

| 1 | 2 | 3 | 4 | 5 | 6 | 7 | 8 | 9 | 10 |

Figure 6-23 Keyframe with bifurcation.

The situation where bifurcation makes sense is when the motion is regular and the object is not changing its shape very radically such as the sequence in Figure 6-23. If a keyframe were first placed at frame 1 and frame 10, then the roto checked mid-way at frame 5 (or frame 6, since neither one is exactly mid-way), the roto would not be very far off. Touch up a few control points there, and then jump mid-way between frames 1 and 5 and check frame 3. Touch up the control points and jump to frame 8, which is (approximately) mid-way between the keyframes at frame 5 and frame 10. Figure 6-24 illustrates the pattern for bifurcation keyframing.

	1	2	3	4	5	6	7	8	9	10
Pass 1 – end frames	•									•
Pass 2 – mid-point					•					
Pass 3 – mid-points			•					•		

Figure 6-24 Keyframe passes with bifurcation.

While you may end up with keyframes every couple of frames or so, bifurcation is more efficient than simply starting a frame 1 and keyframing on 2's, that is, assuming the target object is suitable for this approach. This is because the computer is interpolating the frames for you, which not only puts your shape's control points close to the target to begin with, but it also moves and pre-positions the control points for you in a way that the resulting animation will be smoother than if you tried to keyframe it yourself on 2's. This strategy efficiently "recycles" the work invested in each keyframe into the new in-between keyframe.

6.5.3 Extremes

Very often the motion is smooth but not regular, such as the gyrating airplane in Figure 6-28, which is bobbing up and down as well as banking. In this situation, a

good strategy is to keyframe on the extremes of the motion. To see why, consider the airplane path plotted in Figure 6-25. The large dots on the path represent the airplane's location at each frame of the shot. The change in spacing between the dots reflects the change in the speed of the airplane as it maneuvers. In Figure 6-26, keyframes were thoughtlessly placed at the first, middle, and last frames, represented by the large red dots. The small dots on the thin red line represent where the computer would have interpolated the rotos using those keyframes. As you can see, the interpolated frames are way off the true path of the airplane.

Figure 6-25 Airplane path. **Figure 6-26** Wrong keyframes. **Figure 6-27** Extreme keyframes.

However, in Figure 6-27, keyframes were placed on the frames where the motion extremes occurred. Now the interpolated frames (small red dots) are much closer to the true path of the airplane. The closer the interpolation is to the target, the less work you have to do and the better the results. To find the extremes of a shot, play it in a viewer so you can scrub back and forth to make a list of the frames that contain the extremes. Those frames are then used as the keyframes on the first roto pass. The remainder of the shot is keyframed by using bifurcation.

1 2 3 4 5 6 7 8 9 10

Figure 6-28 Keyframe on extremes.

Referring to a real motion sequence in Figure 6-28, the first and last frames are obviously going to be extremes so they go on our list of keyframes. While looking at the airplane's vertical motion, it appears to reach its vertical extreme on frame 3. By placing keyframes on frame 1, 3, and 10, we stand a good chance of getting a pretty close fit when we check the interpolation at frame 7 (see Figure 6-29). If the keyframe were placed at the midpoint on frame 5 or 6, instead of the motion extreme at frame 3, the roto would be way off when the computer interpolates it at frame 3.

	1	2	3	4	5	6	7	8	9	10
Pass 1 – extremes	•		•							•
Pass 2 – mid-point							•			
Pass 3 – mid-points					•				•	

Figure 6-29 Keyframe passes using extremes.

6.5.4 Final Inspection

Regardless of the keyframe strategy chosen, when the roto is completed it is time for inspection and touch-up. The basic approach is to use the matte created by the roto to set up an "inspection" version of the shot that highlights any discrepancies in the roto, then go back in and touch up those frames. After the touch-up pass, one final inspection pass is made to confirm all is well.

Figure 6-30 Film frame.

Figure 6-31 Roto.

Figure 6-32 Inspection.

Figure 6-30 through Figure 6-32 illustrates a typical inspection method. The roto in Figure 6-31 was used as a mask to composite a semi-transparent red layer over the film frame in Figure 6-32 to highlight any discrepancies in the roto. It shows that the roto falls short on the white bonnet at the top of the head and overshoots on the side of the face. The roto for this frame is then touched up and the inspection version is made again for one last inspection to confirm all the fixes and that there are no new problems. Using this red composite for inspection will probably not work well when rotoscoping a red fire engine in front of a brick building. Feel free to modify the process and invent other inspection setups based on the color content of your personal shots.

6.6 MOTION BLUR

One of the historical shortcomings of the roto process has been the lack of motion blur. A roto naturally produces clean sharp edges as in all the examples we have seen

so far, but in the real world, moving objects have some degree of motion blur where their movement has smeared their image on the film or in the video. Figure 6-33 shows a rolling ball of yarn with heavy motion blur. The solution is an inner and outer spline that defines an inside edge that is 100% solid, and an outside edge that is 100% transparent as shown in the example in Figure 6-34. The roto program then renders the matte as 100% white from the inner spline graduating off to black at the outer spline. This produces a motion-blurred roto such as the one shown in Figure 6-35. Even if there is no apparent motion blur in the image, it is often beneficial to gently blur the rotos before using them in a composite to soften their edges a bit, especially in film work.

Figure 6-33 Motion-blurred target.

Figure 6-34 Shape with inner and outer splines.

Figure 6-35 Resulting motion-blurred roto.

One problem that these inner and outer splines introduce, of course, is that they add a whole second set of spline control points to animate which increases the labor of an already labor intensive process. However, when the target object is motion blurred, there is no choice but to introduce motion blur in the roto as well.

A related issue is depth of field, where all or part of the target may be out of focus. The bonny lass in Figure 6-4, for example, actually has a shallow depth of field so her head and her near shoulder are in focus, but her far shoulder is noticeably out of focus. One virtue of the inner and outer spline technique is that edge softness can be introduced only and exactly where it is needed so the entire roto does not need to be blurred. This was done for her roto in Figure 6-5.

6.7 SEMI-TRANSPARENCY

Another difficult area for rotoscoping is a semi-transparent object. The main difficulty with semi-transparent objects is that their transparency is not uniform as some areas are denser than others. The different levels of transparency in the target mean that a separate roto is required for each level. This creates two problems. The first is that some method must be devised for reliably identifying each level of transparency in the target so it may be rotoscoped individually, without omission or overlap

with the other regions. Second, the roto for each level of transparency must be made unique from the others in order to be useful to the compositor.

Figure 6-36 Semi-transparent lantern.

Figure 6-37 Semi-transparent matte.

A good example of these issues is the lantern being carried by our greenscreen boy. A close-up is shown in Figure 6-36. When a matte is created using a high quality digital keyer (Figure 6-37), the variable transparency of the frosted glass becomes apparent. If this object needed to be rotoscoped to preserve its transparency, we would need to create many separate roto layers, each representing a different degree of transparency. This is usually done by making each roto a different brightness; a dark gray roto for the very transparent regions, medium brightness for the medium transparency, and a bright roto for the nearly solid transparency. While it is a hideous task, I have seen it done successfully.

7 Image Blending

There are many ways to combine images by using image blending operations rather than a compositing operation. These operations have the virtue of not requiring a matte, which is a huge advantage because creating a matte is often a difficult and time-consuming process. Two images are input to an image blending operation and its output is the new image. It's as simple as that. Image blending is also the core technology behind speed changes, a phenomenon that is growing in demand. While these operations have been seen earlier in the context of working with mattes, in this chapter the focus is on how they are used to blend two color images together for an artistic treatment.

The two keys to working with image blending operations are knowing when to use which one and how to control them. This chapter covers both topics. Each image blending operation has a section describing when to use it, tips on how to adjust the appearance of the blended image, and a production case study. Most of the image blending operations also have "no-change" colors that you can take advantage of to limit the effects of the image blending to just the parts of the picture you want.

Homage is paid to Adobe Photoshop's image blending modes because of its enormous contribution to the entire visual effects industry and its application to our work in digital compositing. We are all Adobe Photoshop users, and many readers will want to relate what they read here to Photoshop. All of these image blending operations are found in Photoshop, and most of them are found in the Layers blending modes. For those not found in the Layers blending modes, their secret locations are revealed.

7.1 THE MIX OPERATION

We start our tour of image blending with the ubiquitous and humble mix operation. The mix is used whenever you want to "super" (superimpose) one image over another in such a way that both images are still visible, like the examples shown in Figure 7-1 through Figure 7-3. A mix is performed internally by first darkening the A and B images and then adding them together. The amount of darkening for each image is reciprocal, which means, for example, if one image is darkened by 25% then the

other is darkened 75% so that their darkening adds up to 100%. A slider or percentage number will be available so the amount of the mix can be adjusted to taste. In Photoshop, the mix operation would be equivalent to the Layer Opacity setting.

Figure 7-1 Image A. **Figure 7-2** Image B. **Figure 7-3** Mix of A and B.

The mix is the image blending operation used to do a dissolve. A dissolve is just a mix operation where the amount of mix is animated over time. The mission is to transition from image A to image B in gradual steps over time, such as the example in Figure 7-4. The sequence starts with image A at 100%, and then image A fades down as image B fades up ending with image B at 100%. The dissolve is the process of transitioning from image A to image B. The mix is the mathematical operation performed at each frame to achieve the dissolve.

Image A Mix 25% Mix 50% Mix 75% Image B

Figure 7-4 The mix operation performs the dissolve between two images.

Horizontal bars Vertical bars Mixed

Figure 7-5 Pixel behavior of the mix operation.

The pixel behavior of the mix operation can be seen in Figure 7-5. The horizontal and vertical bars images have five bars each ranging from zero black to 100% white. They have been blended together with the mix operation set at 50% to produce the "Mixed" image. Any pixel in the mixed image can be traced back to the horizontal row and vertical column that it was made from to see the effect of blending them at 50%. This illustration shows all of the cross-combinations of mixing light pixels with dark, dark with dark, light with light, and so on.

7.2 THE MULTIPLY OPERATION

The multiply operation simply multiplies two images together on a pixel-by-pixel basis. The visual results are analogous to putting the source image in a slide projector and projecting it onto an object in the target image. This technique is the solution for all those shots where a character or object moves in front of a projector. It is also useful when you want to paint the source image onto the target image while retaining some of the color and detail of the target image, as if it were stained. Photoshop supports the multiply operation. Perhaps you have wondered what it might be used for.

The case study for the multiply operation is a television commercial for a shameless floral company that wishes to besmirch the natural beauty of Yosemite's El Capitan (Figure 7-6) with crass commercialism by projecting their flower product (Figure 7-7) onto its majestic face. Sometimes, as professionals, we even have to work on hemorrhoid commercials. The prepped flower is shown in Figure 7-8 with a white surround, which is multiplied by the El Capitan image to produce the final result that is shown in Figure 7-9.

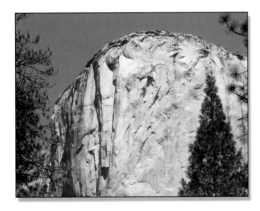

Figure 7-6 El Capitan.

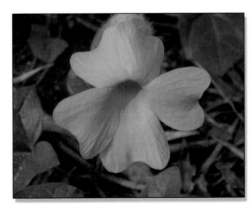

Figure 7-7 Flower.

Figure 7-8 Prepped flower.

Figure 7-9 Multiplied flower.

The prepped flower has a white surround because white is the "no-change" color for the multiply operation. Any pixel multiplied by white (one) is always the original pixel. When any two pixels are multiplied together, the results are always darker than either of the original pixels. Why this is so will be demonstrated in the following. In the meantime, this means that the projected image may need to be brightened up for the multiplied results to look right. This may also mean that both images might need to be promoted to 16 bits prior to the multiply so they will tolerate the brightening without introducing banding.

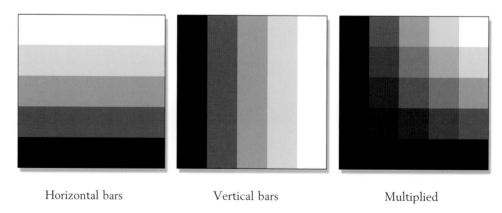

Horizontal bars Vertical bars Multiplied

Figure 7-10 Pixel behavior of the multiply operation.

The pixel behavior of the multiply operation is cunningly revealed in Figure 7-10. The two bars images have been multiplied together to produce the "Multiplied" image. It shows all of the possible cross-combinations of multiplying dark and light pixels—for

these five shades of gray, anyway. As we might expect of a multiply operation, any black in either image produces black in the multiplied image. What may not be expected is that in the multiplied image the pixels are darker than their source pixels.

To see why this is so, consider two pixels with a value of 0.4 and 0.6, for example. When multiplied together the result is 0.24 (0.4×0.6), a result that is darker than either original pixel. Any pixel in the Multiplied image can be traced back to the horizontal row and vertical column that it was made from to confirm the darkening effect of multiplying them together.

7.3 THE SCREEN OPERATION

The screen operation is one of the most powerful and useful of the image blending operations because it solves a very common problem in digital compositing, and that is to add light rays to a shot. Glows around lights, laser beams, god rays, and flashlight beams are just a few of the many applications for the screen operation. All you do is prepare the "light layer" element then screen it with the background. No mattes, no fuss, and, most importantly, no clipping. Photoshop has this operation and uses the same name.

Our case study for the screen operation is a television commercial designed to grant a heavenly aura to the banal Las Vegas gambling casino pictured in Figure 7-11. Such is the power of the screen operation. The art department has prepared the plate of god rays shown in Figure 7-12. Areas of the picture that we do not want to change are made zero black in the god ray plate because black is the no-change color for the screen operation. The god rays are screened with the background and the results are shown in Figure 7-13.

Figure 7-11 Background.

Figure 7-12 God rays.

Figure 7-13 God rays screened.

The reason that the screen operation is such an excellent simulation of light beams is that, like real beams of light, they do not block or obstruct the background image as a composite would. A semi-transparent composite would actually first darken the background pixels, and then add in the light. This causes a loss of detail in the background by lowering its contrast and flattening it out. The screen operation adds the light without obscuring the background just like real beams of light. It can even be used to add atmospherics to a shot such as smoke or dust when they are photographed over black and have no matte.

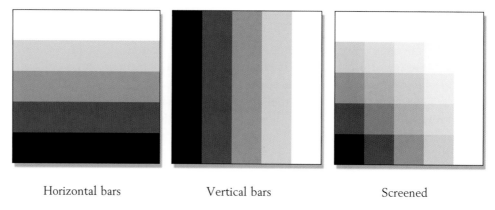

Horizontal bars Vertical bars Screened

Figure 7-14 Pixel behavior of the screen operation.

The secret of the screen operation's pixel behavior is revealed in Figure 7-14. The two bars images have been screened together to produce the "Screened" image, which shows all of the possible cross-combinations of screening dark and light pixels. Comparing it to the Multiply results in Figure 7-10, you can see why the screen operation is considered an inverted multiply. With the multiply operation if either pixel is black the results are black. With the screen operation if either pixel is white the results are white. Also, with the screen operation the pixels are lighter than their source pixels, but with the multiply operation they are darker.

7.4 THE MAXIMUM OPERATION

When two images are "max'd" (maximumed) together, the computer compares them pixel-by-pixel and simply uses whichever pixel has the greater value in the output image. This can be a useful operation for lifting a light colored element out of one plate and merging it into another. This is especially useful when the item of interest is on a gradient rather than a smooth uniform surface, which seems to be the case with many real-world pictures. The rules are that the light colored element must be surrounded by a darker color and the destination plate must have a similar dark color. This actually happens more often than you might think. Photoshop offers this opera-

tion but calls it *lighten*, rather than *maximum*. Perhaps they call it lighten because the resulting image retains the lightest pixels of each image.

The case study for the maximum operation is the classic Victorian house shown in Figure 7-15. Previous shots of the house had clouds in the sky, but on this day, Mother Nature was uncooperative. The mission is to lift the clouds from the shot in Figure 7-16 and place them over the house. Figure 7-18 shows the prepped cloud plate. The cloud layer was first color corrected to approximate the blue sky color in the original plate then masked with black. This prepped cloud plate was then max'd with the original plate to produce the results shown in Figure 7-17.

Figure 7-15 Original plate.

Figure 7-16 Clouds to be lifted.

Figure 7-17 Max'd clouds.

Figure 7-18 Prepped clouds.

The clouds were prepped with a black surround because black is the no-change color for the maximum operation. Any pixel max'd with black will always result in the original pixel. The virtue of maxing the layers together, rather than a composite with a matte, is that the maximum operation feathers in the clouds without a matte line. Because the gradients of the two skies are slightly different, a matte line would have been unavoidable. The prepped clouds' blue sky was also color corrected to closely match the target plate because the maximum operation is done on a channel-by-channel basis so all three channels must be close to the target.

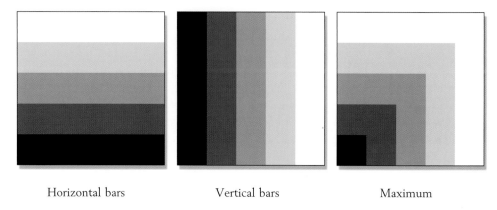

Horizontal bars Vertical bars Maximum

Figure 7-19 Pixel behavior of the maximum operation.

The results of the maximum operation are shown in Figure 7-19. The brightest pixel value from either image has been retained in the "Maximum" image.

7.5 THE MINIMUM OPERATION

The minimum operation is conceptually identical to the maximum operation, only different. The computer compares the two images on a pixel-by-pixel basis, and then uses whichever pixel is the minimum value in the output image. This can be useful for lifting dark elements out of one plate and placing them in another. The rules are that the object of interest must be dark and surrounded by a fairly uniform lighter color. The target image must also have a similar light color. Keep in mind that the source image can be color corrected to get the surround colors similar. Photoshop offers this operation, but calls it *darken* rather than *minimum*, probably because the resulting image keeps the darker pixels from the two source images.

The case study for the minimum operation starts with the original plate shown in Figure 7-20. The frenzied director wanted the lighthouse dramatically framed by the sun when the Goodyear blimp flew by. Delayed by a headwind, the blimp was late and the sun had dipped too low by the time the blimp lumbered by in Figure 7-21. The blimp must be lifted out of Figure 7-21 and seamlessly placed in the original plate. The blimp plate is prepped with a white surround in Figure 7-22, and then min'd with the original plate to produce the dramatic shot shown in Figure 7-23. The director was thrilled. Shot saved, hero compositor.

The blimp was prepped with a white surround because white is the no-change color for the minimum operation. Any pixel min'd with white will always result in the original pixel. Again, the minimum operation blended the blimp without any of the matte lines that a composite would have produced, plus it was quick and easy

Figure 7-20 Original plate.

Figure 7-21 Blimp to be lifted.

Figure 7-22 Prepped blimp.

Figure 7-23 Min'd blimp.

Horizontal bars

Vertical bars

Minimum

Figure 7-24 Pixel behavior of the minimum operation.

to create the prepped blimp plate with a simple soft-edge mask even though the blimp was moving.

The minimum operation is shown in Figure 7-24. The darkest pixel from either image has been retained in the "Minimum" image.

7.6 THE ADD OPERATION

The add operation, not surprisingly, simply adds two images together on a pixel-by-pixel basis. Similar in look to the screen operation, the add operation is also good for adding atmospherics and other subtle detail to a shot. The add operation can give the atmospheric element more "presence" in the shot than the screen operation, but there is a danger of introducing clipping. In Photoshop, the Add operation is not found in the Layers blending modes but in the "Image > Apply Image," as well as in the "Image > Calculations."

The case study for the add operation begins with the night buildings shown in Figure 7-25. A creepy atmosphere is needed for a cheesy detective movie, so the fog layer from Figure 7-26 needs to be added. The fog was shot on a black screen, so the only preparation was to lower the black level so it does not milk up the blacks in the finished picture shown in Figure 7-27.

Figure 7-25 Original plate. **Figure 7-26** Fog. **Figure 7-27** Fog added.

The no-change color for the add operation is black, since adding black (zero) to any pixel always results in the original pixel value. As mentioned previously, the add operation is dangerous to use because it can introduce clipped pixels. If a pixel in the fog plate with a value of 100 is added to a pixel in the original plate with a value of 200, the results will obviously be 300. However, the computer will clip the

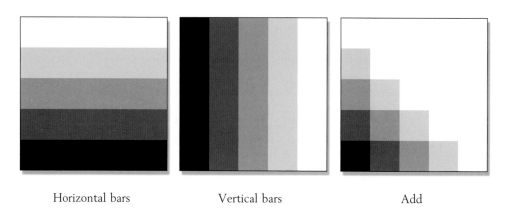

Horizontal bars Vertical bars Add

Figure 7-28 Pixel behavior of the add operation.

300 to 255 because that is the maximum value allowed. Always check for clipped pixels when using the add operation. In fact, this operation is so dangerous that Photoshop hides it in the "Image > Apply Image" and the "Image > Calculations" menus.

The add operation results are shown in Figure 7-28. The pixel values from the two bars images have been summed together in the "Add" image, but over half of them are pure white. This is because their totals exceed 255, which means they are all clipped.

7.7 THE SUBTRACT OPERATION

The subtract operation does exactly what you would expect—subtract one image from another. While very useful for the internal workings of advanced keying operations such as matte extraction and despill, it is not particularly useful for the type of image blending applications that we are discussing here. Perhaps this is why Photoshop buries the subtract operation in the "Image > Apply Image" and the "Image > Calculations" menus.

7.8 NO-CHANGE SUMMARY TABLE

All of the image-blending operations listed previously, except for mix, have a no-change color that you can use to prevent areas of one image from affecting the other. Table 7-1 is a summary list of each operation and its associated no-change color for a handy reference.

Table 7-1 No-Change color summary

Operation	No-Change Color
Mix	None
Screen	Black
Maximum	Black
Minimum	White
Multiply	White
Add	Black
Subtract	Black

7.9 ADOBE PHOTOSHOP BLENDING MODES

Adobe Photoshop has a long list of image blending modes in the Layers palette that include all that we have seen here (except they call maximum "lighten" and minimum "darken"), plus many more. The other Photoshop blending modes, such as "Overlay," "Soft Light," and "Hard Light," uses complex mathematical equations to perform

their blending operations. Some digital compositing programs can duplicate Photoshop blending modes, and others cannot. And herein lies a trap.

If the art director does a "pre-viz" (pre-visualization) of a shot for the client using one or more of these exotic Photoshop blending modes, the client will reasonably expect the final composite to look the same. The problem is that if the compositing program does not support the Photoshop blending modes that the art director used to create the pre-viz version, then the compositor may not be able to deliver a matching shot. The hapless compositor will be forced to spend a great deal of time in a frustrating attempt to match the look of the pre-viz. In the end, after a great deal of work, the results might be close, but they will never be an exact match. The bottom line is that the art director must not use image blending operations for a pre-viz that cannot be duplicated by the compositors.

7.10 SPEED CHANGES

A very important class of image blending operations is speed changes. A shot may be 115 frames long and it needs to be shortened to 97 frames to fit the cut; or, perhaps the actor was too quick in his furtive glance so the director wants it slowed down for dramatic impact. The demand for this effect is skyrocketing because of the growing tendency to edit feature films with off-line editing systems as if they were an MTV show with lots of fancy editorial effects, including speed changes. Think of it as job security for us compositors.

When a shot is lengthened or shortened, some method must be used for generating the in-between frames. There are three different image blending techniques that one may choose from, each with its own advantages and disadvantages. Following is a description of each one, their relative strengths and weaknesses, and when to use them.

7.10.1 Skip Print/Frame Duplication

The simplest of all speed changes is to simply drop frames out of the shot. If every other frame is dropped, the shot is half as long and the action twice as fast. Ugly, but easy. In movieland, this is referred to as a skip print, but each compositing program has its own terminology for this. To lengthen a shot, frames may be duplicated. This would be the frame duplication method. There is no attempt to make an in-between frame, so these two methods can be lumped together and referred to as integer (whole number) speed changes.

Of course in the real world, your speed change shots will rarely be exactly double or half the speed. More often, it will be like the previous example where you need to take 115 frames down to 97. That's an awkward 15.65% speed-up in the shot requiring that you drop 18 frames out of the shot. To drop 18 frames out of 115 means you need to drop one frame every 6.38 frames. There is no frame 6.38, only frame 6 or frame 7, so the computer simply drops the frame nearest to 6.38. Not

much of an image blending strategy. This, unfortunately, is the only option with an integer speed change.

There are two main problems with integer speed changes. The first is that because the correct in-between frames are not used, the action can look odd to the eye. It can stutter or clatter across the screen. The second problem is that the motion blur will not be correct for the new speed. If the action is sped up, the motion blur will be insufficient and can introduce motion strobing, where the motion takes on a staccato-like jitter. If the shot is slowed down, the motion blur can be excessive, resulting in a blurry looking shot. Keeping the motion blur correct for a speed change shot is a very important issue.

7.10.2 Frame Averaging

One step up from the integer speed change is frame averaging, but it is a small step up. With this method, the computer actually makes an in-between frame to smooth out the action and avoid the stutters and judders of the integer method. It also helps with the motion blur problem (sort of). Frame averaging does pretty much what its name implies, it averages adjacent frames together over the length of the shot using the mix operation we saw earlier. This results in a shot with a series of cross-dissolves such as the example in Figure 7-29.

Frame 1 Averaged frame 1.5 Frame 2

Figure 7-29 Frame averaging uses cross-dissolves.

Frame 1 and frame 2 in Figure 7-29 are original frames from the shot and we need to make frame 1.5, exactly halfway in-between. Using a mix operation set to 50%, we get the averaged frame in the middle. If our speed change needed a frame 1.2, we would mix 80% of frame 1 and 20% of frame 2. The 15.65% speed change in the integer example is now trivial for the computer using frame averaging. It just calculates what mix percentages are needed for each new frame, and then mixes them accordingly creating a "rolling cross-dissolve" to produce the new shot. Mixing the frames like this even introduces a pseudo motion blur.

Table 7-2 shows how the frame average rolling cross-dissolve is calculated to stretch a 10-frame shot into a 14-frame shot. The top row shows the new output frame numbers and the bottom row shows the frame average values calculated for each frame. The original frame 1 should be used intact as frame 1 of the new shot and frame 10 should also be used intact as frame 14, but each of the in-between frames is some averaged floating-point value. Frame number 5, for example, calculated a frame average of "3.8" from the original clip, which means it will do an 80% mix of frame 3 with frame 4. Similarly, frame number 13 calculated a frame average of "9.3" resulting in a 30% mix of frame 9 with frame 10.

Table 7-2 Frame averaging 10 frames to 14 frames

Frame number	1	2	3	4	5	6	7	8	9	10	11	12	13	14
Frame average	1	1.7	2.4	3.1	3.8	4.5	5.2	5.8	6.5	7.2	7.9	8.6	9.3	10

This sounds pretty good and works fairly well if the action in the shot is not very quick or the camera move is not very fast. If a shot is slowed down (stretched) and there is fast action, the frame averaged shot looks "dissolvey" because, well, it is. As we saw previously, if you used an integer speed change on a fast action shot, it would look "strobey." Is there anything that can be done to speed change a fast action shot?

7.10.3 Optical Flow

The answer to the nagging question of how to speed change a fast action shot is *optical flow*. Also known as *motion vector* or *motion analysis*, optical flow is another of those wondrous things that only a computer can do. The concept is that the computer compares two adjacent frames, and then creates a list describing how small groups of pixels have moved from the first to the second frame. One small group of pixels moved to the right a bit. Another small group moved down a bit. And so it goes over the entire frame. To describe the motion of each pixel group, the computer

Frame 1 Motion vectors Frame 2

Figure 7-30 Optical flow uses motion vectors.

uses a little mathematical "arrow," called a *vector*. The length of the vector records how far the pixels moved and its orientation indicates the direction of movement.

Figure 7-30 offers a simplified illustration of the motion vectors in optical flow. After comparing small pixel groups in frame 1 to frame 2, the computer decides how far and in what direction each group moved to create the motion vectors. The white dots indicate a region that did not move at all. The regions with vectors that had movement are indicated by the direction of the arrow and the arrow lengths indicate how far they moved. Note that the region where the foot is moving a lot has long vectors, while the lantern and shirt only moved a little so they have short vectors.

Frame average Optical flow

Figure 7-31 Comparison of frame average and optical flow for frame 1.5.

Once we have the motion vectors for frame 1 to frame 2, it is now possible to synthesize a much more realistic in-between frame. Suppose we need frame 1.5. The computer shifts the pixels from frame 1 by half the distance of the motion vectors and creates an "honest" frame 1.5. The visual results of using the motion vectors to generate a new frame are vastly superior to a simple frame average. Just compare the same exact frame 1.5 in Figure 7-31 created with frame averaging and optical flow. The frame-averaged version appears as exactly what it is—a 50% mix of frame 1 and 2. However, the optical flow version is a "synthesized" frame using the motion vector information from the optical flow calculations.

One key advantage of optical flow is that once the motion vectors are generated, they can be used to create any arbitrary fractional frame between frames 1 and 2, such as frame 1.2, frame 1.8715, or anything at all. Figure 7-32 shows a sequence of actual optical flow interpolated frames between the same frame 1 and frame 2 used previously. The interpolated frames represent where the action should be on frame 1.25, 1.5, and 1.75. This technology can even be used to completely replace a destroyed frame. If frame 5 is lost, just use optical flow to interpolate a new frame between frame 4 and 6. Optical flow is truly wondrous.

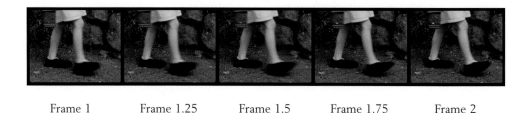

Frame 1 Frame 1.25 Frame 1.5 Frame 1.75 Frame 2

Figure 7-32 Speed change with optical flow.

But wait, there's more! Another key advantage of optical flow technology is that it can also change the shutter timing of a shot. If a shot were seriously shortened, then the motion blur in the original frames would be insufficient for the shorter version and could introduce motion strobing. Conversely, if a shot is seriously extended, then the original motion blur could be excessive by making the shot look soft and smeared. Most optical flow programs offer an option to change the shutter timing, which in turn alters the motion blur of the retimed shot.

So that was the good news, but now for the bad news. Optical flow is a spectacular solution to the speed change problem, BUT—and this is a very big BUT—it also frequently introduces artifacts that have to be fixed. Optical flow programs (and there are several available) are not flawless and can get confused under certain conditions. Those conditions vary from brand to brand, but they are all vulnerable. When this happens, it can be major surgery to repair the artifacts, which may require elaborate techniques akin to wire and rig removal. While this is time consuming and can drive up costs and schedules, the results of optical flow are well worth it.

8 Animation

In this chapter, we look at all things that move. Visual effects shots invariably entail some animation on the part of the digital compositor so an understanding of animation and how it works is essential. The subject of animation in this chapter is looked at from several angles. First is a look at *transforms*, those operations in digital compositing that reposition or change the shape of an image. The affect of transforms on image quality and how pivot points affect the results of a transform are revealed. There is also a section on different keyframe strategies as well as some advice on when to use which one.

Motion tracking and shot stabilization are pervasive parts of today's visual effects shots so revelations on their internal workings and tips on what to watch out for are offered. A close cousin of motion tracking is the match move, so there is some good information about how it works even though it is really a 3D thing. Finally, there is an extensive tour of different types of image warping techniques and when to use them, followed by the granddaddy of all warping techniques, the morph.

8.1 TRANSFORMS AND PIXELS

Transforms change the size, shape, or position of an image, which we do a lot in digital compositing. There are several different transforms, each with its own issues to be aware of. One issue to be aware of for all transforms is that they soften the image, as if a light blur had been applied. Even the simplest transform such as a move softens the image. Why this is so can be understood with the help of the little sequence, starting with Figure 8-1, which shows a close-up of the nice sharp corner of a blue object on a red background. Let us assume the blue object is moved (translated) to the right by 0.7 pixels and shifted up by 0.25 pixels, illustrated with the aid of the arrow in Figure 8-2. The corner of the blue object now straddles the pixel boundaries represented by the black lines. However, this is not permitted. All pixels must stay within the pixel boundaries. It's a rule.

Figure 8-1 Sharp corner.

Figure 8-2 Moved.

Figure 8-3 Averaged.

To accommodate this awkward situation, the computer now performs a simulation of how the picture would look if it were shifted a fraction of a pixel up and over and now straddles the pixel boundaries. The way it simulates this is by averaging the blue and red pixels together to create a new color based on the fraction of the red pixel that they cover.

Since the top row of blue pixels in Figure 8-2 moved up by 0.25, they now cover 25% of the red pixels so the averaged pixels in the top row of Figure 8-3 are 25% blue and 75% red. The right edge of the blue pixels moved over by 0.7 covering 70% of the red ones, so in the averaged version those pixels are 70% blue and 30% red. After the upper-right corner blue pixel is moved, it covers 15% of its red pixel so the averaged pixel is now 15% blue and 85% red. The effect of all this when seen from a normal viewing distance is that the edge of the blue object is no longer sharp. If you ran a gentle blur on the original image shown in Figure 8-1, the results would look very much like the translated version in Figure 8-3.

Figure 8-4 Translation. **Figure 8-5** Rotation. **Figure 8-6** Scale.

We have just seen how a move (translation) softens an image. The same thing happens with the rotate transform as seen in Figure 8-5. The rotated pixels straddle the pixel boundaries and must be averaged just like the translation pixels. However, there is one exception, some programs have a "cardinal" rotate where the image can be rotated exactly 90 or 180 degrees. In these special cases, the pixels are not averaged because the computer is simply remapping the pixels' locations to another exact pixel boundary. No pixel averaging, no softening. Photoshop thoughtfully supports these special cases separately from their "Edit > Transforms > Rotate" menu by offering a separate choice for exactly 90 and 180 degree rotations as well as *flip horizontal* (otherwise known as a *flop*), and *flip vertical*.

The scale transform (Figure 8-6) is particularly hard on images when they are scaled up. One pixel may be stretched to cover one and one-half or two pixels or more, which seriously softens the image. Generally speaking, you can scale an image up by about 10% before you start noticing the softening. Conversely, scaling an image down can increase its apparent sharpness. If an image is softened during a transform, don't think that you can restore the sharpness by reversing the transform, because you can't.

Figure 8-7 Skew / shear. **Figure 8-8** Corner pin.

The *skew transform* (known by some as a *shear*), is shown in Figure 8-7. The left example is skewed horizontally, which slides the top or bottom edges left or right; and the right example is skewed vertically, which slides the left and right edges up and down.

Figure 8-8 shows a couple of examples of a four-corner pin, very popular for those ever-present monitor screen replacement shots. The four-corner pin is like attaching

the image to a sheet of rubber, then pulling on the corners of the rubber. By tracking the four corners to the corners of a monitor the picture on the screen can be replaced. The skew and corner pin transforms can severely deform an image introducing a lot of softening. To prevent this from happening, a high-resolution version of the image can be transformed, and then the results are scaled down to a smaller size to re-introduce its sharpness.

As we have seen, transforms soften images except in the special cases where the image is being scaled down. Then they are sharpened. So what happens if you string several transforms in a row? The image gets progressively softer with each transform. The fix for this is to combine or *concatenate* all of your transforms into a single, complex transform, so that the image only takes one softening hit. Most compositing programs have this feature. For example, if you have a move transform followed by a rotate followed by a scale, replace them all with a single MoveRotateScale transform.

8.2 FILTERS

In the previous pixel-softening alert, we saw how softening occurred because the pixel values were averaged together. However, averaging the pixel values is only one of several possible ways of calculating the new pixels. There are a variety of algorithms that may be used, and these algorithms are called *filters*. Change the filter and you change the appearance of the transformed image. Many compositing programs offer the option to choose filters with their transforms, so an understanding of how different filters affect the appearance of the transformed image is important. Also, choosing the wrong filter can introduce problems and artifacts, so being able to recognize those is also important. We will not be looking at how they work internally as the math is complex and irksome.

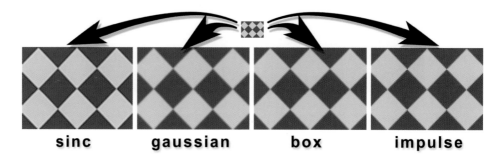

sinc **gaussian** **box** **impulse**

Figure 8-9 The effects of different filters.

Figure 8-9 illustrates the effect of four filters that are commonly used for scaling up an image. The small checker pattern at the top was scaled up by a factor of 5,

using a different filter in each example. The sinc filter on the left adds image sharpening in an attempt to avoid softening the resulting image. It does look sharper than the one next to it, but note the odd dark lines along the inside edge of the dark squares and the light lines along the inside edges of the light squares. This is an artifact of the image sharpening and can be objectionable under some circumstances. If you see this in a resized image and want to eliminate it, then switch filters.

The Gaussian filter does not attempt edge sharpening so it has no edge artifacts, but does not appear as sharp as the sinc filter. The box filter is not as soft as the Gaussian filter, but the jagged pixels of the original small image are starting to show. The impulse filter is jaggiest of them all because it is not really performing a filter operation. It is just replicating pixels from the smaller image using the "nearest neighbor" principle. It is also the fastest, so it is frequently used when the need is to increase the size of an image quickly such as for an interactive display such as your compositing program's image viewer, for example.

8.3 PIVOT POINTS

The scale, rotate, and skew transforms have an additional feature that other transforms do not, and that is a *pivot point*. The pivot point is the center point around which all of the transform action takes place. Some call this an *axis*, others call it a *center*, and still others call it an *anchor point*. If we want to rotate something in the real world, we don't need a pivot point. We just grab it and rotate it. However, the computer must be told where to locate the pivot point for a rotation because the pivot point's location dramatically affects the results; and that is the point about the pivot point.

Let us consider two cases, one where the pivot point is in the center of the image, and the other where it is well off-center. The centered pivot point can be seen in Figure 8-10 as the white cross-hair mark looking a bit like the sights of a high-powered rifle centered on the gingerbread man. The rotate, scale, and skew shown in Figure 8-11, Figure 8-12, and Figure 8-13 do exactly what we might expect of those transforms. There are no surprises here.

Figure 8-10 Pivot point centered.

Figure 8-11 Rotate.

Figure 8-12 Scale.

Figure 8-13 Skew.

The second case as seen in Figure 8-14 has the pivot point located well off-center in the lower-left corner of the frame on the gingerbread man's foot. The results are quite surprising. The rotate in Figure 8-15 has rotated the gingerbread man almost out of frame. The scale in Figure 8-16 has shifted it away from the center of frame. The skew in Figure 8-17 has shifted it toward the right edge of the frame and with any more skew, it will get cut off.

Figure 8-14 Pivot point off-center. **Figure 8-15** Rotate. **Figure 8-16** Scale. **Figure 8-17** Skew.

All of this illustrates the importance of the proper location for the pivot point of a transform. The default location will normally be the center of frame, which will usually be what you want. However, all compositing systems offer the ability to move the pivot point around and even to animate its position. In fact, this is the source of most pivot point problems. What can happen is that the pivot point becomes shifted without you noticing it, then you perform a rotate, for example, and your gingerbread man suddenly disappears out of frame. Tip: always know where your pivot points are.

8.4 TRANSFORMATION ORDER

The previous section showed how moving the pivot point around dramatically affected the results of various transformations. There is another issue that will affect the results of your transformations, and that is the order in which they are done.

Figure 8-18 shows the results of just two transformations: a translate followed by a rotate. Mr. Gingerbread ended up in the upper-right hand corner after the rotate because he was off-centered when the rotate was done using the pivot point in the middle of the screen.

Figure 8-19 shows the very different results of the same two transformations simply by reversing their order. In this example, the rotate was done first, followed by the translate. Mr. Gingerbread is now on the far right of the screen with one foot out of frame.

Translate Rotate

Figure 8-18 Translate followed by rotate.

Rotate Translate

Figure 8-19 Rotate followed by translate.

The point of this story is that if you have more than one transform operation in your compositing script, and then later change their order, you can expect your elements to suddenly shift position, which is usually a bad thing. Many compositing programs have a "master transform" operation that will incorporate the three most common transforms together: Translate, followed by Rotate, and followed by Scale, which is also the customary order of the transformations, and is often abbreviated as "TRS." Most will also have an option to change the order of the transformations from TRS to, say, STR (Scale, followed by Translate, followed by Rotate). Again, be sure to set the transformation order before you spend time positioning your elements so they don't suddenly pop to a new location if reordered after the fact.

8.5 KEYFRAME ANIMATION

When it comes time to move objects around on the screen, or to create animation, the computer is your best friend. An image can be placed in one position on frame 1, moved to a different position on frame 10, and then the computer will calculate all of the in-between frames for you automagically. Frame 1 and frame 10 are known as the *keyframes*, so the computer uses these positions to calculate a new position

for the image for each frame between frames 1 and 10. The calculations used by the computer to determine the in-between frames is called *interpolation*.

Keyframe 1 Keyframe 2 Interpolation animation

Figure 8-20 Simple keyframe animation.

Figure 8-20 illustrates a simple keyframe animation. The classic CGI swan with a tent on her back was first positioned at frame 1 of the animation, which becomes keyframe 1. The frame counter was moved to frame 10, and then the swan was positioned at keyframe 2. The computer now has two keyframes, one at frame 1 and the other at frame 10. When the animation is played back from frame 1 to 10, the computer interpolates the animation for all ten frames. Nice.

Keyframe 1 Keyframe 2 Keyframe 3

Interpolated animation

Figure 8-21 Multiple keyframes for move, scale, and rotate.

Of course, the example shown in Figure 8-20 represents the simplest possible case of keyframe animation. Figure 8-21 illustrates a more realistic situation. This example has three keyframes at frames 1, 10, and 20, and instead of just a straight move, it has a curved motion path, a scale, and a rotate. Note that in keyframe 2, the swan is much smaller and is tilted over. This keyframe has a scale and a rotate to it, in addition to a move. Keyframe 3 also has a scale and rotate, as well as a position change compared to keyframe 2.

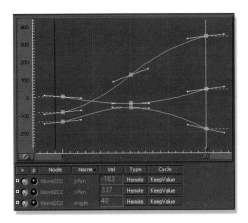

Figure 8-22 Animation curves.

When the keyframes are entered, the computer connects them together with *splines*, the mathematical "piano wire" that we met in Chapter 5, Creating Masks. Of course, because the splines are being used to control animation, we will now have to change their name from "splines" to "curves." It's another compositing rule. An example of these animation curves is shown in Figure 8-22, borrowed from Shake, the super compositing program from Apple. The computer uses splines to connect the keyframes with smooth, gently changing animation curves rather than simple straight lines. Simple straight lines of motion are both unnatural and boring so they are to be avoided at all costs.

The fun part for the digital compositor is being promoted to digital animator and adjusting the splines to refine the shapes of the animation curves. Leaving the keyframes where they are, the slope of the splines can be adjusted to introduce fine variations in the animation such as an ease-in or ease-out, or changing the acceleration at just the right moment for an exhilarating motion accent.

8.6 MOTION BLUR

After carefully entering all your keyframes for an animation, you may discover a disconcerting problem when you play it back at speed. The moving object may

appear to stutter, or chatter across the screen with a nasty case of *motion strobing*. The faster the objects move the more motion strobing. What is happening is that the finished animation lacks motion blur, the natural smearing that an image gets when fast movement is captured by a film or video camera. Even CGI software adds motion blur for all moving objects.

Figure 8-23 shows a few frames of a flying dove. The rapidly moving wings are motion blurred (smeared) across the film frame. Without this smearing in the direction of motion, the bird's wings would be in sharp focus and appear to pop from place to place on each frame—motion strobing.

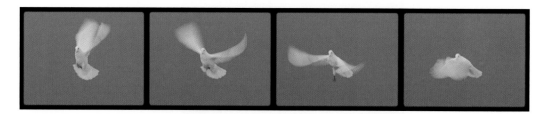

Figure 8-23 Motion blur on fast moving objects.

Most modern digital compositing programs have a motion blur feature that works with their transforms to combat motion strobing. It is now well understood that you cannot go flying things around the screen without it. But what if your compositing program isn't modern? A production expedient (a cheat) that you can try is to apply a directional blur in the direction of motion. It is not as realistic as a true motion blur, hard to animate if the target is moving irregularly, and it is difficult to find the right settings, but it is a sight better than motion strobing.

8.7 MOTION TRACKING

One of the truly wondrous things that a computer can do with moving pictures is motion tracking. The computer is pointed to a spot in the picture and then is released to track that spot frame after frame for the length of the shot. This produces tracking data that can then be used to lock another image onto that same spot and move with it. The ability to do motion tracking is endlessly useful in digital compositing and you can be assured of getting to use it often. Motion tracking can be used to track a move, a rotate, a scale, or any combination of the three. It can even track four points to be used with a corner pin.

One frequent application of motion tracking is to track a mask over a moving target. Say you have created a mask for a target object that does not move, but there is a camera move. You can draw the mask around the target on frame 1, then motion track the shot to keep the mask following the target throughout the camera move. This is much faster and is of higher quality than rotoscoping the thing. Wire and rig

removal is another very big use for motion tracking. A clean piece of the background can be motion tracked to cover up wires or a rig. Another important application is monitor screen replacement, where the four corners of the screen are motion tracked and then that data is given to a corner pin transform (Figure 8-8) to lock it onto a moving monitor face.

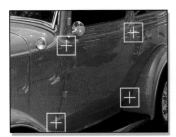 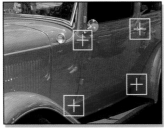

Figure 8-24 Four tracking points for a corner pin.

We can see how motion tracking works with the corner pinning example in Figure 8-24, which shows three frames of a camera move on a parked car. The white cross-hairs are the tracking markers that lock onto the tracking points, the four points in the image that the computer locks onto to collect the motion tracking data. The tracking points are carefully chosen to be easy for the computer to lock onto. After the data is collected from the tracking points for the length of the shot, it will be connected to the four control points of a corner pin operation so that it moves with the car.

At the start of the tracking process, the operator positions the tracking markers over the tracking points, and then the computer makes a copy of the pixels outlined by each tracking marker. On the next frame, the computer scans the image looking for groups of pixels that match the tracking points from the first frame. Finding the best match, it moves the tracking markers to the new location and then moves on to the next frame. Incredibly, it is able to find the closest fit to within a small fraction of a pixel.

The computer builds a frame-by-frame list of how much each tracking point has moved from its initial position in the first frame. This data is then used by a subsequent transform operation to move a second image in lock step with the original. Figure 8-25 shows the fruits of our motion tracking labor. Those really cool flames have been motion tracked to the side of the car door with a corner pin.

While all this sounds good, things can frequently go wrong. By frequently, I mean most of the time. The example here was carefully chosen to provide a happy tracking story. In a real shot you may not have good tracking points: They may leave the frame halfway through the shot; someone might walk in front of them; they might change their angle to the camera so much that the computer gets lost; the lens may

Figure 8-25 Cool flames tracked to hot rod with a corner pin.

distort the image so that the tracking data you get is all bent and wonky; or the film might be grainy causing the tracking data to jitter. This is not meant to discourage you, but to brace you for realistic expectations and suggest things to look out for when setting up your own motion tracking.

8.8 STABILIZING A SHOT

Another great and important thing that can be done with motion tracking data is to stabilize a shot. But, there is a downside that you should know about. Figure 8-26 shows a sequence of four frames with a "tequila" camera move (wobbly). The first step in the process is to motion track the shot, indicated by the white tracking marker locked onto the palm tree in each frame. Note how the tracking marker is moving from frame-to-frame along with the palm tree.

Frame 1 Frame 2 Frame 3 Frame 4

Figure 8-26 Original frames with camera movement.

The motion tracking data collected from Figure 8-26 is now fed to a translation transform (OK, a move operation), but this time, instead of tracking something onto the moving target the data is inverted to pull the movement out of each frame. For

example, if the motion tracking data for frame 3 shifted to the right by 10 pixels, then to stabilize it, we would shift that frame to the left by 10 pixels to cancel out the motion. The tree is now rock steady in frame. Slick. However, shifting the picture left and right and up and down on each frame to re-center the palm tree has introduced unpleasant black edges to some of the frames, as shown in Figure 8-27. This is the downside that you should know about.

| Frame 1 | Frame 2 | Frame 3 | Frame 4 |

Figure 8-27 Stabilizing introduced black edges.

We now have a stabilized shot with black edges that wander in and out of frame. Now what? The fix for this is to zoom in on the whole shot just enough to push all the black edges out of every frame. This needs to be done with great care, since this zoom operation also softens the image.

The first requirement is to find the correct center for the zoom. If the center of zoom is simply left at the center of the frame, it will push the black edges out equally all around. However, the odds are that you will have more black edges on one side than another, so shifting the center of zoom to the optimal location will permit you to push out the black edges with the least amount of zoom. The second requirement is to find the smallest possible zoom factor. The more you zoom into the shot, the softer it will be. Unfortunately, some softening is unavoidable. Better warn the client.

Just one more thing. If the camera is bouncing a lot, it will introduce motion blur into the shot. After the shot is stabilized, the motion blur will still be scattered randomly throughout the shot and may look weird. There is no practical fix for this. Better warn the client about this too.

8.9 MATCH MOVE

Strictly speaking, match move is a 3D function and does not really belong in a book on 2D compositing. However, it is a very closely related technology to our 2D motion

tracking so it warrants an honorable mention and a brief description. The key difference is that motion tracking is tracking the pixels in the picture by trying to keep one image on top of another image. It's an image thing. With match move, the computer is actually constructing a low-detail 3D model of the terrain it sees and is figuring out where the camera is in 3D space along with what lens it is using. It's an all-3D thing. This 3D information is used to place CGI objects in their proper locations so they will be rendered with a camera move that matches the live action. Match move is such an important effect that good-sized visual effects facilities have a separate match move department and there are several dedicated match move programs available for purchase.

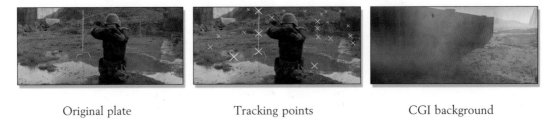

Original plate Tracking points CGI background

Figure 8-28 The elements of a match move shot.

Figure 8-28 shows the elements of a typical match move shot. The original plate on the left is the live action with a sweeping camera move that orbits around the soldier. The middle frame shows the tracking points that the match move program selected to track the shot. They are marked with a white "X" to show the operator each tracking point it has locked onto. The CGI background is the element that must be properly positioned and rendered with a CGI camera move that matches the live action camera.

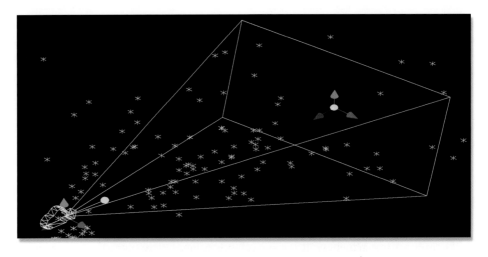

Figure 8-29 Point cloud with match move camera.

The match move program plows through all of the frames of a shot locking onto as many tracking points as it can, typically dozens or even hundreds. The terrain is represented by the point cloud, which is the total of all of the tracking points the match move program could find. The example in Figure 8-29 shows how the point cloud extends far outside the camera's field of view because it covers all of the terrain seen by the camera over the entire length of the shot.

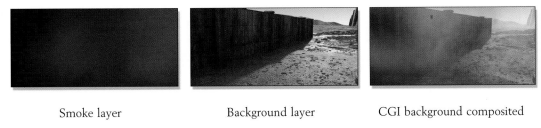

Smoke layer Background layer CGI background composited

Figure 8-30 Match moved CGI layers.

The point cloud is then used by the CGI artists as a line-up reference to accurately position the 3D objects into the scene so that they sit in their proper locations relative to the live action. Figure 8-30 shows two layers of the CGI that used the point cloud as the lineup reference. The match move 3D camera data is then used to move the CGI camera through the CGI elements so they are rendered with the same camera move as the live action. The example in Figure 8-30 shows that the moving smoke and background layers were pre-composited into a single layer in preparation to receive the live action foreground.

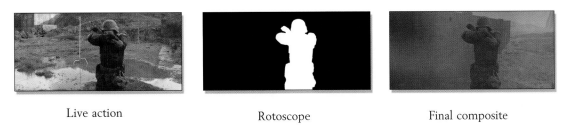

Live action Rotoscope Final composite

Figure 8-31 Live action layer rotoscoped and composited.

The live action goes through a different sequence of operations before compositing. The main problem is that the live action character needs a matte for the composite, but was not shot on bluescreen, so it has to be rotoscoped. Figure 8-31 shows the live action plate, its rotoscope, and the final composite of the live action over the CGI background from Figure 8-30. We now have all the elements necessary to produce the seamless action sequence as shown in the six frames of Figure 8-32, plucked from the finished shot. Here the camera swoops almost 180 degrees around the soldier with the entire CGI environment moving in perfect sync.

Figure 8-32 Finished match move action sequence.

This particular example shows the match move done on a live action character in order to place him in an all CGI world. This same technique can be used to place a CGI character into a live action world, such as adding CGI dinosaurs to a shot. To show a dinosaur running through the jungle, the live action plate is first filmed by running through the jungle with the film camera. The jungle plate then goes to the match move department to be tracked and derive the terrain point cloud and camera move. The point cloud information is then used to position the CGI dinosaur onto the terrain and the camera move information is used to animate the CGI camera in sync with the live action camera. The dinosaur is then rendered and composited into the live action plate.

Since the dinosaur is a CGI element, it comes with a fine matte. However, the dinosaur will need to be composited into the jungle, not over it. This means it will have to pass behind some leaves and foliage. To do that, a roto is needed for every leaf and bush that passes in front of it.

8.10 THE WONDER OF WARPS

The transforms that we saw at the beginning of the chapter all had one thing in common, and that is that they moved or deformed an image uniformly over the entire frame. The corner pin, for example, allowed you to pull on the four corners individually, but the entire image was deformed as a whole—a global deformation, if you will.

Warps are different. The idea behind warps is to deform images differently in different parts of the picture in what are called *local deformations*. Warps even allow just one area to be deformed without altering any other part of the picture. Instead of having an image attached to a sheet of rubber that limits you to pulling on the four corners, warps can be thought of as applying the image to a piece of clay, which allows you to deform any area you wish in any direction and to any degree. Much more fun.

We now take a look at three broad classes of warps: The mesh warp, the spline warp, and procedural warps. How each type of warp works will be explained, and then examples are given of how they are typically used in visual effects shots.

8.10.1 Mesh Warps

The mesh warp was the first-generation image warper, and it still has many uses today. A simplified version of it makes up Photoshop's current warp tool in the "Edit > Transform > Warp" menu. The basic idea is to create a grid or "mesh" of splines, attach it to an image, then as you deform the mesh, the image deforms with it. Figure 8-33 shows the original graphic image and Figure 8-34 shows the overlaid mesh. The mesh is deformed in Figure 8-35 with the resulting deformed image in Figure 8-36. The mesh can also be animated, so a mesh warp animation of a waving flag could be made.

Figure 8-33 Original image.

Figure 8-34 Overlaid mesh.

Figure 8-35 Deformed mesh.

Figure 8-36 Deformed image.

Because the mesh warp has a predefined grid of splines, you cannot put control points anywhere you want. As a result, the mesh warp does not permit getting in close with fine warping detail. This means that it is best suited for broad overall warping of images such as in the flag-waving example. In a visual effects shot, the

main use for the mesh warp would be to gently reshape an element that was not exactly the right shape for the composite, such as fitting a new head on top of a body. If you are not careful, the mesh warp can introduce a lot of stretching in an image, which will in turn introduce softening.

8.10.2 Spline Warps

The spline warp is the second generation of warp tool. It was designed specifically to overcome the shortcomings of the mesh warp, namely the lack of detailed control, and is based on an entirely different concept. A spline is drawn around an area of interest in an image such as the example in Figure 8-38 where warp splines have been added around the duck's bill and feet. Then, as the splines are deformed, the image is deformed. Splines can be placed anywhere in the image and they can deform only and exactly the part of the image you want by exactly how much you want. The original image in Figure 8-37 was spline warped to create the hysterical exaggeration shown in Figure 8-39.

Figure 8-37 Original image. **Figure 8-38** Warp splines added. **Figure 8-39** Hysterical exaggeration.

While the spline warp is more powerful than the mesh warp, it is also more complicated to work with. If a simple overall warp is needed, the mesh warp is still the tool of choice. The spline warp comes into its own when you want to warp just specific regions of the image such as the duck's bill and feet as shown in Figure 8-38. Deforming just those regions would not be possible using a mesh warper. As we will see shortly, the spline warp is also used for a morph. Of course, the spline warp can also be animated not only to animate the shape change of the target object over time, but also to follow the target object around from frame to frame like a roto.

8.10.3 Procedural Warps

Another entire class of image warps is the procedural warps, which just means to warp an image with a mathematical equation rather than by manually pulling on control points. The upside is that they are easy to work with because all you have to do is adjust the warp settings to get the look you want. The downside is their limited control in that the only warps you can do are those that the equation permits. You cannot customize the effect, but you can animate the warp settings so that the procedural warp changes over time.

A few examples of procedural warps are shown in Figure 8-40. The pincushion warp is a common distortion introduced by camera lenses. In fact, there are specific lens warps with many more elaborate adjustments beyond pincushioning that are designed to accurately recreate lens distortions for visual effects shots. A swirl warp is shown in the next example and might be used as an effect in a television commercial. The turbulence warp could be animated to introduce heat waves in a shot or the distortions created by viewing something underwater.

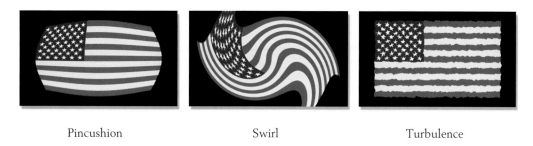

Pincushion Swirl Turbulence

Figure 8-40 Procedural warp examples.

8.11 THE MAGIC OF MORPHS

The morph provides the truly magical ability to seamlessly change one image into another right before the viewers' eyes. This has been a dream of moviemakers ever since Lon Chaney, Jr. appeared in his first Werewolf movie. Of course, this wondrous effect was immediately overused and run into the ground by every ad agency and B movie producer to the point that I actually saw a sign once in a visual effects studio that read, "Friends don't let friends morph." Here we will see "the making of" the morph shown in Chapter 1, which has been re-released here as Figure 8-41.

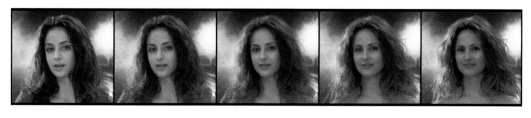

Image A Frame 2 Frame 3 Frame 4 Image B

Figure 8-41 Morph animation sequence.

It takes the computer two warps and a dissolve to make a morph, plus a talented digital artist to orchestrate it all, of course. The morph has an "A" side layer that dissolves (fades) into the "B" side layer. To morph image A into image B, we start by animating image A to warp into image B's shape over the length of the shot like the example in Figure 8-42. Image A starts out with no warp (0%), then by the end of the shot is warped 100% to match the shape of image B. Note that while the model in Figure 8-42 is nice looking at the beginning, by the time she is 100% warped to image B, she is not so nice looking anymore. For this reason, we do the A to B dissolve in roughly the middle third of the shot so we never see an unattractive 100% warped image.

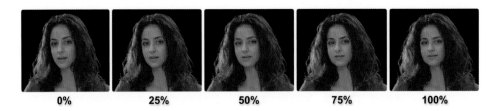

0% **25%** **50%** **75%** **100%**

Figure 8-42 Image A warps from A to B.

The warp animation for image B in Figure 8-43 starts the shot with a 100% warp to match the shape of image A, and then is "relaxed" over the length of the shot. Again, the not so attractive 100% warped image is never shown. If you compare the first frame of Figure 8-42 to the first frame of Figure 8-43, you will see that they have the same general outline, as do their last frames. As a result, the in-between frames also share the same general outline. We now have two synchronized "movies" of the warping faces and their mattes so all we have to do is dissolve between them and composite the results over an attractive background (Figure 8-41).

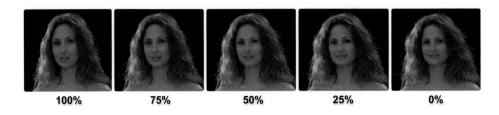

100% **75%** **50%** **25%** **0%**

Figure 8-43 Image B relaxes from A to B.

In any morph, the A and B target objects must first be isolated from their backgrounds. Otherwise, the background stretches and pulls with the target and looks awful. Therefore, the A and B images in the following example were both shot on bluescreen (or greenscreen), and then keyed with a digital keyer prior to being

warped. A side benefit of this is that their mattes also morph with them. If the target objects are not shot on a bluescreen, then you get to roto them before doing the morph.

Figure 8-44 Image A.

Figure 8-45 Warp splines.

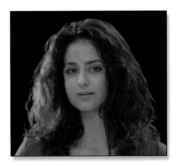

Figure 8-46 Image A warped to image B.

The starting point for morphing image A (Figure 8-44) into image B (Figure 8-49), is to first move, scale, and rotate the images to pre-position them as close as possible. The less you have to push and pull on the ladies' faces, the better they will look. Next is the placement of the warp splines on just those features that need a nudge in order to match their features to each other (Figure 8-45 and Figure 8-48). The general hair and face outlines needed a spline warp as did the mouth and eyes, but the noses were lined up close enough that they did not need to be warped and could "go natural."

Figure 8-47 Image B warped to image A.

Figure 8-48 Warp splines.

Figure 8-49 Image B.

The Art of Compositing

A compositor is, first and foremost, an artist, so this chapter focuses on the art of compositing. There are two levels of artistic excellence. First is the achievement of competent photo-realism, the objective of every digital composite. But beyond replicating reality in a convincing manner, there is also artistic enhancement—going beyond simply professionally assembling the elements provided and adding your own artistic panache to make the shot look cool. Good artistic design makes for good visual effects shots.

Digital compositing can be defined as taking several disparate elements that were photographed separately and integrate them into a single shot such that the various elements appear to have been shot together at the same time under the same lighting with the same camera. This journey begins by color correcting the elements so that they appear to be together in the same "light space." Then there are film and lens attributes that have to be made to match. Finally, the finished composite is sweetened by the addition of special operations designed to enhance realism and improve artistic appeal.

9.1 COLOR CORRECTING

The single most important aspect of a convincing digital composite is color correcting the various layers to all appear to have been photographed together in the same light space. There are several aspects to color correcting and it is easy to chase your tail, so here we will walk through a methodical step-by-step procedure that teases the issues apart and tackles them one at a time. A methodical approach saves time and gives better results.

The first step in the color correction of a composite is for the background plate to be color corrected. This is often referred to as *color grading*, and many visual effects facilities have a specific pipeline set up to ensure that the background plates for a related group of shots are all color graded similarly in order to maintain visual continuity. After the background is color graded, the compositor adds the various layers on top and color corrects them to match the color-graded background plate.

Whether you are compositing CGI or bluescreen elements, each element will need some level of color correcting. The CGI elements usually need less attention because they were originally created using the background plate as a reference and should be fairly close to begin with. However, the bluescreen elements were shot with no way to ensure that they matched the background so they are usually wildly off and require a great deal of love.

9.1.1 The Black and White Points

The starting point for an effective color correcting procedure is to get the black and white points correct because it also results in matching the contrast. The reason these have to be set first is that if they are wrong, then all other color corrections become much harder to judge. To make matters worse, if other color corrections are done first, when the black and white points are finally set correctly, you will then have to go back and refine all the other color corrections. Better to start with the black and white points set correctly first.

Strictly speaking, the black point and white point have a very specific meaning in the world of color science. However, this is not a book on color science, so we will bend the meaning to our purposes. For the purpose of color correcting a composite, the black point shall henceforth be defined as the black that would appear in a completely unexposed part of the picture. While these will be the darkest pixels in the image, they should not actually be set right at code value zero, since that can introduce clipping in the blacks. The white point is defined as the pixel value of a white T-shirt in bright sunlight.* The white point should not be set to code value 255 as that would leave no pixel values above it for highlights. The white point should be more like 230 to 240 or so, leaving a little "headroom" for the shiny bits of the picture.

A problem with the black and white points is that one or both layers of the composite may not have either of them in the picture. It is entirely possible to have a picture that has no totally black parts. Think of a cloudy sky shot. It is also possible to have a picture with no white points in the frame. Think of a black cat eating licorice in a coal bin. If there are no actual black or white points in one or both layers of the composite, then you would still follow the steps in the order outlined below, but with a lot more procedural estimation (guessing).

Pretend for a moment that the two layers you are trying to match both have black and white points within the picture. Our case study begins with the bluescreen in Figure 9-1, which is to be composited over the color-graded background in Figure 9-2. The un-color corrected raw composite is shown in Figure 9-3. The foreground layer is too green and the contrast is too low. We have our work cut out for us.

*The "white T-shirt in bright sunlight" white point is not very scientific. The scientific definition of the white point is a 90% diffuse reflective surface, and that is what a white T-shirt in bright sunlight would be, and the T-shirt is a lot easier to envision.

Figure 9-1 Bluescreen.

Figure 9-2 Background.

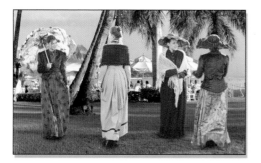

Figure 9-3 Raw composite.

Figure 9-4 Monochrome composite.

An ancient Chinese trick for color correcting digital composites is to make a monochrome version like Figure 9-4 for adjusting the grayscale of an image, which is the black and white points as well as the gamma. We will talk about gamma in a minute. The reason this helps is because it gets the color out of the way and lets the eye focus on the grayscale, or the luminance parts of the picture, which is what gamma and the black and white points are all about. It is a divide and conquer strategy designed to pare down and simplify the task.

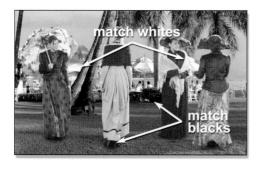

Figure 9-5 Check blacks and whites.

Figure 9-6 Match blacks and whites.

The next step is to inspect the monochrome composite to identify the black and white points in both the foreground and background. In Figure 9-5, the black point for the background plate was found under the shady bush between the ladies, and the black point for the foreground layer was found under the black sole of a shoe. The white point for the background plate was found to be the white awning, and for the foreground layer it is the white shawl in direct sunlight (about the same as our white T-shirt).

Keep in mind that the background plate has already been color graded and we need to match the foreground layer to that. The black point in the background was measured and found to be code value 10, while the foreground black point was code value 22. The white point in the background awning measured 240 and so did the shawl in the foreground. Code value 240 is a bit hot for a white point, but it is a brightly lit outdoor shot and we don't want to start a dust-up with the art director, so we will go with it.

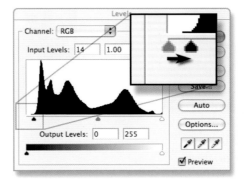

Figure 9-7 Adjusting the blacks.

The white point is good on our foreground layer, but we do need to bring the black point down to about code value 10 to match the background. How this is done depends on the color correcting tools your compositing system offers, but Figure 9-7 illustrates how this would be done using the "Universal Color Corrector," the Levels tool in Adobe Photoshop. The inset close-up shows that the black level has been set to pull the Input Level from 14 down to zero, which will shift code value 22 down to around 10. This increases the contrast of the foreground and we now have a fine match between the foreground and background in Figure 9-6. Keep in mind that when the black point was lowered like this, it had a small effect on the white point so it should be rechecked and touched up if necessary.

If one of the layers doesn't have one of the black or white reference points all is not lost. It is uncommon for a picture to be missing a black point, but let's say the foreground did not have a good white point. Look around the picture for the lightest element you can find. Maybe it appears to be an 80% gray (remember, we are working with the monochrome version here). Search the background plate for what appears to be another 80% gray and match them. Look for similar elements in both

layers, such as skin tones. Assuming skin tones in the background and foreground are in the same lighting they would be about the same brightness, also assuming the two characters had the same skin type, of course. You are definitely guessing—I mean estimating—but it is better than just eyeballing it. At least you tried to be scientific about it.

9.1.2 Gamma

After setting the black and white points, the next step is gamma correction. While the gamma adjustment mostly affects the midtones of a picture, its affect does spread all the way up and down the entire grayscale of an image. Still working with the monochrome version, adjust the gamma of the foreground layer for best match. Unfortunately, there is no slick procedural way to set this unless both the foreground and background layers were photographed with chip charts (Figure 9-8) to be used for a color reference, which did happen once in 2003. That's what I heard, anyway.

Figure 9-8 Chip chart.

The thing to know about adjusting the gamma is that it can shift your black and white points, so be sure to go back and check them after any gamma correction. A gamma correction alters all pixel values between 0 and 255, but does not alter 0 or 255 themselves. Since your black point is hopefully not at zero nor your white point at 255, they will be shifted a bit after the gamma correction. Note that the black point will be shifted more than the white point.

9.1.3 Color

We now have the grayscale set correctly for our case study so it is time to turn the color back on and check the color (Figure 9-9). Yikes! The girls are green! No worries, we will have that fixed in a jiffy. There are a couple of approaches to getting the color of the foreground to match the background. The problem with trying to match color like this is that you really don't know what color the foreground objects are supposed to be unless you were on the set when the objects were filmed. Maybe you will be on the set someday, but for now you will need another approach. The next best approach is careful observation of known color elements in the picture.

> **Caution**—it is not true that equal RGB values will create a neutral gray in all situations. Some display devices have a color bias, so in order to get a neutral gray to the eye the RGB values need to be biased. Another situation is when the lighting in a shot is not neutral. If the lighting were a bit yellow, for example, then to get a neutral gray to the eye it would have to have a bit of yellow in it.

Occasionally, there will be known gray objects in the picture. Their pixel values can be read and used to adjust the RGB values until they are equal.

Whoa, did you see that big caution on the previous page? Maybe you better not make the RGB values equal so much as make the gray object appear a neutral gray to the eye. There may be a known gray object in the background plate that you can use as a reference. Measuring its RGB values might reveal, for example, that a neutral gray in the background has a bit more red than green or blue, so the foreground gray should have a similar red bias.

When sampling pixel values of a photographic image to be used for setting the color of another image, you should run a small blur over the image being sampled. The natural grain or noise in the sampled image introduces variations at the pixel level that can give you false RGB readings. To address this issue some color sampling tools (the good ones) have an option to sample more than a one-pixel spot. They are, in effect, running a little blur over the spot you are sampling.

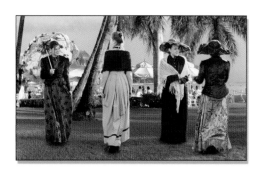

Figure 9-9 Color check.

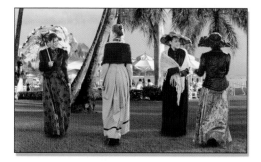

Figure 9-10 Color corrected composite.

One other technique is to use the skin tones, assuming there are some in the shot. We are very sensitive to the color of skin tones so adjusting the color until the skin tones look right can be very effective. Even if you use gray objects to balance the color, be sure to check the skin tones carefully. The "skin tone" method was used to color correct Figure 9-9 to get the color corrected composite in Figure 9-10.

Changing the color of a shot can change its brightness, causing you to go back to the beginning of the color correction procedure and start over. One color has much more affect on the apparent brightness of a picture than the others, and that color is green. Change the green level just a bit and the brightness changes a lot. Change the red or blue and the brightness is hardly affected at all. The idea here is to change the color of a shot without disturbing the green channel, which is not hard to do if you use the patented "constant green" method of color correction.

Figure 9-11 Constant green method of color correction.

Figure 9-11 shows how to adjust the RGB color sliders to increase any primary or secondary color without disturbing the green level. For example, to increase cyan, lower the red. To decrease any of these colors just move the sliders in the opposite direction shown here. For the overly green shot in Figure 9-9, instead of lowering green, the red and blue were raised.

9.1.4 Color Adjustments

When confronted with a layer that needs the color, or hue, corrected to match the other layers of the shot, the next question is which color correction adjustment should be used? Your composing software might offer lift, gamma, gain, contrast, hue, saturation, brightness, color curve adjustments and others, any of which may be used to correct the color problem. How can we choose which one to use? The first order of business is to be clear on exactly what each of these different adjustments does to the code values of the image and its appearance.

Figure 9-12 Reference.

Figure 9-13 Lift.

Figure 9-14 Gamma.

Figure 9-12 is the basic reference setup for demonstrating each color correction operation. The gradient across the bottom shows the pixel brightness from black to white and the graph plots their code values. Figure 9-13 shows the lift operation and how it affects the gradient. It has its largest visual impact in the darks so it is often referred to as "adjusting the darks" but don't be fooled, as you can see it also affects the midtones and whites, but to lesser degrees. Figure 9-14 shows the effect of a gamma adjustment, which is usually referred to as "adjusting the midtones." While its effects are mostly in the midtones, it also affects the darks a lot and the lights a little and it does not introduce clipping. Of course, the lift and gamma adjustments can go in the other direction to darken the image.

Figure 9-15 Gain (scale RGB). **Figure 9-16** Contrast. **Figure 9-17** Brightness.

Figure 9-15 shows the gain operation, which is also known as *scale RGB* because the gain operation actually does scale the RGB values. While it does affect the entire range of pixel values, its greatest impact is in the whites. Watch out for clipping, unless you scale the RGB values down. The contrast adjustment in Figure 9-16 raises both the whites and lowers the blacks so it can introduce clipping at both ends. There is no clipping danger if the contrast is lowered. Figure 9-17 shows the brightness operation, which looks a lot like gain (Figure 9-15) because they are mathematically identical. The only difference is that typically gain allows you to adjust each color individually, while brightness adjusts them all together as one.

 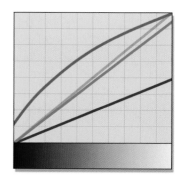

Figure 9-18 Saturation. **Figure 9-19** Hue. **Figure 9-20** Color curves.

Figure 9-18 is an attempt to illustrate saturation but the graph is only suggestive, not literal. A saturation increase moves the RGB values of a pixel further apart, suggested by the three graph lines moving apart. Most saturation operations are smart enough to prevent clipping. The hue adjustment in Figure 9-19 indicates how it actually rotates the pixel values around the color wheel. A green pixel will move to yellow then to red and so on. Figure 9-20 shows three color curves, one for red, green, and blue that can be individually adjusted to affect any portion of the color space any way you want. Color curves are very powerful, but hard to control.

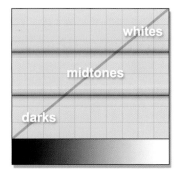

Figure 9-21 Zones.

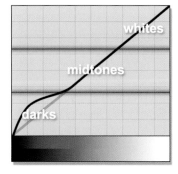

Figure 9-22 Darks only.

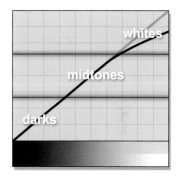

Figure 9-23 Whites only.

There is a more elaborate type of color corrector, illustrated by Figure 9-21, which splits the range of adjustments into three "zones": The darks, the midtones, and the lights. First, the zone to be affected is selected and then all color corrections are limited to that zone and gently blended into the next. Figure 9-22 illustrates increasing the brightness in the darks. The gradient across the bottom of the graph is split to show the effect of the change. The bottom half of the graph is the "before" and the top half is the "after." Figure 9-23 illustrates a lowering of the whites with the gradient showing the change.

Now that we know how each adjustment will affect the code values of our pixels, the next question becomes, "Which adjustment do we use under what circumstances to fix the color of a shot?" Remember, we already have the black and white points set as well as an overall gamma correction. At this point, we are only concerned about the overall hue of the shot, in this case, the green ladies in Figure 9-9.

To decide which color correction operation to use we first need to determine where in the image the color needs to be changed—the darks, the midtones, or the whites. If it is only in the darks, then use the lift; if it is only in the midtones, then use the gamma; if it is only in the whites, then use the gain. Use these operations on a per-channel basis and don't forget that they also affect the other parts of the image, but to a lesser degree. For example, if the darks had too much red, then lower the lift of the red channel. If the whites had too little blue, then increase the gain of the blue channel. If the midtones were too green, then increase the gamma of the red and blue channels. Remember, we want to leave the green channel alone as much as possible to avoid affecting the overall brightness.

9.1.5 Pre-Balancing the Color Channels

The process of color correcting a layer to match the background is made much more difficult if the layer starts way off. Pre-balancing the color channels means to view and adjust the composite one channel at a time to blend it better with the background. While this method is not really suitable for final color correction, it can get things in a much better starting position, which will make the final color correction faster and easier.

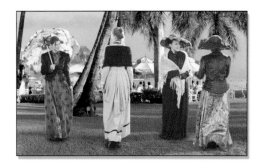

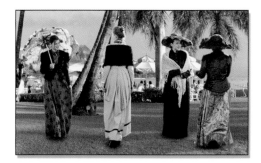

Figure 9-24 Green channel before. **Figure 9-25** Green channel after.

Figure 9-24 shows just the green channel of the composite before color correction, while Figure 9-25 shows the same channel after. After all three color channels have been individually color corrected, then the image viewer is set to show the full color RGB image to do the final adjustments. You will be pleasantly surprised at how close this procedure can get you to a finished color correction.

9.1.6 Gamma Slamming

Visual effects shots are typically developed on a workstation with the picture displayed on the workstation monitor. However, after the shot is finished it goes off to film, video, digital cinema, or some other display device. Those other display systems have different characteristics and color spaces than the workstation monitor that can exaggerate even small differences between the layers of a composite. The shot may also go to a colorist, which may increase the contrast or "stress" the shot in other ways. This can cause the different layers of a composite to visually "pull apart" and become noticeable. Gamma slamming can be used to prevent this embarrassing development by exaggerating any small discrepancies so you can find them before the client does.

The procedure is to add a gamma adjustment to the final composite, which will be used for viewing purposes only, not as part of the shot. With some compositing

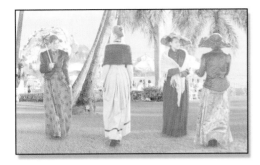

Figure 9-26 Gamma up to 3.0.

Figure 9-27 Gamma down to 0.2.

systems, you can adjust the gamma of the image viewer instead. The gamma is "slammed" from one extreme to the other to "stress" the image and see if any of the layers pull apart visually. Figure 9-26 shows our case study composite with the gamma slammed all the way up to 3.0, blowing out the shot. At this extreme, any difference in the blacks between the foreground and background layers would become very noticeable. Figure 9-1 shows the gamma slammed down to 0.2. If the midtones or highlights did not match between the two layers, that would show up here. Gamma slamming should be done on every composite you do.

Figure 9-28 Original shot.

Figure 9-29 Clipped pixels revealed.

One other important use for gamma slamming is to detect clipped pixels in a shot. Again, we really should not have any pixels in a photo-realistic visual effects shot that have RGB values of exactly zero or 255. Recall from the gamma correction discussion that the gamma operation does not touch the pixels with RGB values of 0 or 255. By slamming the gamma way down to 0.01, for example, almost all of the RGB values less than 255 get pulled down toward black. This leaves on the screen only those pixels with RGB values of 255, which are the clipped pixels.

The original shot in Figure 9-28 was captured with a high-resolution digital still camera so the image is riddled with clipped pixels due to the high dynamic range of the scene content (the bright lights). A severe gamma correction of 0.01 was applied to it to create Figure 9-29, which reveals all the clipped pixels in the shot. Not only does this show you where the clipped pixels are, but it also shows which channels are clipped. Where there are white pixels, all three RGB values must be code value 255 so all three channels are clipped. The pixels that appear red must have red values at 255, but the other channels are lower, so only the red channel is clipped there. Yellow pixels must have red and green at 255 so they are both clipped, and so on through the colors.

If the original images you are given to work with are already clipped, there is nothing you can do. However, you need to make sure that you did not introduce any new clipped pixels into the shot. Slam the gamma on the original image and compare it to your finished composite to make sure you have not added to the problem.

9.2 MATCHING LAYER ATTRIBUTES

In addition to a convincing color correction on all of the layers of the composite, there are a host of additional layer attributes that need to be matched. You will be combining two or more layers of film (or video) and each layer will have its own grain (or noise) that will have to match the rest of the shot. This goes double for CGI or a digital matte painting that has no grain to begin with. If any one of the layers was photographed through a lens, it will have a depth of field and lens distortion imparted to it that needs to be dealt with. Of course, shadows are a key visual cue that must be consistent between the various layers of a composite.

9.2.1 Grain Structure

Film has a very noticeable grain structure that is part of its unique look. Many consider it one of film's major charms. Compositors consider it a royal pain in the arse. The reason it is a problem is that the grain structure of all of the layers of a composite must match. If the layer being added has no grain, such as CGI or a digital matte painting, then it is easy enough to add grain. However, if it is another layer of film, such as a bluescreen element, it already has its own grain. If its grain structure does not match the background, it is much more difficult to fix. If a film element is scaled up or down, its grain structure goes with it and it will no longer match the rest of the shot. Many times a digital matte painting is created using a frame from the film as the base, so now it has grain "frozen" into the picture. All of these grain issues must be addressed.

Figure 9-30 is a gray chip from an actual piece of digitized film to show the film's grain structure. There are two key points: The first point is that the grain pattern on

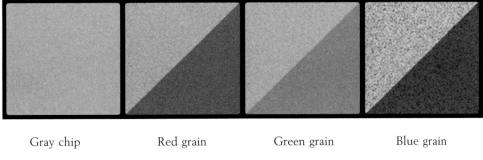

Gray chip Red grain Green grain Blue grain

Figure 9-30 Film grain structure.

each channel is unique. It is not one grain pattern embossed into all three layers, it is three unique grain patterns. The second point is that while the red and green grain is similar, the blue grain is considerably "grainier." The film's grain will vary with different kinds of film stock and different exposures of the film. The grain can vary in both the size of the grain particles and their contrast, meaning, how much they vary from dark to light. The blue channel grain will be both larger and have more contrast than the red and green channels as you can see in Figure 9-30.

If the grain of a layer of film is a problem, then why not just degrain it and regrain to match? Because degraining film is very difficult. If a blur or median filter is used, the picture turns soft. There are special degrain programs out there, but they are pricey and tend to soften the picture, but not as badly as a simple blur. If you don't have sophisticated degrain tools, there is one trick that can help. Since most of the picture detail is in the red and green channels, but most of the grain is in the blue channel, you can usually improve the situation by blurring just the blue channel.

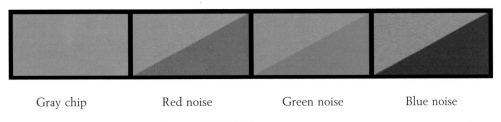

Gray chip Red noise Green noise Blue noise

Figure 9-31 Video noise structure.

Video does not have grain, but perversely, it has noise, which is the video version of grain, shown in Figure 9-31. Even more perversely, it is again the blue channel that has the highest level of noise. Like film grain, the video noise pattern is unique for each channel. The good news is that video noise is almost always much less than film grain. The exception stems from low light shots where the videographer has cranked up the video camera's gain to brighten the picture, which dramatically

increases the video noise level. Whether film or video, the digital compositor's mission is to match the grain or noise between all layers of the composite.

9.2.2 Depth of Field

All lenses, whether they are on film, video, or digital cameras, have a depth of field. That is, a zone where the picture is in focus and everything in front and behind that zone is out of focus. Cinematographers use this very deliberately when selecting lenses for a shot in order to keep the item of interest in sharp focus and everything else out of focus. The eye ignores the out of focus parts, so this is an important cinematographer's tool for keeping your eye where they want it. This makes the depth of field a very important part of the storytelling, in addition to being an essential element of a technically correct composite.

Your mission as a digital compositing artist is to introduce the correct depth of field to each layer that you add to the shot by defocusing it as needed. You inspect the scene carefully, estimate where the new layer is relative to the other objects in the shot, and then set its depth of field appropriately. If the element moves front to rear, you may have to animate the defocus. While something out of focus is blurry, a blur is not a defocus. Some compositing programs acknowledge this with an honest "depth of field" or "defocus" operation. Use 'em if you've got 'em. The rest of us must use a blur and hope that nobody notices. Of course, if you apply a blur to an element to defocus it, the grain will be wiped out so it will have to be restored with a regrain operation.

Figure 9-32 Medium.

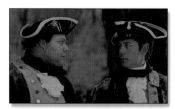

Figure 9-33 Closer.

Figure 9-34 Close-up.

In general, the depth of field gets shallower the closer the focused target is to the lens. Here are some examples of this beginning with Figure 9-32. This medium shot has the two characters in focus, but the far wall is out of focus (note the flowers in the background). The depth of field is even more noticeable in Figure 9-33 where the two chaps are chatting over a very blurry background. The close-up in Figure 9-34 has such a shallow depth of field that the lady's far shoulder is actually out of focus. An extreme close-up of a face might have the nose and eyes in focus but the ears might be out of focus!

9.2.3 Shadows

The eye notices the lack of shadows immediately, so they are an essential element of a convincing composite. Nothing integrates two layers together like having the shadow of one layer cast on the other. Nothing reveals a bad composite like their absence. Any existing shadows in the background plate should be studied for clues as to the direction, sharpness, and density for making your faux shadows. If there are no shadows to study, then think about the nature of the lighting in the shot as a guide to the nature of the shadows that would be cast.

Shadows are not simple things. They have an inner core and an outer edge, and there is the all-important contact shadow. In this section, we will take a look at creating a progressively more realistic shadow to see what makes up a good shadow. The shadow is applied to the background layer prior to the composite by multiplying it by each shadow mask. Let's take a look.

Figure 9-35 Bad mask.

Figure 9-36 Bad shadow.

We start with the bad mask in Figure 9-35 producing the bad shadow in Figure 9-36. What makes this shadow bad is that the mask is one solid density throughout. As a shadow falls away from its contact point, it gets lighter because progressively more ambient light is falling on it. The mask should be denser near its contact point then fade off the further out it goes.

Figure 9-37 is a better mask that creates a better shadow, as shown in Figure 9-38. A spline shape was used and the inner and outer splines that are normally used

Figure 9-37 Better mask.

Figure 9-38 Better shadow.

to make the motion blur were used to fade off the shadow the further it gets from its base. But if you look closely at the feet in Figure 9-38, they still don't look like they are in solid contact with the ground. The reason is that as the shadow goes under the feet, which are supposed to be in contact with the ground, the shadow should become extremely dense. This dense shadow at the point of contact is called a *contact shadow*.

Figure 9-39 Best mask.

Figure 9-40 Best shadow.

A contact shadow has been added to make the best mask in Figure 9-39, which makes the best shadow in Figure 9-40. Compare Figure 9-38 to Figure 9-40 and you can see how much more firmly the feet are in contact with the ground.

So where do you get your shadows? There are three places where you might get them. First is from the bluescreen plate itself. If there are shadows in it and you are using a fine digital keyer and you are a master at tweaking it, the keyer can lift the shadows and composite them for you. At least that is what the manual says. The second possible source is to use the compositing matte. It can often be squashed and stretched and blurred to make a decent shadow. The third and last place to get a shadow is to roto one by hand.

9.2.4 Lens Distortion

All cameras, whether film, video, or digital still, capture their scenes through a lens, and even the finest prime lenses introduce lens distortion into the picture. Sometimes it is minimal and doesn't create a problem, other times it is hugely problematic and gets in your face. Although perhaps a bit overdone for dramatic impact, Figure 9-41 does show the nature of a typical lens distortion. Sometimes the cinematographer will actually shoot a grid chart like this so visual effects folks can figure out the lens distortion and factor it into the shots. More on that interesting idea in a bit.

Lens distortion ruins our day in three different ways. The first problem is in motion tracking. Imagine tracking two or three points on a plate as the camera pans from left to right. Referring to Figure 9-41, instead of the points moving smoothly in a rigid flight formation across the frame, they would drift apart then drift back together as they moved through different regions of the lens distortion. This will

Figure 9-41 Lens distortion.

confuse the motion tracker and give you bad track data. The second problem is the shape distortions on objects. Figure 9-42 shows three frames of a camera pan. If an element fit perfectly over the main cluster of buildings in the center of frame 1, by the time the camera moved to frame 3 , the buildings would be distorted and the element would no longer fit. The third problem is that you are required to match these lens distortions in your composites. Because CGI is rendered with mathematically perfect lenses, it has no lens distortion so you will have to put it in.

Frame 1 Frame 2 Frame 3

Figure 9-42 Lens distortion on moving footage.

The general solution to lens distortion is to un-distort the plate. There are programs and tools that are specifically designed to figure out the lens distortion and flatten out the plate. These tools are especially effective if a grid chart was photographed with the same lens that was used for your shot. Don't laugh. It has happened. Once the plate is flattened, you can then do your motion tracking and compositing on nice flat elements, then re-distort the finished composite to re-introduce the original lens distortion. Very nice. If you are also doing a camera pan on a flat element such as a matte painting, be sure to introduce a little lens distortion. If you don't, instead of looking like the camera is panning around a real scene it will look like someone is sliding a flat postcard in front of the screen.

One thing to watch out for is zoom lenses. A prime lens is difficult enough to cope with and it has a single, fixed focal length and unchanging lens distortion. The zoom lens has a constantly varying lens distortion as it racks through the zoom providing infinite challenges to the lens un-distort tools.

9.3 SWEETENING THE COMPOSITE

Once you have done a yeoman job of color correcting and a matching layer attributes of a shot, there are several things that can be done to "sweeten" the composite. The following are things that turn a good composite into a great composite. They not only subtly enhance the photo-realism, but they add an artistic flourish to the shot that makes your work stand out.

9.3.1 Light Wrap

In the real world, light bounces around everywhere ricocheting off everything and landing on everything else. We call this *interactive lighting.* Interactive lighting is difficult to do in a 2D composite, because it is a 3D phenomenon. The CGI folks have tons of built-in support for this that they refer to as "global illumination models." But their world is 3D, so they can compute the 3D interaction of light between the various surfaces in a scene. We cannot. We have to fake it. Following is a truly great fake.

As we saw in the chapter on bluescreen compositing, the edges of the talent get spill light from the bluescreen, which contaminates them. Light from the backing color seems to "wrap" around the edges of the talent. The same thing would happen if the talent was standing in the middle of a cornfield. The difference is that the cornfield light would look natural and nice as it softly lights the edges of the talent, so nobody would be trying to remove it. In fact, if the talent were composited into the cornfield without this edge lighting, it would look somehow odd and not belonging. The light wrap is a simulation of this natural edge lighting phenomena.

Our case study of the light wrap technique begins with the original composite in Figure 9-43. Note how the gray sphere looks just pasted on top of the background and does not look at all like it is in the same "light space." The first step is to create the light wrap mask that is shown in Figure 9-45. Note how it is dense at the outer edge then fades off toward the inside. To make this mask, simply start with the matte used to composite the foreground (Figure 9-44), give it a good blur, invert it (swap black and white), and then multiply the inverted version by the original matte. The results will look like Figure 9-45.

Figure 9-43 Original.

Figure 9-44 Matte.

Figure 9-45 Mask.

Figure 9-46 Final.

Figure 9-47 Light wrap.

Figure 9-48 Soft BG.

The next step is to create the light wrap element itself, shown in Figure 9-47. Make a very blurry version of the background plate (Figure 9-48), then multiply it by the mask from Figure 9-45. The reason for the big blur on the background plate is to blend away any fine detail. If the fine detail is not eliminated, the edges of the foreground will simply appear semi-transparent. Not what we want.

Note how the light wrap element in Figure 9-47 is dark around the bottom where there is no light from the background. Also, both the color and the brightness of the background light are captured in the light wrap element. The last step is to simply screen the light wrap element from Figure 9-47 over the original composite in Figure 9-43 to produce the final composite shown in Figure 9-46. The gray sphere now looks like it has light from the background plate lighting up its edges. Sweet.

The light wrap is supposed to be a subtle effect, more felt than seen. For purposes of expository impact, I have grossly exaggerated the effect in this case study. Hopefully, you won't in your composites. You can control the width of the light wrap by how big the blur is when you make the mask, and how bright it is by lowering its brightness before it is screened. We don't want to suddenly see a bunch of glowing composites out there!

9.3.2 Edge Blend

The edges in the background plate have a certain sharpness that must be matched by the edges of the composited elements. In film, a "sharp" edge might be 3 to 5 pixels wide. For High Definition video it might be 2 or 3 pixels, and for NTSC, it will typically be about one pixel. If there are depth of field issues, then the edges can be many pixels wide. Very often when pulling a matte for a bluescreen, the matte edges become "hardened" (sharp-edged), so when the foreground is composited with this sharp-edged matte, its edges become too sharp compared to the rest of the background. Something must be done.

That something is edge blending. The basic idea is to create a thin mask that goes all around the perimeter of the foreground layer, and then use this mask to gently blur only the edges of the composite. This is a completely different look and much more natural than just blurring the matte before compositing. Composite with your best matte, then edge blend the finished composite.

Figure 9-49 Original composite.

Figure 9-50 Matte.

Figure 9-51 Edge blended.

Figure 9-52 Edge mask.

Our case study begins with the original composite in Figure 9-49 whose edges are deemed too sharp for the rest of the picture. To create the edge mask in Figure 9-52, start with the matte used to composite the foreground and run an edge detect on it. The edge detect produces a thin mask that runs around the perimeter of the matte, but most importantly, this mask straddles the edge between the foreground and the background. This is key, because we want to actually mix the foreground and background pixels across the edge. The last step is to apply a modest blur to the original composite that is masked with the edge mask from Figure 9-52. This is another one of those "felt, but not seen" treatments. View the finished composite from a normal viewing distance to judge whether the effect has been over or under done.

For high-resolution work like feature film or HDTV video, the width of the edge mask should be 2 or 3 pixels. For NTSC, a normal composite would not require

edge blending unless the element was defocused. Check to see if the edge blended region has lost too much grain. If yes, then use the same edge mask to regrain the edge blended region. Now the question is, "Which to do first: edge blend or light wrap?" The answer is . . . light wrap first, edge blend second.

9.3.3 Layer Integration

Very often, a beginning compositor will just slap A over B and call it done. While the results may be reasonably photo-realistic, they will certainly be uninspiring. As artists, we need to add our artistic touch to the shot. One way to do that is to integrate the layers with each other so that the foreground is not just on the background but is in the background. The basic idea is to design the shot so that some portion of the foreground layer is situated behind some element of the background. This puts it in the background.

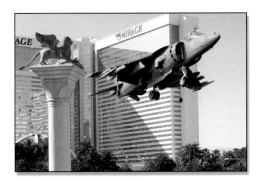

Figure 9-53 Jet on the background.

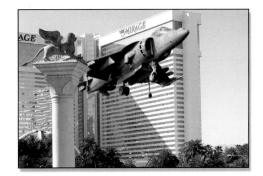

Figure 9-54 Jet in the background.

Our case study begins with the big budget, action stunt blockbuster in Figure 9-53 where Arnold Schwarzenegger is dropping in to his favorite Las Vegas casino for a little light gambling. Arnie's jump jet is competently composited over the background, but with a small shift in the jet's position to the left, it is now behind the foreground column in Figure 9-54. This places the jet within the background plate, which helps to sell the composite. It is also more visually interesting. So look around the background plate to see if there is an opportunity to integrate the foreground layer into the background in an artistic and interesting way. This is why we get the big bucks.

9.3.4 Artistic Embellishment

When working on a visual effects shot, you will be given the background plate and the one or two (or ten) foreground layers that are to be composited together. Of

course, you will do a technically competent, even artistic job and pull excellent mattes, color correct everything well, manage the lens distortion, and do your light wrap and edge blending. However, there is another level to aspire in which you add your own small artistic embellishments to a shot to add interest and detail.

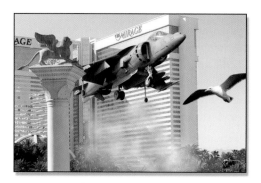

Figure 9-55 Dust and gull added.

Figure 9-55 picks up where we left off with Arnie's landing. A couple of embellishments have been added: A dust layer created by lifting some smoke out of the studio's elements library then color corrected to fit in, plus a rare Las Vegas desert seagull was lifted out of another shot from the same movie. Adding small artistic embellishments like this adds your personal creative signature to a shot and endears you to the client. Of course, be sure not to get carried away with this and clutter up the shot or run over schedule.

9.4 A CHECKLIST

There is a lot to think about and remember when preparing a visual effects shot, so here is a checklist to help you out. I recommend you go through the checklist when first setting up a shot to help you plan what you are going to include. When the shot is done go through the checklist again to make sure you have addressed everything.

9.4.1 Color Correction

- Do the black and white points match? (check with grayscale)
- Does the gamma match? (check with grayscale)
- Did you do a gamma slamming check?
- Do the flesh tones look realistic?
- Does the overall color match between the layers?
- Have I checked for clipped pixels?

9.4.2 Lighting

- Does the shot need light wrap?
- Does the shot need shadows?
- Do the shadows have reasonable density and fall-off?
- Is any atmospheric haze needed?
- Does the shot need any interactive lighting?

9.4.3 Layer Attributes

- Is the edge sharpness consistent between all layers?
- Does the shot need edge blending?
- Have any depth of field issues been addressed?
- Does the grain or noise match between all layers?
- Have I accounted for any lens distortion?
- Are the layers integrated as much as possible?
- Can I add any small artistic embellishments?

10 Scene Salvage

Scene salvage covers a broad range of issues that all have one thing in common—something is wrong with the picture and you have to fix it. Sometimes these are production accidents such as a scratch on the film, a hair in the gate, flashing frames, or a light leak. Insurance money often pays for these. Sometimes they are pre-planned, post-production processes such as wire and rig removal where it was planned to fix them after principal photography anyway. Then sometimes it is just a normal part of life like dust busting. Many of the tasks described here are considered entry-level work and may be the first type of job you get when starting your career in digital compositing.

The production accident class of problems is often the most challenging to fix because they are, by definition, unplanned acts against nature and can be hideously complex to deal with. Some are simply unfixable. A regular visual effects shot can be complex, but at least somebody sat down and thought through the best way to build the shot and prepared elements appropriately. We hope.

This chapter works through several case studies of common scene salvaging problems. The examples are designed to do two things: First, to show the enormous range of problems that can be repaired by the modern digital compositor today; and second, to demonstrate many of the techniques used to perform those repairs. The repair techniques include clone brushes, motion tracking, clean plates, and many others. While a repair technique is demonstrated for each problem, in the real world a given shot may require any (or all) of the techniques described herein.

10.1 DUST BUSTING

Film cameras are mechanical things, so even though they are cleaned regularly during the shooting day dirt somehow still manages to get on the camera negative. When the negative goes to the lab for developing, the dirt puts a black spot on it, which turns into a white spot when the print is made, or if the film is transferred to video, or if the negative is scanned for a visual effects shot. That's when you get it. Digitally painting out these "dirt hits" is called dust busting.

Virtually every visual effects shot will need dust busting unless it was initially captured on video. In larger facilities, there may be a dust-busting department, but in smaller facilities, the digital compositor often does this personally. There are automated tools used to remove dirt, but they also tend to remove some things that you didn't want removed. There are semi-automated tools that make their best guess then ask for human permission before obliterating a dirt spec. If there are a lot of shots to dust-bust, then these systems make economic sense. Otherwise, you will be using a paint program similar to Adobe Photoshop and dust busting with a clone brush. The clone brush copies a small piece of the picture from a matching location and pastes it over the dirt spec.

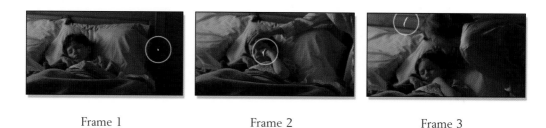

Frame 1 Frame 2 Frame 3

Figure 10-1 Negative dirt appears as white flecks.

Figure 10-1 shows a sequence of three frames of enduring maternal charm, except for the obnoxious white dirt flecks popping on and off every so often. Each dirt hit is circled for easy identification. One even lands right on the cherub's cheek in frame 2. The clone brush is the dominant tool for dust busting and works by having two circular regions: one where the pixels will be copied from (the source), and one where they will be laid down (the destination). Because the clone brush is copying small sections of the picture from place to place, the grain characteristics, color, and texture of the region are preserved. The art in dust busting is to thoughtfully select your source.

Figure 10-2 Slope of the brightness.

Figure 10-3 Don't clone parallel to the slope.

Figure 10-4 Clone at right angles to the slope.

The brightness of a region is almost never uniform. It invariably "slopes" from dark to light in one direction like Figure 10-2, indicated by the arrow. If the source

(marked with crosshairs in Figure 10-3) is selected parallel to the line of the slope then a darker region will be cloned into a lighter one making a noticeable blunder. The direction of the brightness slope must be carefully observed, then the clone taken at right angles to it like the example in Figure 10-4. This ensures that the source region is the same brightness as the destination region. However, it is sometimes difficult to find these properly sloping regions when dust busting.

Frame 1 Frame 2 Frame 3

Figure 10-5 Dust-busting frames with a clone brush.

Returning to our dirty frames, a close-up of the dirt hit in each frame, as shown in Figure 10-5, shows how the clone brush is set-up for each fix. In each case, the slope of the clone brush source and destinations is perpendicular to any slope in the brightness of the repair region. Frame 1 is in a very dark region so this is somewhat forgiving. Frame 2 is a serious challenge because the cheek has a lot of slope to its brightness, but there is not much room to clone from. Frame 3 has the seam in the board to retain so the clone brush is set parallel to it in order to restore the seam over the dirt.

10.2 WIRE REMOVAL

The explosion in popularity of wild action films has caused a commensurate explosion in the use of "wire gags," where the hero is trussed up with a harness under his clothes connected to wires and pulleys. On the other end of the wires are the beefy folks that pull on them at just the right moment to boost the hero so he can leap over tall buildings or karate kick eleven bad guys before touching down. Of course before the shot can be used, the wires have to be removed. That's where we come in.

Our wire removal case study depicts a camera push in to a boy perched precariously on a fifth story balcony. Since OSHA takes a dim view of dropping kids from balconies, the production company decided to add the safety wires. Now we get to remove them, starting with the target frame in Figure 10-6. The challenge here is that the camera is moving and the wires cross over a complex background, namely the building. We need to replace the wire with a thin strip of building without the wire. Because of the camera move, we have just what we need in Figure 10-7, which will serve as the source frame for a clean piece of building. Note that the wire is

covering a different part of the building in Figure 10-6 compared to Figure 10-7, so we will borrow a thin strip of clean building from the source frame to cover the wire in the target frame.

Figure 10-6 Target frame.

Figure 10-7 Source frame.

Figure 10-8 Source frame repositioned.

The first step is to reposition the source frame to line it up with the target frame. Figure 10-8 shows the source frame repositioned so that the buildings are lined up exactly. The alignment of the source and target frames is checked with a 50% mix in Figure 10-9. You can see that the buildings are right on top of each other, but that there are two sets of wires. This is exactly what we want. This means that under the wire in the target frame, there is now a clean area of the building from the source frame.

Figure 10-9 Source and target frames aligned.

Figure 10-10 Paint through.

The last step is to "paint through" from the aligned source frame to the target frame using a "clone" brush. A clone brush can also clone between two different images as we are doing here. Figure 10-10 shows the right-hand wire nearly painted out with cloned pixels from the building of the aligned source frame. Since the camera is continuously moving, it will be necessary to continuously select new source frames and align them on a frame-by-frame basis over the length of the shot, but the results will be most excellent.

This wire removal shot had the added complication of a complex background that had to be restored where the wire used to be. If this had been a bluescreen shot, it would have been a simple matter to just clone nearby bluescreen pixels over the

wires within the same frame, which would avoid the additional step of aligning a source frame to paint through.

10.3 RIG REMOVAL

When a motion control shot is done on a model, it has to be supported by some kind of armature or rig. Sometimes the armature is static and the camera moves, but the rig can also be a motion control device that moves the model around. Motion control, whether for cameras or rigs, means that the device in question is moved by electric motors under computer control. There are no humans moving the camera or model. The main advantage to this is repeatability. The shot can be filmed in several identical passes, each capturing a different lighting version of the model, then these passes are combined in compositing very much like the multipass renders for CGI, as we saw in Chapter 3, Compositing CGI.

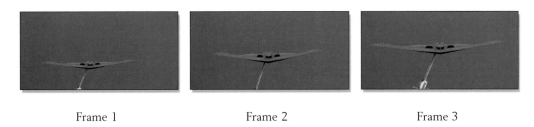

Frame 1 Frame 2 Frame 3

Figure 10-11 Bluescreen motion control shot with an armature rig.

The rig removal case study begins with the original B2 stealth bomber motion control bluescreen footage, as shown in Figure 10-11. The camera is locked off, but the model is coming toward camera and rising in frame. The fact that the rig does not change shape but only gets larger and drifts to the right offers an opportunity for a simple solution for this shot.

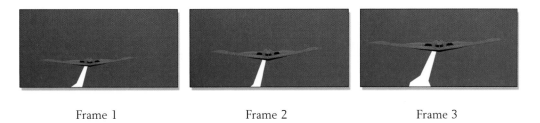

Frame 1 Frame 2 Frame 3

Figure 10-12 Mask motion tracked over the rig.

The solution starts by creating a single mask that covers the rig, then motion tracking it over the rig for the length of the shot as shown in Figure 10-12. Because

the rig is not changing shape, we do not have roto it. The mask is drawn over the frame that has the most exposed rig, which is Frame 3. The shot is then motion tracked in reverse. The last step in the rig removal takes advantage of the fact that the background is a uniform bluescreen surface instead of something complex and detailed such as terrain, so we can simply composite an adjacent piece of the bluescreen over the masked area.

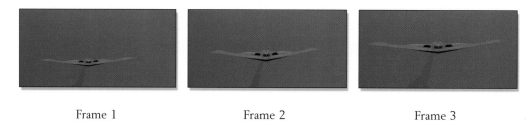

Frame 1 Frame 2 Frame 3

Figure 10-13 Bluescreen shifted over to cover the rig.

The final fix is seen in Figure 10-13. For each frame, the bluescreen was simply shifted to the right just enough to cover the motion tracked mask. A small problem was introduced because the left side of the bluescreen is a bit darker than the center and right. As this darker region was shifted over and composited over the rig, it covered it with a slightly darker version of the bluescreen, which you can actually see in the finished composite. The fix is to apply a small color correction to the bluescreen patch to match it up better with the rest of the backing. The uncolored corrected version was used here to show the problem.

The slick thing about this particular example is that the entire rig removal was done procedurally—that is, using rules that the computer follows rather than using frame-by-frame manual techniques. The only manual operation was the creation of the single original mask. Everything after that was procedural. Procedural solutions, when they can be used, are faster and give more consistent results than manual techniques.

10.4 HAIR REMOVAL

Even though there is an assistant camera operator (the AC), whose job it is to load film and clean the lens and film gate, it often happens that a hair gets stuck in the gate anyway. This vexing event will afford us the opportunity to examine some more scene salvage techniques and to collect some more insurance money. The hairy frames can be seen in Figure 10-14. The camera is wandering left and right while it tilts up on the shelves and the hair is twitching a bit, as it often does. The hair twitches because the film is advanced from frame to frame, which tends to tickle the hair each time.

Frame 1 Frame 2 Frame 3

Figure 10-14 Hair removal sequence.

The hair is constant in size and position (except for the twitching), so we can make a single mask to cover the hair for the whole shot, as shown in Figure 10-15. The mask is made large enough to allow for the twitching, and the edges are very soft to blend the edges of the repair.

Figure 10-15 Hair mask.

Frame 1 Frame 2 Frame 3

Figure 10-16 Clean plate motion tracked to each frame.

The next step is to create a clean plate, which is a single large image that covers all of the area that the hair contaminates as the camera moves around. The clean plate is cobbled together by cutting and pasting together pieces from several different frames to create a "master" hairless version. It is then motion tracked to follow the camera move, which locks the clean plate to the moving shelf like the sequence in Figure 10-16. This puts a piece of clean background behind the hair on every frame. The last step is simply to composite the clean plate over the hairy frame using the hair mask from Figure 10-15. The repaired frames are shown in Figure 10-17.

Frame 1 Frame 2 Frame 3

Figure 10-17 Repaired frames.

While this technique of motion tracking a clean plate works well, it does introduce a small problem, and that is the grain. The clean plate has "frozen grain" because it is made up of pieces of film frames so the grain in the repaired area will be noticeably static compared to the surrounding area, which can be quite objectionable. The fix is to degrain the clean plate, then use the same hair mask to regrain the repaired area of each frame. The degrain operation will soften the clean plate a bit, but a slightly soft area where the hair used to be will be far less objectionable than the frozen grain.

10.5 SCRATCH REMOVAL

Occasionally it happens that the camera negative gets scratched. This can happen in the camera or in the lab. Some small bur presses on the film, and then the equipment drags the film over the bur imparting a continuous scratch down the length of the film. I once saw a 2000 foot scratch where an entire 2000-foot roll of film was damaged. Think of it as job security. Even modern film scanning can introduce a "digital scratch" if the scanning sensor develops a bad spot.

The way to spot the difference between the two types of scratches is to play the footage at speed. The mechanical scratch will weave side-to-side a bit, but the digital scratch will be rock steady. Knowing this helps with the fix because if the scratch is rock steady we can make a small tight-fitting mask, but if it is weaving, the mask has to be wider to cover the moving target. The smaller the masked region to repair is, the more solutions are available and the easier the fix.

Frame 1 Frame 2 Frame 3

Figure 10-18 Scratch removal sequence.

Our scratch removal case study begins with frame 1 in Figure 10-18. The scratch is the dark vertical line just left of the man and it passes through three different "zones" in the picture—the wall, his shirt and pants, and the plate on the table. The camera is locked off (not moving), but people move and squirm when they talk. Since the scratch spans these three different "zones," we will need three different fixes, and therefore, three different masks. Figure 10-19 shows the first mask, the thick white line covering the wall scratch. The mask for the clothes fix is shown in Figure 10-20 and the plate mask is in Figure 10-21. We now have each zone separately isolated over the length of the shot.

Figure 10-19 Wall mask.

Figure 10-20 Clothes mask.

Figure 10-21 Plate mask.

The wall fix is an easy one. Since the wall has no detail other than grain, we can use a computer trick that "grows" the edges of the masked region toward the center to fill in the scratch with wall pixels. This edge-growing fix is shown partially completed in the close-up of Figure 10-22. The problem that this process leaves is that the pixels in the repaired region look noticeably smeared horizontally. We will simply use the same mask to regrain this area and be done with it.

Figure 10-22 Edge grow technique.

Figure 10-23 Warp and track clothes.

Figure 10-24 Clean plate repair.

The clothes are fixed by first making one clean "patch" of clothes by painting out the scratch. This clean patch is then tracked and warped over the scratched area like the illustration in Figure 10-23 (the background plate has been turned to grayscale to better show the clean patch). The mask is used to composite just the thin strip

needed to cover the scratch. The plate is an easy fix because the camera is locked off. A clean plate is painted for the dinner plate (Figure 10-24) and simply composited with the plate mask in Figure 10-21.

10.6 LIGHT LEAKS

If the camera door is not closed tightly, light can leak into the camera body and "flash" the unexposed negative producing a light leak, which we get to fix. One of the troublesome characteristics of a light leak is that it is not static—it dances around, advancing and retreating from frame to frame. This means that the worst-case frame usually defines the scope of the fix.

In a few cases, it may be possible to use some of the techniques seen above to cut and paste and track elements from one frame to another to rebuild the damaged part of the picture, but that is rarely practical for light leaks. The reason is that light leaks tend to damage large areas, not just a dust mote or a hair in the corner. If the picture content is simple, such as a languid pan across the Serengeti Plain, such heroic rescues can work. But if it is more typical picture content the fix is surgery—simply cut out the bad part of the picture.

Frame 1 Frame 2 Frame 3

Figure 10-25 Light leak sequence.

In the light leak case study of Figure 10-25 you can see how the light leak varies between the three frames. The basic technique is to flip through all the frames of the shot to find the worst-case frame, and then set the size of the crop to that frame in order to cut out all of the damage. In some cases, the light leak might be worse at one end of the shot than the other. If so, it might be possible to slowly change the size of the cropped region over the length of the shot to preserve the maximum amount of picture. Obviously, the crop window cannot be dancing around trying to follow the light leak frame-by-frame. To minimize the amount of cropping, the cropped region should have the same aspect ratio of the film's projection format—1.85 in this case—as illustrated in Figure 10-26. If the frame were cropped to the full 1.33 frame, more of the picture would be lost.

Frame 1 Frame 2 Frame 3

Figure 10-26 Cropped light leak sequence.

Once the optimal crop region is found, the entire shot is cropped and then scaled up to the original frame width as shown in Figure 10-27. Of course, this will soften the image. You might try sharpening it, but that will kick up the grain. You could try degraining it after sharpening it, but that will soften the picture again. When the client objects, you can help him out by suggesting that he avoid light leaks in the future.

Frame 1 Frame 2 Frame 3

Figure 10-27 Resized frames.

10.7 DEFLICKER

There are a surprising number of things that can cause frame flicker, which is a rapid fluctuation in brightness from frame to frame. Strobing lights on the set, camera shutter problems, or mechanical interferences such as helicopter blades are some of the culprits. Each problem introduces a characteristic type of flicker, some easier to fix than others. The strobing light causes just a portion of the scene to flicker, and this may include the faces of the talent. Very difficult. The shutter can cause the entire frame to flicker uniformly. Not too difficult. The mechanical interference will usually affect one region of the image uniformly. Tricky. Fixing these types of problems is called *deflicker*.

Frame 1 Frame 2 Frame 3

Figure 10-28 Sequence of flickering frames.

The deflicker case study in Figure 10-28 represents the kind of problem introduced by strobing stage lights. Note how the right side of the picture fluctuates in brightness from frame to frame. The obvious question that springs to mind about now is how is it possible that nobody on the set noticed the flickering light? The reason is that humans view the scene with their eyes while the camera views it with a shutter that rapidly opens and closes. There is a certain type of light commonly used on the set called an HMI light that is designed to flicker rapidly. The eye doesn't see the flickering but if it is out of sync with the shutter, the camera does. More job security.

A strobing HMI light is causing the right side of the picture to flicker lighter and darker. This part is trivial to deflicker. Just make a clean plate from a frame with the correct brightness and do a soft edged composite over the right side of the frame. More problematic are the flickering highlights on the talent because people are always moving and changing shape. The fix for this is a hideous process of warping and tracking bits and pieces of adjacent frames over the flickering regions. Thank goodness the insurance is paying for this.

This may be one of those situations where it makes sense not to perform a 100% fix of the problem. In this example, fixing the right side of the frame would be easy, only take a few hours, and might fix, say, 90% of the flickering. The remaining 10% is only slightly objectionable but could take days to fix. The client might find the 90% fix acceptable given the cost of doing the full 100% fix. Saving the client money is a good way to get him to hire you again for his next job.

There is one case where the fix is easy, and that is if the entire frame flickers uniformly as might happen with a twitchy shutter. Here the fix is to essentially perform a frame-by-frame color correction to keep the brightness uniform. There are even dedicated deflicker tools available that are designed to make this particular task easier.

Working with Video

11

Most digital compositors work with video, a perversely complicated medium. This complexity comes from the need to compress the video information as much as possible to lower the data rate for broadcast. This compression takes many forms and introduces issues and artifacts that we have to cope with when compositing visual effects in video. If you understand how the medium works, then you can prevent many problems from being introduced in the first place.

If you are working with a dedicated video system such as Flame, it has design features built into it to make many of these issues transparent to the artist. However, if you are working with a "desktop" compositing system, then you will have to manage these issues yourself. This chapter is not so much about the theory of video as it is about the practical aspects of working with it in a visual effects shot. It describes the issues that cause trouble, and then offers workflow solutions to help you get around them.

11.1 SDTV (STANDARD DEFINITION TELEVISION)

SDTV is the digital television standard that you may know as NTSC and PAL. The picture aspect ratio is 4×3 (or 4:3, or 1.33, or "133") and the video is interlaced—an irksome concept we will tackle in the very next section. SDTV is messy and full of noxious complexities that make digital compositing much more difficult than it should be. The reason that it has all of these peculiarities is because they were needed in the early days of television in order to lower the amount of data required to broadcast a frame of video. Once designed into the specifications we were stuck with them. Following are explanations of these noxious complexities along with strategies on how to cope with them. There is a lot of coping here.

11.1.1 Coping with Interlaced Video

You need to understand interlaced video because you will often have to get rid of it before you can work on a shot. In this first section, we are only concerned with

understanding what interlaced video is and how it works. In later sections, we will see how to de-interlace video.

The video frame is made up of a series of horizontal scan lines, but unlike film where a frame is a frame, with video a frame is made up from two fields. Each field contains half the scan lines of the frame, with field 1 holding the odd scan lines and field 2 the even scan lines. When these two fields are merged, or interlaced, like the illustration in Figure 11-1 they make up one frame of interlaced video. The illustration in Figure 11-1 is made up of exaggerated scan lines to make the process easier to see.

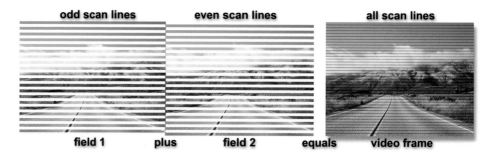

Figure 11-1 A frame of interlaced video is composed of two fields.

For NTSC television, there are 30 frames per second (PAL has 25), and since each frame is made up of two fields, it means there are 60 fields per second (50 for PAL).

A video camera actually scans the scene from top to bottom twice each frame, first all the odd scan lines then all the even scan lines. This means each field captures a different moment in time. This is the basic problem with interlaced video. Two different moments in time are merged together in each frame so the picture information is not "temporally coherent."

Here is a thought experiment to help envision interlaced video. Think of a film camera with its shutter. It captures one frame per shutter, and does this 24 times per second. Simple. Now imagine that we have an "interlaced" film camera that has two shutters and two rolls of film. Both shutters expose the film at 24 frames per second, but they alternate turns—when one is open the other is closed. The two shutters together are now capturing 48 frames of film every second. Now take all the odd scan lines from one roll of film and merge them (interlace them) with the even scan lines from the other roll of film to get back to 24 frames per second. You now have interlaced video—it's just at 24 frames per second instead of 30. But you also have two moments in time per frame.

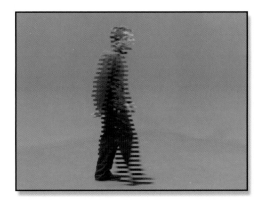

Figure 11-2 Horizontal motion.

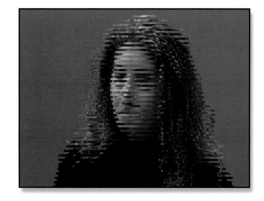

Figure 11-3 Vertical motion.

Figure 11-2 illustrates what happens when something moves horizontally with interlaced video. The character is in two different positions for each of the two fields because, again, each field is a different moment in time. Figure 11-3 shows the equally bizarre effect of vertical motion in an interlaced system. You cannot run a blur or perform a rotate or scale on interlaced images like this. Any operation that filters adjacent pixels results in a horribly disfigured image because the two sets of scan lines become garbled together.

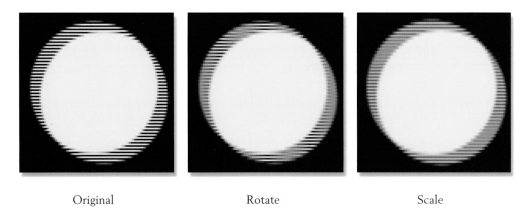

Original Rotate Scale

Figure 11-4 Transformations done on interlaced images.

The garbled scan lines from transformations are shown in Figure 11-4. The original image on the left is a close-up cropped out of an interlaced video frame. Note how clean and distinct each scan line is. The middle frame shows what a rotate of just 2 degrees does to the interlaced scan lines. In some areas, the scan lines are completely blurred away. The scale example on the right shows the damage caused

by scaling the original image up by just 2 percent. There are more regions of blurred scan lines.

Before any of these types of operations are performed, the video frames must be de-interlaced so that each frame represents one moment in time. De-interlacing discards one of the fields, and then replaces it by interpolating the scan lines of the remaining field. All modern compositing programs have video de-interlacing features. However, if you are only performing operations that do not filter adjacent pixels, such as color correction, then there is no need to de-interlace.

There are two different interlacing cases. The first case is where the video was captured with a video camera. In this situation every single frame will show interlaced scan lines and the shot will need de-interlacing. The second case is where a film was transferred to video. This results in only some of the frames showing interlaced lines. This case does not require de-interlacing, but simply a 3:2 pull-up, which is described in its own section below. Before you start any de-interlacing, you need to confirm which type of video you have—a video capture or a film transfer.

11.1.2 Coping with Non-Square Pixels

One of the more pesky issues when working with SDTV is its non-square pixels. Because of this, the picture you get on your workstation does not look like what you saw on the TV screen. This subject was touched on briefly in Chapter 2. On the TV screen, the pixels are squeezed horizontally by 10% so they are tall and thin as in the illustration in Figure 11-5. When this image gets to your workstation, its monitor has square pixels so the image suddenly pops wider by 10%. The number of pixels is the same, it is their shape that has changed, so the shape of the displayed image changes. Circles on the TV screen become ovals at the workstation. Figure 11-5 illustrates how the image appears wider on a workstation monitor than on the TV screen due to the non-square pixels.

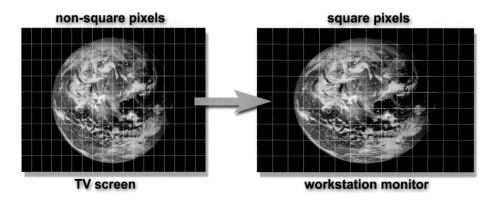

Figure 11-5 An NTSC image stretches by 10% when viewed on a workstation monitor.

In most situations, you can ignore the fact that the video frames are stretched by 10% on the monitor. You can just do your thing, then put the finished shot back out to video. The TV screen will squeeze the images back where they were and all will be well. If you do need to correct for the non-square video pixels, then first de-interlace the video, then resize the video frames from 720 × 486 to 720 × 540. This will create a "square pixel" version for you where a circle is a circle, not an ellipse. Figure 11-6 illustrates this workflow. If the finished results are to go back to video, then resize the frames back to 720 × 486 and re-interlace.

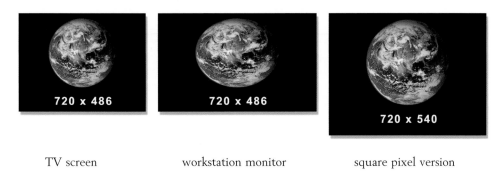

TV screen workstation monitor square pixel version

Figure 11-6 Squaring the pixels on a workstation.

If you are creating a brand new element for SDTV such as a station graphic or digital matte painting, you will want to work in the "square" resolution of 720 × 540, then resize to 720 × 486 before sending it off to video. If you don't, your circles will become squeezed horizontally by 10% and become noticeably elliptical.

PAL squeezes the pixels in the vertical direction, so when a PAL image goes to a workstation the image pops vertically by 10% instead of horizontally like NTSC. The PAL video frame resolution will be 720 × 576, so to square it the width must be increased to 768 × 576. If creating a PAL image, build it at 768 × 576 then resize it to 720 × 576 before sending it to video.

11.1.3 Coping with Color Sub-Sampling

Yet another data compression scheme used in video is color sub-sampling. The idea is that the human eye is very sensitive to brightness (luminance) detail, but not so sensitive to color detail, so why transmit color information that nobody cares about? The video camera captures an RGB image, but it is converted from three channels of red, green, and blue to a YUV image. Still a three-channel image, the YUV image has the luminance in the Y channel and the chrominance information divided between the U and V channels.

Now here's the rub—the U and V (chrominance) channels are digitized, or sampled, at half the resolution of the Y (luminance) channel—again, because the eye

doesn't care and we need the bandwidth. For every 4 digital samples of the Y channel there are 2 samples of the U and 2 of the V. This sampling scheme is known as 4:2:2 to remind everybody that the UV chrominance is sampled at half the resolution of the Y channel. The 4:2:2 sampling scheme with its half resolution chrominance information is illustrated in Figure 11-7.

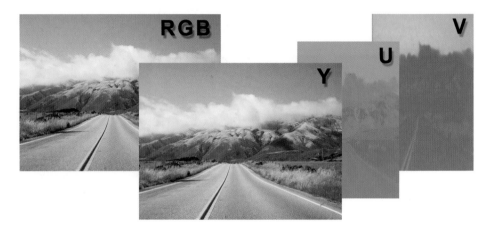

Figure 11-7 YUV image with 4:2:2 sampling.

When a YUV image is loaded into a workstation, the compositing program converts it to RGB so you can work with it in normal RGB color space and display it on your RGB monitor. The important thing to realize is that this RGB image has made-up pixel colors based in interpolating the U and V information. It has been stretched horizontally, and then combined with the Y information to make the RGB image.

This arrangement is fine for normal digital compositing operations—until you need to pull a key on a bluescreen (or greenscreen). The eye may not care about the half resolution color in 4:2:2 sampling but your digital keyer does. The keyer is trying to use the color information in the image to create a matte, but the color information is half resolution. This makes for bad mattes. It gets worse.

4:2:2 is not the worst-case scenario; it is the best-case scenario. There are other video standards out there that sample the chrominance even less. They are known as 4:2:0 and 4:1:1 sampling, and there are others, each worse than the last. The client should not be trying to shoot bluescreens with these low quality video cameras, but they will anyway because the cameras and tapes are cheap, the pictures look OK on their monitor, and they don't know any better. Usually by the time you get involved the video will already be shot so all you can do is grin and bear it.

Figure 11-8 Bluescreen RGB channels.

Figure 11-9 Y channel of the YUV version.

Figure 11-10 UV channels of the YUV version.

There is one little trick that you can use that can help with the sub-sampled color when pulling a matte for a bluescreen shot, and that is to add a gentle blur to the UV channels. We will use the close-up of the bluescreen in Figure 11-8 as an example. The first step is to convert the bluescreen RGB image to YUV. You can now see the difference in horizontal resolution between the Y channel in Figure 11-9 and the UV channels in Figure 11-10.

Figure 11-11 Comp with original bluescreen.

Figure 11-12 Comp with blurred UV channels.

Figure 11-13 Blurred UV channels.

Next, give only the UV channels a gentle blur like the example in Figure 11-13. Be sure not to blur the Y channel. We need all of its detail for the keyer. Now convert the blurred UV version of the YUV image back to RGB and present it to your digital keyer. The example in Figure 11-11 shows a composite using the original bluescreen from Figure 11-8. You can see a noticeable improvement between it and the blurred UV version in Figure 11-12. It's not perfect, but it can help.

There is such a thing as 4:4:4 video, which was actually developed for the demands of visual effects shots. It is, in effect, a true RGB video with equal information for the luminance and chrominance channels. If you should be so lucky as to get a hold of any of this video you will find it does not have any of the color sub-sampling problems we have seen here and it should be a joy to key—for video.

11.1.4 Coping with Edge Enhancement

Tragically, there is no coping with edge enhancement. It is a built-in feature of video cameras that applies a sharpening filter to the video image, which creates an edge artifact that wreaks havoc with a keyer trying to pull a matte on bluescreen or greenscreen. Figure 11-14 shows the original greenscreen, a normal red channel, and a sharpened red channel. The sharpened red channel has an arrow pointing out the artifact, which is the bright line around the outer edge of the character. Depending on the colors in the picture, it can be a dark line. As far as the keyer is concerned, there should be no lines at all.

Original greenscreen Normal red channel Sharpened red channel

Figure 11-14 Edge enhancement artifact.

When bluescreens are captured on video, the edge enhancement feature of the video camera must be turned off to avoid introducing this edge artifact. It disturbs the true relationship between the color channels right at the critical edges causing the keyer to get confused and introduce its own edge artifact into the composite. One possible solution is to try some plug-ins that have been developed that claim to be able fix the problem. The best fix is to not put the artifact in the picture in the first place.

11.1.5 Coping with Frame Rates

It is often said that NTSC video has a frame rate of 30 fps (frames per second), but of course, this isn't really true. Its true frame rate is 29.97 fps. The original black and

white TV used to be an honest 30 fps, but when the color signal was added back in 1953 they had to shift the signal 0.1% slower to solve a natty technical problem. This has introduced a problem for the rest of us—confusion. True 30 fps and 60 fps video standards have recently been added for SDTV. The problem is that some equipment and software manufacturers label their buttons and knobs as "30 fps," which now might be either a true 30 fps or simply shorthand for 29.97. When working with software that has a pop-up menu listing a selection of frame rates and you see both 29.97 and 30, you can assume the "30" choice is an honest 30 fps.

We all know that film runs at 24 fps, but sometimes you will see something labeled as 23.98. The film does run at an honest 24 fps in the movie theatre, but when it gets transferred to video, the film's 24 fps has to be converted to NTSC's 29.97, not 30 fps. This means that the film's 24 fps will be 0.1% slower, which comes out to 23.98 frames of film per second.

PAL does run at an honest 25 frames per second and there is no slick way to retime the 25 fps into NTSC's 30 fps. When 24 fps film is transferred to PAL, the film is simply transferred frame-to-frame so it ends up running at 25 fps on TV. This speeds the movie up by 4%, but nobody notices. This does raise the pitch of the sound track noticeably but that is an easy fix.

11.1.6 Coping with Timecode

While we look at the length of a shot in terms of its number of frames, video people measure their work in time and frames—so many hours, minutes, seconds, and frames. This is called *timecode*, and it is written like this—03:20:17:12—which is read as three hours, 20 minutes, 17 seconds, and 12 frames. You need to know this because the client may hand you a videotape and simply tell you that the shot you are to work on is located at 03:20:17:12, so you will have to know what that means.

Another side effect of the 29.97 frame rate instead of the honest 30 fps cited above is that the timecode for video drifts off from real time. At an honest 30 fps there would be exactly 108,000 frames of video in one hour. But at 29.97, there is actually only 107,892 frames in an hour, a difference of 108 frames per hour. Because timecode is really counting frames of video, these extra 108 frames means that an "NTSC hour" would run 3.6 seconds longer than a real hour. We can't be having that when broadcasting a television show. This just keeps getting better.

The brilliant solution is drop-frame timecode. To keep the slightly slow-running timecode clock in sync with real time they wait until the timecode is almost one full frame behind real time, then skip (drop) the next timecode to catch up. So in one hour, 108 timecode frames will be dropped out so the show will display a timecode of exactly one hour when the clock says one hour is up. Sometimes you will be given a videotape that has non-drop frame timecode, which is more appropriate for production and visual effects. If a videotape has non-drop frame timecode, you should find "NDF" in big letters on the label somewhere. If it is drop-frame, they should put "DF" on it.

11.2 HDTV (HIGH DEFINITION TELEVISION)

We now leave the murky world of SDTV and step into the bright sunlight of HDTV. The first thing you will notice is the spectacular increase in the size of the picture. Figure 11-15 compares the same image content displayed on two different video monitors of equal screen resolution. The HDTV picture has more than two times as many scan lines as the SDTV picture, and it is widescreen, like a movie. In fact, the primary design intent of HDTV was to make it more compatible with feature films not only in aspect ratio but frame rate and picture information content. Unfortunately, HDTV retains the same 4:2:2 color sub-sampling established by SDTV.

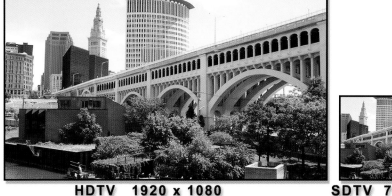
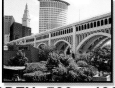

HDTV 1920 x 1080 **SDTV 720 x 486**

Figure 11-15 The mighty HDTV picture compared to the puny SDTV picture.

The important thing about HDTV is that it is not just a standard; it is a family of standards. In it, one can mix and match the image size, scan modes, and frame rates. But the really big news is that all HDTV standards specify square pixels—no more squeezing and stretching video images! Another constant with all HDTV standards is the aspect ratio, which is 16×9 (or 16:9). If you do the math it comes out to an aspect ratio of 1.7777777.... Some will refer to it as "177" and others will call it "178," depending on whether they prefer to truncate (1.77) or round off (1.78). We now take a look at the family of standards for HDTV.

11.2.1 Image Size

HDTV supports two high-resolution image sizes: 1920×1080 and 1280×720. In video slang, the 1920×1080 will be referred to as "1080" and the 1280×720 as "720." In each case, they are citing the number of scan lines in a frame. Since the aspect ratio of HDTV is fixed at 1.78 for all standards, declaring the number of scan

lines unambiguously defines the horizontal resolution so it need not be stated. We just know.

11.2.2 Scan Modes

There are three scan modes in the HDTV standards. Tragically, one of them is interlaced, as we saw above. The good news is that there is a progressive scan mode, which works exactly like a scan mode should. It starts scanning the frame at the top and works its way to the bottom, one line at a time. The really good news is that a great majority of HDTV folks use the progressive scan mode, so your chances of running into interlaced HDTV are fairly low. Why the progressive scan is preferred will be revealed below in "The 24P Master" section.

The third scan mode, Progressive Segmented Frame (abbreviated PsF) is in actuality a progressive scan mode and its images would be identical to those captured with the normal progressive scan. The differences are internal to the camera and videotape, so we don't need to worry about it. I just didn't want you to go blank if someone started talking about their PsF video.

11.2.3 Frame Rates

Technically, HDTV supports all of the frame rates in the known universe. However, in the real world (where you and I work), you are most likely to only see 30 fps and 24 fps HD video. OK, someone could throw some PAL at you at 25 fps, but that's about it. Of course, HDTV also supports 29.97 and 23.98 frame rates. Fortunately, when working on a visual effects shot, we are concerned about the frame count, not the frame rate. We are going to take 100 frames in and put 100 frames out. The precise frame rate only becomes an issue when it is laid back to videotape.

11.2.4 Nomenclature

With the array of HDTV standards available, it becomes very important to be specific when describing the particular format of a given production job. To do that we need some official nomenclature in order to sound like professionals. If we are talking about an HD (HDTV) project that had a resolution of 1920 × 1080, progressive scan, at 24 fps, it would technically be known as 1080/24P (scan lines, frame rate, scan mode). If the project were the same resolution but an interlace scan at 30 fps (like NTSC) then it would be described as 1080/30I. Some would even shorten these to "1080p" and "1080i." Of course, you could encounter a 720/25P or a 1080/60PsF, but those are fairly uncommon.

11.2.5 The 24P Master

Today, when a feature film is transferred (mastered) to video, it is transferred to the 1080/24P HDTV standard. When a television show or movie is captured in HD, it

is usually recorded as 1080/24P. The 1080/24P standard has become so pervasive it has developed its own shorthand name—24P.

24P has become the de facto HD standard for one simple reason, all of the many video variants can easily be made from this one master. First of all it is 1920×1080, so it is the highest resolution. Any other version you wish to make will be equal or lower resolution. Second, because of the progressive scan and the 24 fps frame rate, new versions can be made that are 24 fps, 25 fps, and 30 fps.

So how do you make a 25 fps video from a 24 fps master? Simple, just play it back at 25 frames per second. This is what our PALs in Europe have been doing with the 24 fps feature films for the last half century. Sure, the movie plays 4% too fast, but nobody notices. Also, the sound does jump up in pitch a bit, but that's an easy fix in the audio sweetening department.

To make a 30 fps video out of a 24p master is also easy, just transfer it with a 3:2 pull-down as if it were a feature film. We will learn more about how the 3:2 pull-down works shortly, so please stand by.

11.3 TITLE SAFE

Sometimes the digital compositor gets tapped to add some titles to a project, so you must be prepared. One of the key issues for titles is knowing where "title safe" is, meaning the rectangle within which the titles need to fit. There is no official SMPTE spec for title safe as it is more like an industry standard practice. Title safe is quite different for SDTV and HDTV, as you can see in Figure 11-16.

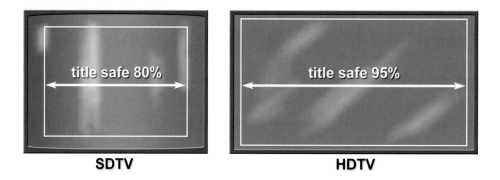

Figure 11-16 Title safe for SDTV and HDTV.

Title safe for SDTV is the center 80% of the video frame. Make a rectangle the size of the video frame and scale it by 0.8 and that will make a title safe guide. The reason it is so much smaller than HDTV's 95% is historical. In the early days of TV, the displayed picture size varied quite a bit from television set to television set. So that titles would show up on the worst-case television set, it was necessary to make sure they were within the 80% rectangle. Today, TV's are much more uniform but

the practice endures anyway. HDTV does not suffer from this kind of set-to-set variation, so the title safe rectangle is a snug 95%.

11.4 3:2 PULL-DOWN

The telecine process transfers film to video but there is a fundamental conflict between their frame rates. Film runs at 24 fps and video at 30 fps. We need to end up with one second of film becoming one second of video, so the solution is to stretch 24 frames of film out to 30 frames of video using a technique called 3:2 pull-down. In order to change 24 fps to 30 fps, every 4 frames of film has to be mapped to 5 frames of video. This is done by spreading every 4 frames of film out to 10 video fields. Some think of this as expanding the film, or cine, to match the video, so they call it *cine-expand*.

Figure 11-17 shows how 4 frames of film are mapped into 10 video fields. These 10 fields form a 5-frame sequence of video that is repeated for the length of the clip. The first frame of film (frame "A") is mapped to the first two video fields as one might expect. Film frame B is then mapped to the next 3 video fields, frame C to 2 fields, and frame D to 3 fields. The entire film clip is transferred to video fields using the pattern or "cadence" of 2:3:2:3:2:3:2:3 . . ., and so on. One side effect of this is that the number of frames will increase by 25%, meaning, 96 frames of film become 120 frames of video.

One trouble that this makes for the compositing community is that the 3:2 pull-down periodically creates video frames that are an interlaced mix of two different film frames. We saw in the previous section, "Coping with Interlaced Video," that this is bad. Check out video frames 3 and 4 in Figure 11-17. Frame 3 is a mix of film frames B and C, while frame 4 mixes frames C and D. As a result, two out of every five video frames have two different "moments in time" like the nasty interlaced video we saw above. These mixed frames must be eliminated before we can do any serious manipulation of the images.

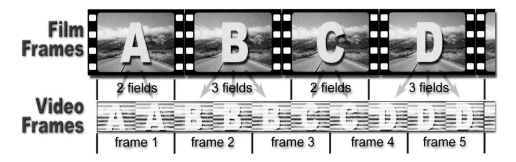

Figure 11-17 The 3:2 pull-down pattern.

You may have noticed that the first video frame made with the "A" frame of film went down with 2 video fields with the next film frame getting 3 fields. So why is it called a 3:2 pull-down instead of a 2:3 pull-down? Because, years ago, when telecine was young, the cadence really was 3:2:3:2. Later, for technical reasons, it was switched to 2:3:2:3, but the old "3:2" name has stuck for the sake of tradition. Plus, it was too hard to retrain everybody.

The 3:2 pull-down is used in far more places than just transferring film to video. When 24p video has to be broadcast, the broadcast standard is 30 fps interlaced, so the 24p video is transferred to 30 fps interlaced videotape using a 3:2 pull-down. Another application of the 3:2 pull-down is the DVD player in your home. When a feature film is mastered to a DVD it is done at 24 fps, then the DVD player detects this and applies a 3:2 pull-down on the fly in order to send a 30 fps signal to the TV set. The reason this is done is to save the disk space that would have been wasted on the 25% duplicated fields and instead that disk space is used to improve the quality of the picture coming off the DVD.

11.5 3:2 PULL-UP

Any 30 fps video that has a 3:2 pull-down in it can be restored back to 24 fps using a process called *3:2 pull-up*. The 3:2 pull-up process simply drops out the third video field in the 2:3:2:3 pattern restoring it to a sensible 2:2:2:2 pattern like the example in Figure 11-18. It shows the third video field for frame B and frame D being dropped out generating a new set of 4 frames made up of exactly 2 fields each. This creates a set of video frames that exactly matches the original film frames.

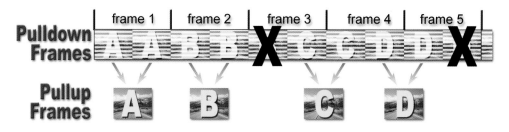

Figure 11-18 The 3:2 pull-up pattern.

The 3:2 pull-up is non-destructive because it is simply throwing out duplicate fields. The number of frames drops by 20%, but one second of interlaced video is now one second of 24p video. Since the 3:2 pull-up reverses the telecine process, some refer to this as "reverse telecine." Others see it as compressing the 30 fps video back to 24 fps so they call it "cine-compress." We just call it a pain in the arse.

There is a nettlesome detail to performing a 3:2 pull-up, and that is trying to figure out the "cadence" of the original 3:2 pull-down pattern. Referring again to Figure 11-18, if you count the video fields starting at the left you will see that field number 5 is dropped out, then field number 10. You might conclude from this that a 3:2 pull-up drops field 5, then every fifth field after that, but then you would be wrong 80% of the time. It drops field 5 of the pull-down if, and only if, the clip starts on an "A" frame. If that frame were cut out in editing, which happens about 80% of the time, it would make the "B" frame (frame 2) the first frame of the clip. In this case you would drop the third field, then every fifth field after that. And so it goes down the line with the 2:3 cadence being any one of five possibilities depending on which of the five video frames is the first frame of the clip.

How are you supposed to cope with this? Your software should offer you five possible cadences to choose from to match which of the five possible frames your clip starts on. You might have to try each of them to discover the cadence of your video clip. The test that you have found the right cadence is to check at least five sequential frames to make sure all of the interlaced frames are gone.

11.6 DV COMPRESSION ARTIFACTS

There has been a recent explosion in the use of a new generation of video cameras known as DV cameras—"DV" for Digital Video. They go by the names of DV, DVCAM, DVCPRO, and others, and they are beginning to show up in visual effects productions for both SDTV and HDTV. The attraction for videographers is that these cameras are less expensive than the previous generation and they record on inexpensive 1/4-inch cassette tapes. Their crimes against pixels are that they not only use a sparse 4:1:1 sampling scheme, but they compound this by adding a 5-to-1 JPEG data compression that further corrodes the picture information. They also only capture a 720 × 480 picture to save even more money. While the video they capture might look OK to the eye, you can't fool the computer.

Figure 11-19 illustrates the sorry difference between 4:2:2 sampled video (top row) and the DV sampling of 4:1:1 with JPEG compression (bottom row). It compares the red, green, and blue channels so you can see the hideous artifacts introduced by the low color sampling combined with data compression. The problem with this is that when watching the video on a TV monitor, it looks surprisingly good. This misleads inexperienced people to believe that it will be fine for bluescreen and greenscreen shots. It will not. You will spend more time trying to cope with the 4:1:1 sampling and compression artifacts than pulling the matte. The bottom line is, trying to key DV video will result in a lot of extra work and poor quality results. You should warn the client.

Red Green Blue

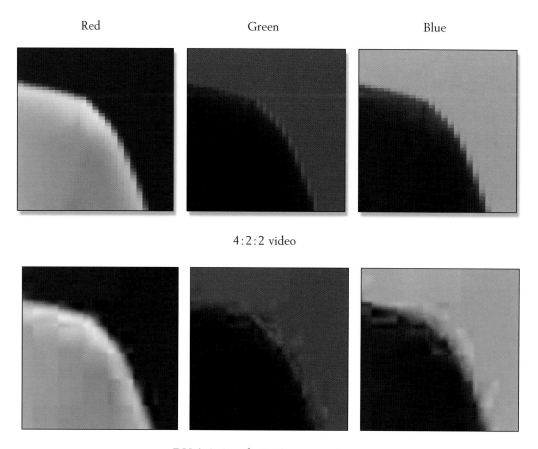

4:2:2 video

DV 4:1:1 with JPEG compression

Figure 11-19 Comparison of 4:2:2 video with DV video.

12 Working with Film

One of the problems with doing visual effects for feature films is that the client is steeped in film formats and nomenclature, but the poor digital artist is only exposed to pixels. The process is so digital now that you can go through an entire visual effects career and never see or touch a real piece of film. Added to this lack of exposure is the fact that film has a great many different formats, some even with non-square pixels. The main purpose of this chapter is to describe the most common film formats you are likely to encounter, what they are used for, their aspect ratios, and their scanned image resolutions. Along the way, it is hoped you will also pick up some film terminology.

If you are going to work on 35 mm feature film visual effects you should know a few key facts about film beyond that it runs at 24 frames per second, such as there are 16 frames per foot and that there are 90 feet of film per minute. Yes, film people count the length of a shot not in run-time or frame count, but in feet and frames. For example, a five second shot would have 120 frames to you and I, but to a film person this shot is 7 feet and 8 frames long.

Fitting widescreen films into the 1.33 aspect ratio of SDTV screens has never really worked very well, but it is still important to know about the various approaches that are used to letterbox and "pan and scan" a film for video. While you may think of title safe as a video issue, if you ever work on titles for film someone is going to ask you if they are 4 by 3 safe. Hopefully, you will have read the title safe section of this chapter before that happens. We will also take a look at how film is digitized to create those digital files for your visual effects shots and how they are recorded back out to film.

The last section examines the Digital Intermediate (DI) process and what it means to you as a digital compositor. The DI process actually "wraps around you," meaning that the film frames you work on will probably be digitized by the same DI facility that your finished work will be delivered to. It will therefore behoove you to know something about them, their process, and how your work fits into it.

12.1 CAPTURE VS. DISPLAY FORMATS

When a cinematographer (a.k.a. Director of Photography, or DP, or DoP) looks through the viewfinder of his film camera, he sees the entire scene as it is being captured on the film. This is the camera aperture. He also sees a ground glass outline of the intended display format of the film, that is to say, what portion of the frame will be projected in the theatre. This is the projection aperture. An example of what the cinematographer sees in the viewfinder is shown in Figure 12-1. The cinematographer carefully composes the shot so that the item of interest is always contained within the projection aperture since that is what we will ultimately see in the theatre.

Figure 12-1 The view through a viewfinder.

This issue of the capture format (camera aperture) vs. the display format (projection aperture) is unique to film. With video, the camera captures only and exactly what will be displayed on TV. Not so with film. The exposed film frame is almost always larger than the final displayed image in the theatre, and there are differences between the various camera apertures and the various projection apertures. Understanding these differences are a key part of working with film.

When film is digitized, the entire camera aperture is normally scanned and delivered to the compositor, and there are several different camera apertures that may be used for photography and scanning. When working on the visual effects shot, the camera aperture is not the most important thing. What is most important is the "safe-to" aperture. This is the projection aperture that the visual effects must be made safe to—that is, everything inside this aperture must be done perfectly, and everything outside of it can be ignored. The safe-to aperture may be the same as the projection aperture or it may be different, and different is always wider, and wider means more work. This can have a major impact on how much work and cost will go into each shot, so it is very important to get clear at the start of a project. The client must be asked to go on record and declare the safe-to aperture for all the visual effects shots.

12.2 ACADEMY AND FULL APERTURE

A 35 mm film frame can be exposed using one of two primary camera apertures: Academy aperture or full aperture, and the film scans you get could be from either format. The format the camera records to is controlled by a metal plate in front of the film with a rectangular hole cut in it, called the *aperture*. Full aperture (Figure 12-2) exposes the image from perf to perf, meaning the little holes used to sprocket

the film through the camera, which are called *perforations.* You can see how the image spans four perfs and completely fills the frame with just a thin black frame line above and below to separate it from the next frame. This exposes the maximum film area, has an aspect ratio of about 1.33, and is now referred to as "super 35," a more hip and modern term than "full aperture."

Figure 12-2 Full aperture.

Figure 12-3 Academy aperture.

In the days before Dolby Digital Surround Sound 7.1 with Mega Joule Quadraphonic Audio Blasters, the sound track was simply printed on the projection film right alongside the picture like the example in Figure 12-3 (the white squiggles to the left of the image are the sound track). In order to leave room on the film for the sound track, the picture area had to be squeezed over to the right and made about 10% smaller than the full aperture frame, but still devoted four perfs per frame. In those days, the camera aperture was also academy so the exposed film matched the projected film. Compare the image size of the academy aperture to the full aperture, which has 33% more pixels. An academy aperture scan has an aspect ratio of about 1.37, but both academy and full aperture are referred to as "1.33"—even though they aren't.

When film was first digitized at Kodak's Cinesite facility in Hollywood way back in 1992, most of the film footage being digitized was academy. Over time, the practice has shifted to shooting the movie as super 35 (full aperture). The larger image area of super 35 reduces the grain size and makes for a sharper picture. The resolution of a full aperture scan is 2048 × 1556 and is referred to as a "2k" scan. For an academy aperture, the film scanner's optics scans the same full aperture area at the same resolution, but only write to disk in the academy area, which results in an 1828 × 1332 scan. It is as though the film scanner scanned the full aperture frame then cropped it to the academy aperture. As a result, both formats have the same number of pixels per square millimeter of film.

You may actually never see an academy film scan in your digital compositing career, but you might need to make one. The super 35 format is fine for principal photography (shooting the movie) and doing visual effects, but before it gets to the theatre it must be converted to an academy aperture in order to fit the theatre projector. In some cases you may be given a super 35 scan to do a visual effects shot, but the deliverable format might be an academy aperture. If you simply scale the super 35 scan from 2048 × 1556 down to the academy size of 1828 × 1332, you will have imparted a small 4% horizontal stretch to the results because their aspect ratios are not identical. You might want instead to crop the super 35 image to a 1.37 aspect ratio, and then scale it down to academy (1828 × 1332).

12.3 PROJECTION FORMATS

Within the academy and full aperture capture formats there are several projection formats. The film projector in the theatre also has a metal plate with a rectangle cut in it, called an *aperture*, which the film projects through. This masks off the film to its projection aspect ratio regardless of the size or shape of the image on the print. Of course, only academy prints go to the projector, but when working on the super 35 film scan, you will need to know what the projection format is so you can work within it on the super 35 version. Later, the super 35 frame will be sized down to academy for projection.

There are standard guides, called *camera guides*, that draw white rectangles over the scanned film frame to show where the various projection apertures are. When working on a film job, you need to know what projection aperture to work to so you can compose your shots correctly. This is a critical piece of information for the entire show and must be confirmed by the client before any work is done. Following are the three most common projection formats you will encounter. They are illustrated for super 35 in Figure 12-4 and for academy in Figure 12-5.

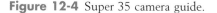
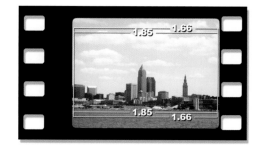

Figure 12-4 Super 35 camera guide. **Figure 12-5** Academy camera guide.

12.3.1 2.35

In the super 35 format, the inside-most camera guide is the 2.35 aspect ratio, which will be cropped out of the frame, then squeezed horizontally and stretched vertically to make an anamorphic Cinemascope frame that goes to the film recorder. This is referred to as a "scope extraction" because it is extracting the Cinemascope window from the super 35 frame. The procedure is to crop a 2048×872 window out of the super 35 frame and resize it to 1828×1556. There is more about the Cinemascope film format in a following section. The 2.35 aspect ratio camera guide is only used on super 35 film. You will notice it is absent from the academy camera guide in Figure 12-5. The reason is that the academy frame is just too small to resize to 2.35. It just isn't done.

12.3.2 1.85

The next camera guide is the 1.85 projection aperture. This is the American definition of "widescreen." The most common scenario is to be given a super 35 film scan to work with, but told that the film format is 1.85.

12.3.3 1.66

The 1.66 aspect ratio is what Europeans consider to be widescreen. Its significance to the red-blooded American compositor is that even though you may be working on a show to one of the other formats, you will often make your work "safe to" the 1.66 format. This means that even if your show is a 1.85 format, your work (matte lines, dust busting, garbage mattes, etc.) must be good out to the 1.66 line because when your movie goes to Europe (and they all go to Europe), it will be projected out to 1.66. The one exception is if the format is 2.35; in this one case, you know that the picture outside of the 2.35 window is going to be cropped and thrown away when the scope extraction is done, so no sense wasting time making it pretty out there.

12.4 CINEMASCOPE

Cinemascope (or "Cscope" or "scope") is a very unusual film format. Not uncommon, just unusual. It is both a capture format and a projection format. In other words, it is the one film format that projects in the theatre exactly what is seen on the original camera negative. The basic idea is that filmmakers wanted a very widescreen image projected in the theater. If you tried to crop a wide image out of the middle of an academy frame and just blow it up to fill a widescreen, it would look soft and lacking in detail. To get more picture detail you have to use more of the negative. The solution that filmmakers came up with was to expose the negative from top to bottom just like full aperture, but use an anamorphic lens on the camera that squeezes the

image horizontally by 50% to fit it within academy to leave room for the sound track. The resulting anamorphic film frame is shown in Figure 12-6.

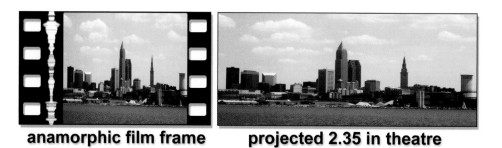

anamorphic film frame **projected 2.35 in theatre**

Figure 12-6 How cinemascope images work.

When it is time to project the film in the theatre, the projector has another anamorphic lens that stretches the image horizontally by a factor of 2, exactly canceling out the squeeze on the film frame. This results in a projected image with a 2.35 aspect ratio like the example in Figure 12-6. This arrangement uses twice the amount of negative than simply cropping the 2.35 out of the academy aperture. Note that the exposed film area of the anamorphic film frame is much taller than the normal academy aperture frame shown back in Figure 12-3. A Cscope film frame that was photographed anamorphically has the width of an academy aperture but the height of the full aperture.

In today's film slang, the term "2.35" is synonymous with "Cscope." However, one technical footnote here is that 2.35 is now actually 2.40. The top and bottom of the frame are now shaved just a wee bit when projected in the theatre. Rumor has it that this was done to leave a little more room at the black frame line at the top and bottom of each frame of the negative for splicing. Seems that the splices were showing up on the screen when projected. Not good. The potential confusion here is that some folks will actually have the nerve to use the technically correct term "2.40" to refer to Cscope, rather than the traditional term "2.35."

The problem with digital compositing and anamorphic frames is that the pixels are not square (they have an aspect ratio of 2.0), and we saw what a migraine that was with video. For many operations such as keying and color correction, the anamorphic image can be left "squeezed." However, for any transformations such as rotate, scale, and skew the image must first be "flattened" to restore square pixels, just like video. There are some compositing programs intelligent enough to recognize the anamorphic images and compensate internally so the image does not have to be flattened. It also must be flattened before any motion tracking, unless you have one of the real smart motion trackers that knows about anamorphic images. A typical anamorphic scan will be 1828 × 1556, so when it is flattened it suddenly balloons to 3656 × 1556, a very large image indeed that will tax even the mightiest workstation.

The good news is that cinemascope photography is getting less and less popular thanks to the digital intermediate process, which we will look at later in this chapter. Cinemascope photography is difficult because the anamorphic lenses are large, expensive, degrade image quality, and are hard to work with. With the digital intermediate process, the film is now photographed in super 35, and then the digital "scope" extraction described above is done in the DI suite before it is sent to the film recorder. It is recorded as an anamorphic image on film, even though it was originally shot "flat." The digital scope extraction works just fine and produces a nice crisp image with none of the pain of working with anamorphic lenses. As a result, shooting super 35 and doing a scope extraction is all the rage in Hollywood.

12.5 VISTAVISION

VistaVision is occasionally used as a visual effects format but is no longer projected in the theatre, so it is now a capture format only. As you can see in Figure 12-7, the "vista" frame spans 8 perfs and is huge compared to the super 35 4-perf frame. All this extra negative is used to photograph visual effects elements in very high detail, which can then withstand a great deal of abuse by the digital compositor. Regions can be cropped out and blown up, or a digital camera can pan around the frame in a process called a *post move* (a camera move done in post) without the image quality breaking down. A vista frame is also what you get with a 35 mm photography camera, so sometimes stills will be shot and used for visual effects shots.

VistaVision frame **super 35 frame**

Figure 12-7 Comparison of VistaVision frame size to super 35.

The odd thing about vista frames is that they are actually lying on their sides. The 35 mm film is put through the camera horizontally, so when the film is held up next to normal 35 mm film, the image is sideways. If you rotated the VistaVision frame

in Figure 12-7 by 90 degrees and placed it below the super 35 frame you would find their widths to be the same. A typical 2k vista scan will be 3072 × 2048 producing an aspect ratio of 1.5. The vista frame has exactly twice the negative area of the super 35 frame.

12.6 3-PERF FILM

Here's trouble, 3-perf film is a capture format only, and is exactly what it sounds like, there are 3 perfs of 35 mm film for each frame instead of the normal 4 perfs. It is the exact same 35 mm film stock that is used in regular film cameras, which is simply loaded into special film cameras that advance each frame of film 3 perfs instead of the usual 4. It was originally invented because it reduced the amount of 35 mm film consumed when shooting a movie by 25%. Since 35 mm film is expensive, this was a significant savings.

Met with enthusiasm when it was first introduced, the excitement died down when it was realized how many difficulties it introduced into the film post-production process. Why I said at the top that 3-perf is trouble is because it creates editorial confusion, which becomes shot length and timing confusion for you at compositing time. The reason is that film editorial measurements are based on feet and frames: 4-perf film has 16 frames per foot, but 3-perf has an awkward $21\frac{1}{3}$ frames per foot. You actually have to use a full 3 feet of film just to come out to an even number of frames (64).

3 perf frame **4 perf frame**

Figure 12-8 Comparison of 3-perf frame to 4-perf frame.

However, recent technological advances have caused a resurgence in 3-perf film and you are sure to run into it soon. The two main influences that have resuscitated 3-perf film are the digital intermediate process and HDTV. The digital intermediate

process eliminates many of the troubling aspects of working with 3-perf once the film is digitized, since it becomes a digital file like any other and is easily converted to a common projection format such as 1.85 or 2.35. The reason HDTV helped is if you are shooting 35 mm film for a HDTV finish (such as a quality television show), the 1.75 aspect ratio of 3-perf film is very close to the 1.78 aspect ratio of HDTV and makes a superb capture medium that costs 25% less than using standard 4-perf 35 mm film. A 3-perf scan will be 2048 × 1168.

12.7 70MM FILM

There are a few film scanners that can scan 70 mm film so there is definitely a slim chance that you could run into it. It is both a capture format and a display format. A 70 mm film frame spans 5 perfs rather than the 4 of super 35 so it is often referred to as "5 perf 70." The 4096 × 1840 scan has an aspect ratio of 2.2 and the film frame is huge compared to 35 mm as you can see in Figure 12-9. In truth, the camera negative is actually only 65 mm wide. When the film goes to theatrical print it is printed on 70 mm wide stock with the extra width outside of the perfs to make room for multiple sound tracks, so the actual image sizes are identical. Because of these two different sizes, you may also hear this format referred to as "65/70."

70 mm film frame

35 mm film frame

Figure 12-9 Comparison of 70 mm film to 35 mm film.

12.8 SUPER 16 FILM

Kodak has recently introduced a number of new 16 mm film stocks to breath new life into the super 16 film format, so you could run into this. There are two situations where super 16 makes good production sense. One is as a film capture instead of video capture for an HDTV show. Its 1.66 aspect ratio frame can be trimmed slightly during telecine to become a good fit for the 1.78 of HDTV. The other situation is for a real low budget film that cannot afford 35 mm film. A comparison of their frame sizes is shown in Figure 12-10.

16 mm film frame 35 mm film frame

Figure 12-10 Comparison of 16 mm film to 35 mm film.

Since 16 mm and 35 mm films are made out of exactly the same plastics and emulsions, the only real difference in image quality is the film grain. Since the super 16 frame is half the size of the 35 mm frame the grain is twice as big, so the new stocks Kodak has introduced have a much smaller grain structure. However, super 16 has but one lonely perf per frame. This means that it is prone to gate weave when photographed and again when scanned. This means that it is not very good for visual effects since the scanned layers would "squirm" against each other. However, with some image stabilizing they can be made serviceable.

12.9 FITTING FILM INTO VIDEO

As we saw in Chapter 11, film and SDTV do not play nice together. The frame rate problems are solved with a 3:2 pull-down, but there is still the question of the shape of the screen. SDTV is nearly square with its 4×3 (1.33) aspect ratio, while film can have a much wider screen with aspect ratios from 1.85 to 2.35. In this section, we will examine the various solutions to this mismatch between the shape of the video and film pictures and how to format film titles so they will be compatible with the video version of the movie.

12.9.1 Letterbox

The letterbox format is one of the most common solutions to fitting a widescreen movie into an SDTV 4×3 video frame. This format is also referred to as "fit side-to-side." The example on the left side of Figure 12-11 illustrates a 1.85 movie in letterbox format. The widescreen film frame is "padded" top and bottom with black until the aspect ratio of the frame matches the video. This has the unfortunate effect

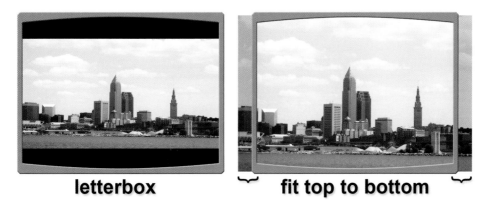

Figure 12-11 Letterbox vs. fit top to bottom.

of shrinking the movie down to where your personal film credit might be hard to read. A true cinematic tragedy.

The other solution is to fit the widescreen movie top to bottom in the video frame and simply lose the left and right sides of the picture as shown on the right side of Figure 12-11. The lost parts of the picture are indicated by the curly brackets along the bottom edge. While this rarely loses enough picture area to bother the viewer, the director and cinematographer might be apoplectic about the loss of their original 1.85 composition along with their "artistic intent."

HDTV's aspect ratio of 1.78 is very close to film's 1.85 so you could fit the film into HDTV by trimming just a bit off the top and bottom of the film frame. If the movie were a 2.35, however, it might have to be letterboxed.

12.9.2 Pan and Scan

For a very widescreen film format such as 2.35, the letterbox format can shrink the movie to truly tiny proportions. One solution is to fit the movie top to bottom, then shift the picture left and right as the action requires in a technique called "pan and scan."

The top image in Figure 12-12 represents the original 2.35 film frame with a typical 4×3 video monitor superimposed for a size comparison. A great deal of the widescreen image will be lost if things are left this way. The bottom series of pictures illustrate how the entire panoramic shot might be salvaged by panning the image from right to left. This can get a little disorienting if the scene is a two-shot with one person on the left and the other on the right and the camera is whipping left, then right, then left to follow the conversation. A pan and scan like this might even be done on a 1.85 film if the action seemed to warrant it.

2.35 film frame

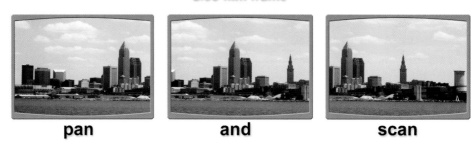

pan **and** **scan**

Figure 12-12 Using pan and scan on a 2.35 widescreen film frame.

12.9.3 HTDV

As it was pointed out in the previous chapter, HDTV was designed to be a much better fit for feature film. The standard American theatrical widescreen format is 1.85, which is very close to HDTV's aspect ratio of 1.78. You could either shave a few pixels off the ends of the 1.85 film frame to fit it into 1.78 (fit top-to-bottom) or it could be formatted in letterbox like the example in Figure 12-13 (fit side-to-side) with just a thin strip of black at top and bottom. A Cinemascope film with a projection aspect ratio of 2.35 in letterbox format is shown on the right.

1.85 letterbox **2.35 letterbox**

Figure 12-13 Feature film letterboxed into HDTV.

12.9.4 Title Safe

In the chapter on working with video, we saw how to make a title safe guide for SDTV and HDTV video. In the course of film work, it may come to pass that you will have to make some titles. Film does not have a title safe industry practice per se, but when the film goes to video (which they always do) then it may be necessary for the titles to be title safe for the 4 × 3 pan and scan version. For you to do that you will have to know where the 4 × 3 title safe is within the film frame.

camera guide

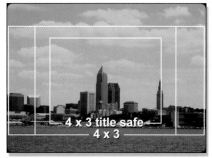
title safe in camera guide

Figure 12-14 How to create a 4 × 3 title safe guide.

Let's say you have some nice 2k super 35 film scans like the example in Figure 12-14 and the show format is 1.85. Draw a 4 × 3 box (a 1.33 aspect ratio rectangle) that fits top to bottom within the 1.85 camera guide. Make a copy of the 4 × 3 box and scale it by 0.8 to make the 4 × 3 title safe rectangle you see in Figure 12-14. This is the 80% guide we saw in the Title Safe section of Chapter 11. By keeping the titles within the 4 × 3 title safe rectangle they will be title safe when the film is transferred to SDTV video. If the show is going to SDTV in letterbox format, then this is not an issue. However, the letterbox format will shrink the text size a great deal, so a larger font may need to be used that will be readable in letterbox. Either way, do make sure that you get the client's decision on this in writing.

12.10 DIGITIZING FILM

The film is digitized by a large and expensive machine called a *film scanner*, with a lovely example of a Spirit 4k scanner in Figure 12-15. Each camera roll (the rolls of film exposed in each day's shoot) is typically 400 feet long and contains many shots, but only a few are actually used. The developed camera rolls are mounted on the film scanner and it is told not only which shots to scan, but also exactly which frames

from those shots to scan. Because film scanning is still expensive, only the frames actually needed for the movie are scanned, plus a few extra frames on both ends known as "handles." The latest film scanners can actually scan film in real-time—that is, a two-hour movie only takes two hours to scan. However, since the scanning process must be halted for each camera roll to be mounted onto the scanner the process actually takes several days.

Figure 12-15 Film scanner.

The finished scans that you receive are typically 2k in resolution, but film scanners usually scan the film optically at 4k resolution, and then resize the raw 4k scan down to 2k for final output. A 4k scan resized down to 2k is a better scan than a straight 2k scan. Some film scanners actually optically scan the film at 6k, while others are actually less than 2k and resize the image up, and then apply an image sharpening operation to cover up the low-resolution scan. Needless to say, if you are the one getting the film scanned, be sure to find out what the optical scanning resolution is because it is usually different than the delivered resolution.

The 2k film scans will be 10-bit log data in either a DPX or Cineon file format. The two formats are very similar indeed, the DPX file format is a considerably expanded and modernized version of the older (and fading from existence) Cineon files. They both contain the same 10-bit log data so images in either file format will look identical. The pertinent question now is what is this "log data" that film scans come in and how do you work with it?

12.11 LOG FILM DATA

The log film data story is both lengthy and complex and in an introductory book like this one, the tale needs to be kept short. However, there is much useful information about log data that would benefit the budding compositor without getting too hung up in our exponents.

If you have ever seen a piece of developed negative you may have noticed how the image looks low contrast, thin, and washed out compared to the print that is made from it—whether it's a paper print, a theatrical print, or a slide. Log data is a scan of that negative so it has a similar appearance. Figure 12-16 is a classic test pattern that Kodak distributes for calibrating film equipment that is displayed here as its original log data (thank you, Kodak). It, too, is low contrast; thin and washed

out like the negative it came from. The reason it looks so ugly is that we have not made a "print" of it yet. The process of making a print dramatically increases the contrast, density, and color saturation until it looks more like Figure 12-17.

Figure 12-16 Log image.

Figure 12-17 Print of the log data.

The log image in Figure 12-16 is what would be sent to the film recorder to film out as a new negative. It is also how the picture looks when working with log data on feature film visual effects and how the finished effects shots would be delivered. Of course, in a proper setup the workstation monitor has a special "print LUT" that displays the log data as it appears in Figure 12-17, which is also how it will appear when the print is projected in the theatre. In other words, the workstation monitor LUT displays the log data with a "simulation" of how it will look when printed and projected in the theatre.

With normal image data like video, CGI elements, and digital matte paintings the data is linear, not logarithmic. This means that the data represents the brightness of pixel values. With log data, however, the data represents the exponents of the brightness of pixels, not the brightness directly. This fact completely changes the math required when performing composites and color correction. As a result, log data is difficult to work with, so it is shunned by some and mishandled by others. The reason that filmmakers want you to put up with log data is that it can represent very high dynamic range images without clipping, just like film. This is something that normal linear data cannot do.

However, there is another approach looming on the horizon, which we saw in Chapter 2, Digital Images, and that is the EXR image file format. It is unique among file formats in that it is both linear and has an extended dynamic range. In fact, it was specifically developed for working with feature film scans without resorting to log data. I expect that eventually EXR will take over the feature film visual effects world and no one will have to suffer the labor of log anymore.

12.12 RECORDING FILM

Digital images get put back out to film using a large and expensive machine called a film recorder, with a classic example of an Arri film recorder in Figure 12-18. The 2k frame files are typically loaded onto a nearby disk array that has a dedicated high-speed network connection to the film recorder. The digital frames are read from the disk array one at a time and exposed to film. Film recorders are not yet as fast as film scanners. The hot new ones lope along at a few frames per second, so they run at around eight times real-time. However, the technology in this industry moves rapidly so we can look forward to real-time film recorders soon.

Figure 12-18 Film recorder.

There are two basic technologies used by film recorders: One is CRT-based where the picture is filmed off of an incredibly high quality monitor; the other technology is laser-based, where the image is "painted" directly on the raw film negative by sweeping red, green, and blue lasers. Some new machines use LED's instead of lasers. Because the laser-based systems provide such a pure, sharp, and intense light source they tend to be faster, produce sharper images, and have better color separation (saturation) than the CRT type of film recorders. They can also use a finer grained film than CRT systems because they have such high intensity light sources. This is not to say that CRT film recorders don't do a good job or that new models coming online aren't getting better. This is to say that if you are selecting a film recording service, do some test filmouts and project them.

In times of yore, the finished visual effects shot was shot out to film and the digital negative was delivered to the client to be cut into the movie. Today, the digital files are much more likely to be delivered to the DI facility to join their neighbors on the timeline of the digital color corrector, so we will now take a look at the DI process.

12.13 THE DIGITAL INTERMEDIATE PROCESS

The Digital Intermediate (DI) process color corrects the entire feature digitally in a computer instead of chemically in a film lab. The changeover to DI has swept through Hollywood like a tornado. Once it caught on, everybody had to have it. Some directors require the promise of doing a DI for their movie as part of their

contract with the studio. Many of the studios have built their own DI facilities. The reason that it is so popular is that it grants the filmmaker's biggest wish—more creative control. Here is a Hollywood film fact: no director or cinematographer that has done a DI has ever wanted to go back. But go back to what? Before we begin a tour of the DI process we need to understand the conventional workflow that it has replaced, what is now referred to nostalgically as the "wet" process.

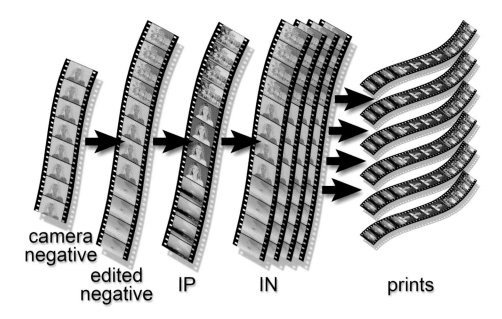

Figure 12-19 Conventional film post-production.

The conventional film postproduction process is depicted in Figure 12-19. It is referred to as "wet" because it entails exposing and developing a couple generations of the film in a lab with all their tubs and vats of developers and baths and rinses. The postproduction process encompasses three main objectives—producing an edited version of the movie, color correcting each shot, and creating a master to strike all of the theatrical prints. These multiple generations of the film are made with special intermediate film stocks, so named because they are intermediate between the camera negative and the theatrical prints.

12.13.1 Editing the Film

Today, movies are edited on video. The camera negatives are transferred to video in telecine, and then the editor "cuts" (edits) the movie using this video. Problem is, when it is done, the editor has an edited video, not an edited film. The next step is to "conform" the film to the video, where each clip of film is matched to each clip

of video, and then the precious and irreplaceable camera negative is cut to match. The camera negative is cut into pieces by a negative cutter (yes, there is a special guy or gal just to cut the negative) then spliced together to form the edited negative (see Figure 12-19), the film version of the edited movie.

12.13.2 Color Correcting

Once the edited negative is ready, it is taken to a film lab for color timing, which is film speak for color correcting. When the various shots are first cut together, they vary from shot to shot in brightness and color. One is too dark, the next too cyan, the next too bright, etc. This makes for jarring viewing so the shots must all be color corrected in order for them to play together nice. The edited "neg" (short for negative) is put on a machine that allows control of red, green, and blue light sources so the brightness and color can be adjusted on a shot-by-shot basis to expose another piece of intermediate film. Since we are color timing from a negative, the resulting color timed intermediate piece of film is a positive, or IP, short for interpositive. We now have the color-timed IP shown in Figure 12-19.

12.13.3 The Print Master

It is a film fact that when you duplicate a piece of film you get a negative of the original. In order to strike the theatrical prints, which must be positives, we will obviously need to use a negative. But we don't have a negative. The color timing process left us with the color-timed IP, which is a positive. We are going to have to make a copy of the IP in order to make a negative in order to strike the prints. This negative will be made on another intermediate film stock and will be called the *internegative*, or IN, also shown in Figure 12-19.

Rather than being a wasted duplication step just to get a negative, the IN step is actually a good thing. The reason is that it takes a lot of time and money to make the color-timed IP and you do not want to ruin it by running it thousands of times on a film printer to make the thousands of prints that go out to the theatre. It is much better to take the one expensive IP and make several cheap INs, then put the expensive IP in a safe place and use the cheap INs to make the thousands of prints. If an IN gets eaten by the film printing machine, just throw it away and get a new one. No worries.

12.13.4 How DI Works

Now that you are an expert on the wet process of color timing a feature film, we can contrast that with the new and improved Digital Intermediate process by following the diagram in Figure 12-20. The first and very important difference is that we are not going to chop up the precious and irreplaceable camera negative. As we saw in the Film Scanner section, the entire camera roll is placed on the film scanner and the selected frames are scanned leaving all of the camera rolls intact and uncut.

While depressing to the negative cutter's union, this is a great relief to the director, cinematographer, and movie producers.

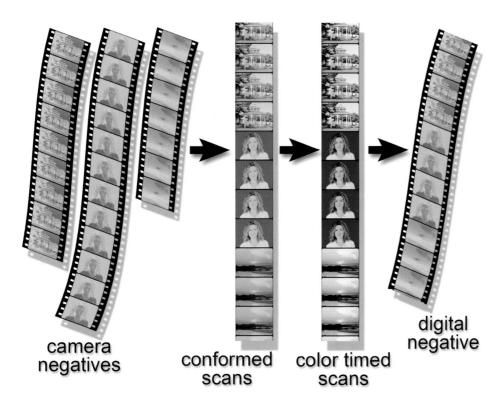

camera negatives conformed scans color timed scans digital negative

Figure 12-20 Digital Intermediate film post-production.

The movie can now be conformed (edited to match the video) by simply placing the scanned frames in the right order on the timeline of the digital color corrector. This is the DI replacement for the edited negative in the wet process. Next the conformed scans are color corrected, or color timed, by a talented colorist. He must be talented because he is paid 10 times as much as you or I. This produces the color timed scans in Figure 12-20 and is the DI replacement for the color timed IP in the wet process.

The last step is to send the conformed and color timed film frames to the film recorder to be exposed back to film. This produces the digital negative in Figure 12-20. Since this is filmed out using an intermediate film stock, this piece of film is in fact the digital intermediate for which the entire DI process is named. It is also the DI replacement for the IN in the wet process.

You may recall from the conventional process diagram (Figure 12-19) that several IN's were needed to strike the thousands of prints but we have produced only one here. Today it costs tens of thousands of dollars to film out one IN, so it is not

practical to film out 5 or 10 of them. The one IN is taken to a film lab which dups it to an IP, then from there to several INs, and from those the thousands of prints are struck.

The real win here is the enormous creative control over the color correction that is possible in the DI suite with a digital color corrector compared to the wet process in the film lab. The wet process has only a few simple color correcting capabilities while the digital kind is virtually limitless. In addition to that, the DI suite offers unique image processing capabilities such as grain reduction, dust busting, speed changes, image sharpening, and scene salvage, to name just a few.

When a movie is color timed with the wet process it produces the finished film, but not the video version. For that the movie must be separately transferred to video on a telecine and color timed a second time for video. When a movie uses the DI process the color-timed digital frames are laid off directly to HDTV video as the 24P master we saw in Chapter 11, and from that all other video variants are easily created. The DI process therefore produces both the film and video masters, so some refer to it as Digital Mastering. If the movie is slated for a Digital Cinema showing the D-Cinema version is also made directly from the color-timed digital files.

12.13.5 DI and You

So why does the modern digital compositor care about this DI process anyway? Because it has a direct effect on the visual effects shots that you will be delivering to your client. The client will be reviewing your shots with some kind of real-time playback on some kind of workstation, or even QuickTime movies on his laptop, but the final deliverable will be 2k log files sent to the DI facility of his choice.

The DI facility has a digital pipeline of its own and will have requirements for file formats, directory structures, and naming conventions that you will need to conform to. Basically, your work must move seamlessly from your digital pipeline to theirs. Contact them to get their specs and set up your job accordingly.

Another issue is the deep magic of working with log image data. This is tricky stuff that must be dealt with correctly or the color space of the delivered images will be embarrassingly messed up. One of the classic amateur mistakes is to convert all of the log images to linear, clipping them in the process, then converting the clipped images back to log. The colorist will spot this immediately. Worse than the prospect of reworking all of the shots, it reveals that whoever delivered the effects shots does not know what they are doing when working with film.

One last issue is perhaps the most important. When two or more layers are composited together and color corrected to match there will always be small mismatches between the layers. In the DI suite, the color timing process can "stretch" the composite causing the layers to "pull apart," exaggerating the mismatches. This is one of the main reasons for the gamma-slamming tip in Chapter 9.

The important point made in Chapter 4 about color grading bears repeating here. One thing that should be done before any compositing on feature film scans is a "color grading" of the background plates. You cannot know what the final color

timing look of the movie will be, of course. Color grading is just a basic color correction designed to generally balance the picture and fix any seriously off-color plates. Many of the scans will be over-exposed or too cyan, for example. If these are used as is, and the composited layers are color corrected to match an off-color background, when the composite goes to DI it will be heavily color corrected, which increases the chances of pulling the layers apart. A basic color grading before compositing will ensure that the colorist will do a less severe color correction, thus reducing the chances of tearing your work apart.

Glossary

Because this is an introductory book, the terms defined in this glossary are not overly technical. While an engineer or color scientist may not appreciate this, I trust that the newcomer to visual effects will. The bolded words found within the definitions signify that they are also defined in this glossary.

Numbers

2:3 pull-down—see **3:2 pull-down**.

2:3 pull-up—see **3:2 pull-up**.

2D—abbreviation for "2-dimensional," refers to manipulating only images—no **3D** elements.

2k—shorthand for an image with a horizontal resolution of 2048 pixels.

3:2 pull-down—to spread 24 frames of film out to 30 frames of video by transferring the film frames to **video fields** with a field pattern of 2:3:2:3:2:3.

3:2 pull-up—to remove a **3:2 pull-down**, restoring the original **24 fps** of film to **24 fps** of video by deleting the duplicated fields.

3D—abbreviation for "3-dimensional," another term for **CGI**.

3-perf—a special 35 mm film format that advances the film **3 perfs** per frame to conserve film stock, which results in a 1.75 **aspect ratio** image.

4:3 (or 4 × 3)—"four by three," the **aspect ratio** of SDTV.

4k—shorthand for an image with a horizontal resolution of 4096 pixels.

4-perf—a 35 mm film format that advances the film **4 perfs** per frame, which results in a 1.33 aspect ratio image.

8-perf—see **VistaVision**.

16:9 (or 16 × 9)—"sixteen by nine," the aspect ratio of HDTV.

16 mm—a small film format with a single **perf** per frame and a **1.66 aspect ratio** image at **full aperture**. See **super 16**.

24 P Master—an **HDTV** videotape with a resolution of 1920 × 1080 at **24 fps** using a **progressive scan** that is used to master all other derived video formats of lower resolution such as **NTSC** or a DVD.

35 mm—feature film format that advances the film **4 perfs** per frame with a 1.33 **aspect ratio** image at **full aperture**.

70 mm—a large film format that advances the film 5 **perfs** per frame with a 2.2 **aspect ratio** image.

A

Academy aperture—to expose **4-perf** 35 mm film to leave room for the sound track, which results in a 1.37 aspect ratio image.

Add operation—an **image blending** operation that merges two images without a matte by simply adding or summing the images together.

Algorithm—an ordered set of rules or operations to be followed by a computer.

Alpha—see **alpha channel**.

Alpha channel—the **CGI** term for an image channel that contains a matte.

Ambient light pass—one of the passes of a multi-pass **CGI** render that contains the light information for how the ambient, or overall wide area lighting illuminates its surface.

Anamorphic—a film format that captures the picture on film with a lens that squeezes the image by 50% horizontally, then a similar lens on the film projector stretches the image horizontally back to normal.

Animation curve—a **spline** curve that graphs one axis of an animation such as the position in X or the degrees of rotation. The **keyframes** are the **control points** of the curve and the computer **interpolates** the in-between frames.

Aperture—a rectangular hole cut in a metal plate that masks off film so only the desired area within the aperture is used.

Articulated rotos—a rotoscope technique where the **rotos** are drawn in several different pieces and then connected together like a hinged skeleton.

Artifact—a damaging change to an image resulting from an image processing operation.

Array—rows and columns of numbers arranged like a checkerboard.

Aspect ratio—a number that describes the shape of a rectangle, which is calculated by dividing its width by its height.

Atmospherics—adding live action or **CGI** smoke, dust, atmospheric haze, and so on to a shot.

Axis—see **pivot point**.

B

Background—the bottom layer of a composite over which all of the other layers are placed on top.

Bifurcation—to fork into two, such as when placing **keyframes** at the ends of a shot, then place another keyframe halfway between them, then another halfway between those, and so on.

Bit—a one or zero used to make up a computer **byte**.

Bit depth—the number of bits that make up one channel of an image, such as an 8-bit image. Also refers to all of the bits in all the channels of an image, such as a 24-bit image, referring to a **three-channel** 8-bit image.

Black point (informal)—the black **code value** achieved in completely unexposed parts of an image.

Blacks—the darker areas of an image.

Blending modes—the name Adobe Photoshop uses for their **image blending** operations.

Bluescreen—to film a target object in front of a blue or green screen so it can later be isolated by the computer and composited into another background.

Box filter—a type of low-quality **filter** that is fast to compute.

Brightness—refers to the level of a color that can range from black to full intensity.

Bullet time shot—to freeze a moment in time as the camera swirls around the target object by recording the scene with several still cameras triggered at nearly the same instant, then integrated into a moving scene.

Byte—a group of 8 bits.

C

Camera aperture—the metal plate with a rectangular hole used in a film camera to control the size and shape of the exposed image on the negative.

Camera guide—a chart laid over a film frame that provides outlines to mark the various **projection apertures**.

Camera negative—the negative film stock that is exposed in the camera when shooting a scene.

Camera roll—the roll of film taken out of the camera on location after it is exposed.

Cardinal rotate—to rotate an image by exact 90 or 180 degree increments.

CGI—abbreviation for **Computer Generated Image**.

Channel—a single 2-dimensional array of numbers that holds the **code values** of the pixels of an image.

Chrominance—the **hue** and **saturation** component of a color, distinct from its **brightness**, or **luminance**.

Chroma-key—to create a **matte**, or **key**, based on the **hue**, **saturation**, and **value** of the target object.

Cine-compress—see **3 : 2 pull-up**.

Cine-expand—see **3 : 2 pull-down**.

Cinemascope—a film format with an **anamorphic** frame (squeezed 50% horizontally) that is stretched 200% horizontally at projection time to be displayed at a 2.35 **aspect ratio**.

Cineon—an older image file format developed by Kodak to hold 10-bit **log** film scan data.

Clean plate—a background frame that has the same image content as a target object, but without the target object itself.

Code value—the number that represents the **brightness** and color value of a pixel.

Clone-brush—a digital paint program brush that copies pixels from a pre-selected area to the painted area.

CLUT—abbreviation for Color Look-Up Table, an image format that creates color images with an array of indexes, or pointers, into a short list of **RGB** colors.

Color curves—**spline** curves that remap the brightness values of color channels.

Color channel—the Red, Green, or Blue **channel** of an **RGB** image.

Color correct—adjusting the **RGB** values of an image to change its appearance.

Color difference mask—a high quality mask created by subtracting the **color channels** of an image from each other. Forms the basis of most digital **keyers**.

Colorist—the artist that **color-times** (**color corrects**) a feature film or television show.

Color sub-sampling—in video, to **sample** the color or **chrominance** of the image at half the horizontal resolution of the **luminance**.

Color timing—to **color correct** a feature film by re-exposing the edited negative to an **intermediate film stock**, while adjusting the **RGB** lights used to expose it.

Composite—the process of combining two or more image layers together with the use of a **matte** to define the transparencies of the layers.

Compression—to convert an image to a different format in order to reduce its file size.

Compression artifact—an **artifact** introduced into an image by a **lossy compression** scheme.

Computer Generated Image (**CGI**)—an image totally created in the computer, such as a **3D** animation or a digital matte painting.

Concatenate—to link a series of operations together into a single operation.

Conform—to match the film frames to the video used to edit a movie.

Contact shadow—a deep shadow at the point of contact between two surfaces.

Contrast—a color correcting operation that raises the **whites** and lowers the **blacks** of an image.

Control point—for a **spline** or animation curve, a point placed by the operator that is used to control the position and shape of the spline.

Crowd duplication—to duplicate sections of a crowd to fill a large area such as a stadium or theatre.

CRT—abbreviation for Cathode Ray Tube, the technology that makes monitors using a vacuum tube and colored phosphors excited by an electron beam.

Cscope—abbreviation for **Cinemascope**.

D

Data compression—to reformat a set of data for the purpose of reducing its file size.

D-Cinema—see **digital cinema**.

Deflicker—digital removal of **frame flicker** from a shot.

Degrain—to reduce or remove the grain in a film frame.

De-interlace—the process of removing the interlacing from video to produce "clean" frames by discarding one of the **video fields** and interpolating a replacement from the remaining video field.

Depth compositing—to composite layers front-to-rear based on the data in their **Z channel**, which indicates their relative distance from the camera.

Depth of field—the zone or region in a scene where objects are in focus. Objects in front or behind this zone will be out of focus.

Despill—an image processing operation that removes the excess **spill** light from a bluescreen or greenscreen that discolors the target object.

DI—abbreviation for **Digital Intermediate**, the digital **color timing** process used for film finishing.

Difference mask—a low quality **mask** created by taking the simple difference (absolute value) between two images, a target object and a **clean plate**.

Diffusion pass—one of the passes of a multipass **CGI** render that contains the light information for the diffuse, or nonreflective surface attributes.

Digital cinema—a high-resolution digital projector used to display a **digitized** feature film rather than using a film projector.

Digital intermediate—to **digitize** an entire feature film, **color correct** it with a computer, then record it back out to a new negative. Technically, the new negative is the digital intermediate.

Digital mastering—the modern method of film finishing where the entire movie is digitized, color corrected with a computer, then recorded back to film, then the color corrected image data is converted to **HDTV** to create the **24P master** video.

Digital negative—the negative digitally created by exposing film with a **film recorder**.

Digitize—to **sample** some value (color, sound, etc.) and convert it to a number.

Display aspect ratio—the ratio of the width of a display device divided by its height.

Disk array—a collection of disk drives working together as a single large disk drive.

DPI—abbreviation for Dots Per Inch, a printing term that defines how many image pixels are used per inch of paper.

DPX—a sophisticated image file format that can hold 10-bit **log** film scan data or 10-bit linear **HDTV** video data and multiple channels.

Drop-frame timecode—a video **timecode** scheme that periodically skips or drops out a frame of timecode, but not picture, to keep the timecode from falling behind real time.

Dust-Busting—digital removal of dust and dirt that was on the film negative when it was scanned.

Dups—shorthand for "duplicates"; in other words, to make copies.

DV—abbreviation for Digital Video, a family of video cameras and tape players that utilize low color **sampling** plus **data compression** to make small, inexpensive

video equipment. It also introduces **artifacts** that create problems for digital keyers.

E

Edge blend—a procedure used in a composite that applies a masked blur to gently blend together the **foreground** and **background** pixels all around the perimeter of a foreground object.

Edge enhancement—a feature in video cameras that applies edge sharpening to the video signal. It also introduces edge **artifacts** that create problems for digital keyers.

Edited negative—the master negative created by cutting together all of the selected shots from their original **camera negatives**.

Exponent—the power that a number is raised to. For the example of two raised to the eighth power (2^8), the "8" is the exponent.

EXR—shorthand for OpenEXR. It is ILM's advanced image file format that supports high dynamic range images using a 16-bit "short float" word with unlimited user-defined channels.

Extremes—the point where a motion channel reverses direction, such as the vertical channel at the highest point of a tossed ball. Used to place keyframes on the extremes of the path of motion of an object.

F

Film recorder—a large and expensive precision machine that records digital images out to film.

Film scanner—a large and expensive precision machine that scans and digitizes film frames.

Filter—image processing operation typically used with **transformations** that calculate a new pixel from surrounding pixels.

Floating point—to represent numbers with decimals, such as 1.2 or 0.7839 instead of whole numbers, such as 100 or 255.

Foreground—the layer composited over a **background**. There is often more than one foreground element in a composite.

Four-channel—a **three-channel** image that has a fourth channel added that contains a **matte**, often referred to as the **alpha channel**.

Four-corner pin—to deform an image by shifting any of its four corners.

FPS—abbreviation for Frames Per Second.

Frame averaging—to average (**mix**) adjacent frames together as a way to increase or decrease the number of frames in a shot.

Frame duplication—to duplicate frames of a shot to lengthen it.

Frame flicker—rapid fluctuation of brightness from frame-to-frame. The entire frame might flicker or just one area of the frame, depending on the cause.

Frame line—the thin black line of unexposed film between frames.

Frame rate—a number that describes how many times per second a display system redraws (refreshes) its screen.

Full aperture—to expose **4-perf** film "perf-to-perf" for the maximum area of exposed negative, which results in a 1.33 aspect ratio image.

G

Gain—to scale the **RGB** values of an image up or down increasing or decreasing their **brightness**.

Gamma—a mathematical equation that calculates a new pixel value by raising the old pixel value to a power; for example, $0.5^{1.2}$ applies a gamma of 1.2 to a pixel value of 0.5. Used for brightening and darkening images.

Gamma slamming—to severely change the gamma of the display of an image to either crush or stretch its brightness in order to reveal defects in the composited layers.

Garbage matte—a low-detail matte created quickly to **mask** large areas of an image.

Gaussian filter—a type of **filter** that does not incorporate sharpening.

Geometric primitives—a simple geometric shape such as a circle or a square.

Geometry—the polygons and spline surfaces that make up the **3D** shape of **CGI** objects.

Grain structure—refers to how the grain appears, its physical size and brightness variation.

Graphic image—an image created with computer graphics tools as opposed to a photograph of a scene.

Grayscale—a **one-channel** image that contains only **brightness** information and no color.

GUI—abbreviation for Graphical User Interface, which is the "control screen" of a program that the operator interacts with.

Grunge pass—one of the passes of a multi-pass **CGI** render that contains the light information for dirt and defects of the surface.

H

HDTV—abbreviation of High Definition Television, a family of standards with an **aspect ratio** of 16 × 9, square pixels, and multiple frame resolutions and scan modes.

Hair removal—digital removal of a hair in the camera gate that was exposed along with the film.

Holdout mattes—a **matte** used to fill in the "holes" or thin parts of another matte to make it solid.

Hue—the attribute of a color that describes which color it is—red, yellow, magenta, etc.

Hue curves—color correction curves that affect only the selected **hue** range.

I

Image aspect ratio—a number that describes the shape of an image that is calculated by dividing its width in pixels by its height in pixels.

Image blending—combining two images mathematically without a **matte**.

Image resolution—the width and height of an image in pixels.

Impulse filter—not a true filter, it simply selects the nearest pixel from the source image to be used in the output image. Very low quality, but very quick to compute.

IN—abbreviation for **InterNegative**.

Indexed color—see **CLUT**.

Interlaced video—a video scan mode where the odd lines are scanned during one pass of the **video field** and the even lines on another pass of the video field, and then the two fields are integrated (interlaced) into one frame of video.

Interactive lighting—the light in a scene that bounces from object to object, as well as the process of simulating light from one layer of a compositing shining on another layer.

Intermediate film stock—a film stock used in a film lab to re-expose other film stocks during film postproduction.

Internegative—a negative exposed from the color-timed **interpositive** using an **intermediate film stock** that is then used to expose the theatrical prints of a move.

Interpolate—to calculate new data points between two existing data points.

Interpositive—a positive exposed from the **edited negative** using an **intermediate film stock**.

Invert—to reverse the order of the brightness values of an image, to swap black and white.

IP—abbreviation for **InterPositive**.

J

JPEG—abbreviation for Joint Photographic Expert Group, a **lossy compression** scheme specifically designed to reduce the file size of photographic images.

K

Key—a **one-channel** image used for either masking off an image processing operation or for compositing two images together that indicates which pixels to use from the foreground and background.

Keyer—a computer program that pulls a **matte** from a **bluescreen** or greenscreen, performs a **despill** operation, then composites it over a **background**.

Keyframe—the frame of an animation that the operator has positioned an object. The computer will then **interpolate** the object's position between the keyframes.

Keyframe animation—to animate an image by positioning it only on selected **keyframes**, and then the computer calculates all in-between frames.

L

Laser—an extremely pure (monochromatic) and bright light source that creates incredibly parallel light beams with perfectly synchronized photons moving in unison (coherent). Used in some film recorders.

Layer-based compositing—a compositing program that represents the workflow as timelines and layers that unfold to reveal the image processing operations.

LED—abbreviation for Light Emitting Diode, a solid-state device that emits a pure light. Used in some film recorders.

Lens distortion—the distortion or warping imparted to an image due to optical irregularities in the lens.

Letterbox—a format for fitting widescreen film into video that preserves the film's original **aspect ratio** by shrinking the film image down to fit side-to-side within the video frame and placing a black strip above and below the film frame.

Lift—a color correcting operation that raises the blacks most, the midtones less, and the whites the least.

Light leaks—accidentally exposed regions of the camera negative due to light leaking into the camera body.

Light wrap—a procedure to "wrap" light from the background layer of a composite around the edges of a foreground layer to make it appear more realistic.

Linear—the relationship between image brightness and its code value such that any change in the code value causes an equal change in the brightness.

Local deformation—to deform or distort an image in a specific region only, instead of deforming the whole image.

Log—shorthand for "logarithmic," a film scan encoding method that records the exponents (the log) of the pixel brightness rather than the brightness directly.

Lossless compression—an image **compression** scheme to reduce file size that does not degrade the quality of the image.

Lossy compression—an image **compression** scheme to reduce file size that degrades the quality of the image.

Luma-key—to create a **matte**, or **key**, based on the luminance, or **brightness**, of the target object.

Luminance—the brightness component of a color, distinct from its **hue** and **saturation**.

LZW—abbreviation for Lempel-Ziv-Welch, the names of the three inventors of this lossless compression scheme.

M

Mask—a one-channel image used to restrict an image processing operation to the area defined by the mask.

Match move—to analyze the terrain and camera move in a live action shot, and then use the data to position **CGI** elements within the live action scene with a matching CGI camera move.

Matte—a one-channel image used for compositing two images together that indicates which pixels to use from the foreground and background.

Maximum operation—an **image blending** operation that merges two images without a matte based on retaining whichever pixel has the maximum, or greatest value. "Lighten" in Photoshop.

Mesh warp—an image **warp** technique that places a deformable grid over an image that, in turn, deforms the image.

Minimum operation—an **image blending** operation that merges two images without a matte based on retaining whichever pixel has the minimum, or least value. "Darken" in Photoshop.

Mix operation—an **image blending** operation that merges two images without a matte based on scaling their RGB values then summing (adding) them together.

Monitor LUT—a LUT (Look-Up Table) used to color correct a monitor.

Monochrome—meaning "one color," another term for a grayscale image.

Morph—an animation that deforms and dissolves one image into another in a way that appears that the first image has seamlessly changed into the other.

Motion blur—the smearing or streaking of an image in the direction of its motion while the camera shutter is open.

Motion control—a camera or rig that is moved by electric motors under computer control.

Motion strobing—a "stuttering" artifact introduced to an animation when an object moves too fast for the amount of **motion blur** it has.

Motion tracking—to lock an image to a moving background image so that they move together in perfect sync.

Motion vector—the data collected with the **optical flow** technique that logs the direction of motion of local regions of an image from frame-to-frame.

MPEG-2—abbreviation for Moving Pictures Expert Group, a **lossy compression** scheme specifically designed for moving images such as film or video.

Multipass compositing—to composite a **CGI** object that has been rendered as several different lighting passes such as **ambient**, **diffuse**, **specular**, etc.

Multiplane compositing—to composite **2D** images placed in a true **3D** environment with a 3D camera.

Multiply operation—an **image blending** operation that merges two images without a matte based on multiplying them together.

N

Neg—shorthand for "negative."

Node-based compositing—a compositing program that represents the workflow as a series of interconnected nodes, or icons, that represent image processing operations.

Non-drop frame timecode—a video **timecode** scheme that does not periodically drop out a frame of timecode.

Non-square pixels—pixels that have an aspect ratio of other than 1.0; that is, not square.

NTSC—the American standard of television with a display **aspect ratio** of 1.33 and a 30 **fps** interlaced display.

O

Occlusion pass—one of the passes of a multipass **CGI** render that contains the light information for how the CGI object blocks light onto its own surfaces.

On 2's—to set **keyframes** every two frames.

One-channel—an image that consists of a single array of numbers that indicates brightness only and no color.

Optical flow—a high quality image processing technique used to lengthen or shorten a shot by analyzing the direction of motion of small regions of pixels from frame-to-frame to calculate the new set of frames.

P

PAL—the European standard of television with display **aspect ratio** of 1.33 and a 25 **fps** interlaced display.

Pan and scan—a format for fitting a widescreen film into video that fits the film image top-to-bottom and crops the sides of the film. It does not preserve the aspect ratio of the film.

Particle systems—particles generated by a computer in vast numbers used to create smoke, rain, fog, etc.

Perf—shorthand for "perforations," the small holes on both sides of the film that are used by sprockets to advance the film and hold it steady.

Perspective—the differing appearance in relative size and position of objects in a scene due to their different distances and locations from the camera.

Photographic image—an image from a live action scene captured with a camera.

Pivot point—the center around which a transform takes place, such as the center of scale or the center of rotation.

Pixel—the smallest unit of a digital image, like one "tile" of the image.

Pixel aspect ratio—a number that describes the shape of a pixel calculated by dividing its width by its height.

Plate—a layer of film or video used in a composite or visual effects shot.

Point cloud—the entire group of 3-dimensional **tracking points** that the computer has identified in a **match move** shot.

Post move—to crop a moving window out of a shot to add a camera move in postproduction.

Print—the high-contrast full color film that is projected in the theatre.

Print LUT—a LUT (Look-Up Table) for a monitor to display log film data as it would appear as a print projected in the theatre.

Procedural—to perform an operation using rules, or procedures, instead of doing it by hand.

Procedural garbage mattes—**garbage mattes** that are created using rules, or procedures, instead of drawing by hand.

Procedural mask—a **mask** created using a rule, or procedure, instead of drawing by hand.

Procedural warp—an image **warp** technique that deforms an image based on a rule, or **procedure**.

Progressive scan—an **HDTV** scan mode that scans the scene from top to bottom without skipping any scan lines.

Projection aperture—the metal plate with a rectangular hole used in a film projector to control the shape (**aspect ratio**) of the projected image to the screen.

PsF—abbreviation for Progressive Segmented Frame, an HDTV scan mode that uses a **progressive scan** of the scene, but records it onto videotape with all of the odd scan lines followed by all of the even scan lines.

Premultiplied CGI—a **CGI** image that has already been multiplied by its alpha channel to introduce anti-aliasing and transparency into the **RGB** channels.

Premultiply—to multiply the **RGB** channels of a **CGI** image by its **alpha channel** in order to introduce anti-aliasing and transparency into the **RGB** channels.

R

Reflection pass—one of the passes of a multipass **CGI** render that contains the light information for how the CGI object reflects the environment that it is in.

Render—the stage of a computer graphics process where the final image is calculated by the computer.

Reverse telecine—see **3:2 pull-up**.

RGB—abbreviation for Red, Green, and Blue.

RGBA—abbreviation for Red, Green, Blue, and Alpha, which is a color **RGB** image with an **alpha channel**.

RGBAZ—a five-channel image that contains Red, Green, Blue, Alpha, and Z (depth) data.

Rig removal—digital removal of **rigs**, poles, or armatures from a live action shot.

Rigs—poles or robotic mechanical arms that support an object that is moved under computer control.

RLE—abbreviation for Run Length Encoding, a lossless image compression scheme.

Roto—see **rotoscope**.

Rotoscope—to hand-draw a matte for a target object frame-by-frame.

S

Safe-to aperture—the rectangular area in a visual effects shot where all of the effects must be made good in order to cover all projection formats. Outside of the safe-to aperture the visual effects are not seen.

Sample—to measure something such as color, sound, or weight.

Saturation—the attribute of a color that describes how pale or colorful it is.

Scene salvage—to repair the frames of a physically damaged shot.

Scope—shorthand for "**Cscope**" which is shorthand for **Cinemascope**.

Scope extraction—shorthand for "**Cinemascope**" extraction done during the **digital intermediate** process where a 2.35 aspect ratio window from the **super 35** frame is resized to the Cinemascope frame for filmout.

Scratch removal—digital removal of a scratch on the scanned negative.

Screen operation—an **image blending** operation that merges two images without a matte based on an inverted multiply calculation.

SDTV—abbreviation for Standard Definition Television, defines the specifications for **NTSC** television with 30 fps interlaced video at 720 × 486 resolution.

Semi-transparency—partially transparent.

Set extension—to extend a physical set by adding a virtual set created with **CGI**.

Shadow pass—one of the passes of a multipass **CGI** render that contains the light information for how the shadows fall onto the surface.

Shear—to shift the top, bottom, left, or right edge of an image to deform it. Also known as **skew**.

Sim—shorthand for **simulation**.

Simulation—a computer model of a physical system such as water, fire, falling, or colliding objects.

Sinc filter—a type of **filter** that incorporates sharpening.

Skew—see **Shear**.

Specular pass—one of the passes of a multipass **CGI** render that contains the light information for the specular, or highly reflective surface attributes.

Speed change—to lengthen or shorten a shot by increasing or decreasing the number of frames using one of several possible methods for calculating the new frames.

Spill—the colored light from a bluescreen or greenscreen that discolors the target object filmed in front of it.

Spline—a mathematically generated line that can be curved by adjusting its **control points** and handles.

Spline warp—an image **warp** technique that places splines over an image that, in turn, deforms the image.

Stabilize—to remove the camera jitter from a shot by using motion tracking data.

Strobing—a rapid flicker.

Subtract operation—an **image blending** operation that merges two images without a matte based on simply subtracting the images from each other.

Super 16—a 16 mm film format with only 1 **perf** per frame and a 1.66 aspect ratio image.

Super 35—another term for **full aperture**.

T

Temporal—having to do with or relating to time.

Temporal coherency—to move smoothly over time as opposed to random jittering from frame-to-frame.

Tension—the adjustment of a **spline** that affects how "stiff" the line is.

Three-channel—an image that has three channels, or layers, that holds the color information for an **RGB** image.

Timecode—the "time stamp" embedded into each frame of video that records the hour, minute, second, and frame number on each frame.

Title safe—the region within the video frame to place titles so that they don't get too close to the edge of the television screen.

Tracking points—the "landmarks" in an image that the computer locks onto frame-by-frame during the **motion tracking** of a shot.

Transform—see **transformation**.

Transformation—an image processing operation that changes the position, size, shape, or orientation of an image (move, scale, rotate, and so on).

Transformation order—the order in which a series of transformations are done.

Translate—to change an object's **X**, **Y**, or **Z** location.

Translation—the act of moving an object.

U

Unpremultiply—to reverse a **premultiply** operation by dividing the **premultiplied CGI** image by its **alpha channel**.

Unpremultiplied CGI—a **CGI** image that has NOT been multiplied by its alpha channel to introduce anti-aliasing and transparency into the **RGB** channels.

V

Value—an attribute of a color that is similar to **brightness** or luminance, but calculated slightly differently.

Video field—one half of a video frame that consists of either the even or odd scan lines with each field capturing a different moment of time.

VistaVision—a 35 mm film format that lays the film on its side and advances the film 8 **perfs** per frame, which results in a 1.5 **aspect ratio** image.

W

Warp—to arbitrarily deform an image as if it were attached to a sheet of rubber.

Wet process—the term for the old process of **color timing** a feature film.

White point (informal)—the code value of the brightest diffuse white in the picture, such as a white T-shirt in broad sunlight.

Whites—the lighter, brighter parts of an image.

Wire gag—live action stunt technique where stunt men are suspended by wires and pulleys, and then boosted to jump or fly by off-screen assistants.

Wire removal—to use clone brushes or compositing techniques to remove the wires attached to actors or objects used to make them appear to fly or float.

X

X—symbol for the horizontal direction.

Y

Y—symbol for the vertical direction.

Z

Z—symbol for the direction perpendicular to the screen.

Z channel—a **channel** added to an image that contains depth information (distance from the camera) about the objects in the image.

Index